THE SU... ...N ART & DE...GN

THE SU... ...N ART & DE...GN

Design2006 Graphis Mission Statement: Graphis is committed to presenting exceptional work in international design, advertising, illustration and photography. Since 1944, we have presented individuals and companies in the visual communications industry who have consistently demonstrated excellence and determination in overcoming economic, cultural and creative hurdles to produce true brilliance.

Design2006 Graphis Mission Statement: Graphis is committed to presenting exceptional work in international design, advertising, illustration and photography. Since 1944, we have presented individuals and companies in the visual communications industry who have consistently demonstrated excellence and determination in overcoming economic, cultural and creative hurdles to produce true brilliance.

Design2006

CEO & Creative Director: B. Martin Pedersen

Managing Editor: B. Martin Pedersen
Associate Editor: Carla Miller
Designer: Danielle Macagney
Production Manager: Luis Diaz

Photographer: Alfredo Parraga

Published by Graphis Inc.

(opposite page) **Eric Chan Design Co. Ltd**/*Hong Kong Heritage Museum*

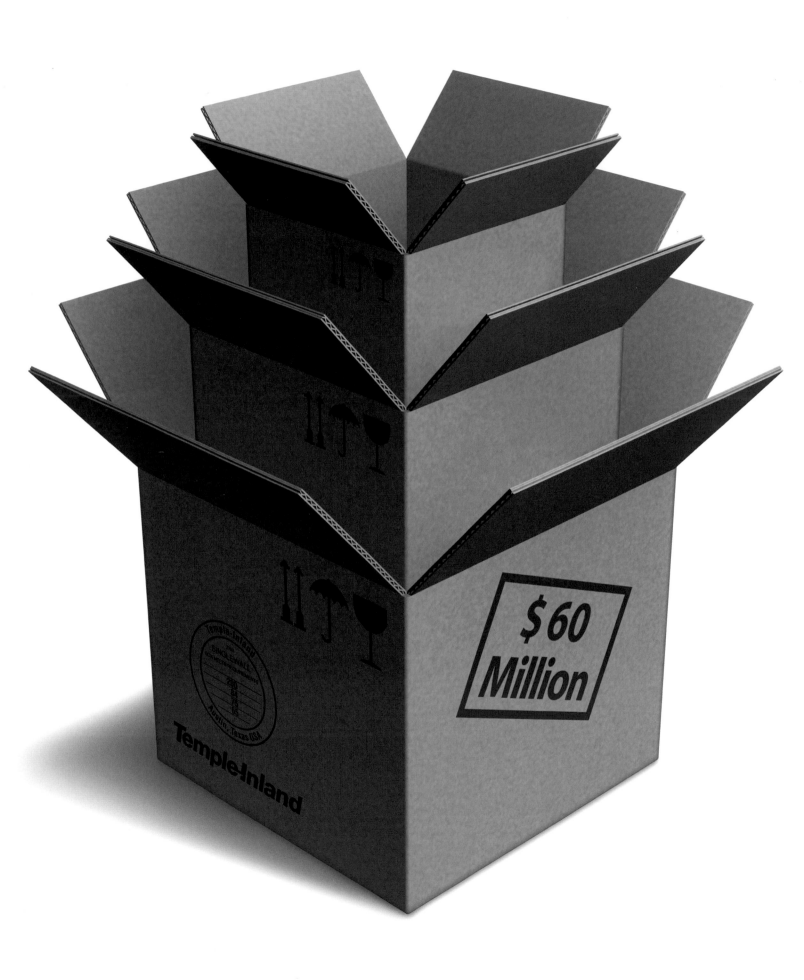

Peter Kramer *Rex Peteet*

Contents Inhalt Sommaire

Remarks: We extend our heartfelt thanks to contributors throughout the world who have made it possible to publish a wide and international spectrum of the best work in this field. Entry instructions for all Graphis Books may be requested from: **Graphis Inc.**, 307 Fifth Avenue, Tenth Floor, New York, New York 10016, or visit our Web site at www.graphis.com.

Anmerkungen: Unser Dank gilt den Einsendern aus aller Welt, die es uns ermöglicht haben, ein breites, internationales Spektrum der besten Arbeiten zu veröffentlichen. Teilnahmebedingungen für die Graphis-Bücher sind erhältlich bei: **Graphis Inc.**, 307 Fifth Avenue, Tenth Floor, New York, New York 10016. Besuchen Sie uns im World Wide Web, www.graphis.com.

Remerciements: Nous remercions les participants du monde entier qui ont rendu possible la publication de cet ouvrage offrant un panorama complet des meilleurs travaux. Les modalités d'inscription peuvent être obtenues auprès de: **Graphis Inc.**, 307 Fifth Avenue, Tenth Floor, New York, New York 10016. Rendez-nous visite sur notre site web: www.graphis.com.

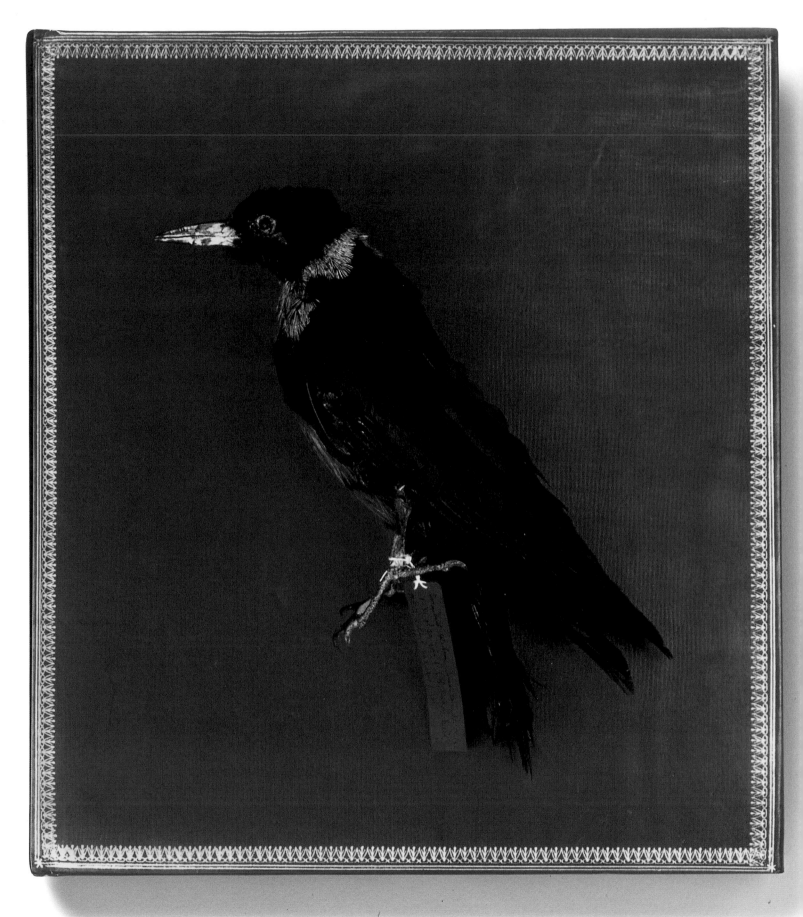

Q&A Mucca Design Rarest of the Rare

This is a beautiful book, how much of what we see came from the client and/or from you?

The Harvard Museum provided beautiful images for us to work with. They asked for a striking package that would represent the Museum and it's intriguing artifacts. We suggested the idea of a half jacket and a printed case, which would allow us to showcase the cover images in their entirety, as well as create a tactile experience.

What was your ultimate goal for the book? Do you feel that you have achieved this?

We wanted a package that would evoke a cabinet of wonders and pique the viewer's curiosity. I believe we were successful.

What was the biggest challenge that you faced?

The client did not want to be portrayed as a stodgy institution, so the main challenge was to take the historical material and give it a fresh, contemporary appeal.

What was the print run?

There were 15,000 copies in the first print run and we went back to press for an additional 3,500 in a second printing.

How many copies have been sold?

We've netted over 12,000 copies so far.

Has the book been successful?

Yes, the book has sold well and it was named a "Top 10 Science Book" by Discover magazine.

See pages 30&31

Andrea Brown *Senior Art Director* Andrea is Senior Art Director at Mucca Design, an award-winning graphic design studio in New York that works with: publishers, fashion designers, restaurateurs, software companies, architects, and hoteliers to craft brand personalities that are unique and distinctive. Recently,she has completed projects for various New York restaurants, including: Japanese Brasserie, Sant Ambroeus, and Country. Before joining Mucca Design in 2000, she designed many book jackets for Broadway Books at Random House and her work has appeared in Print Magazine. *Credits:* We designed this hard cover for Harper Collins. The book tells the stories behind the Treasures at the Harvard Museum of Natural History. The communication objective was to intrigue readers and viewers with a preview of the unusual artifacts portrayed in the book. *Title* Rarest of the Rare; *Design Firm* Mucca Design; *Art Director* Matteo Bologna; *Designer* Andrea Brown, *Client* Harper Collins; See pages 30, 31.

Q&A KatsuiDesignLitherone

You've appeared in our 'Japanese Masters' book and your work is very fresh and original. How do you manage being ahead of the industry at your age?

Well, I think it's necessary for a designer to always be motivated and stimulated from the freshness of the present.

Do you get carte-blanch from your client?

I feel you should always think one step ahead of your client's intention. I think one step ahead of my client's intention.

What was most challenging?

The client was a printing machine company so, when creating this piece, I considered the quality of the design to the mass reproduction of the print. This was a challenge. Since the client is a printing machine company, I considered the challenge to be the vast reproduction of the piece.

At present, what professional goals are you trying to achieve?

I'm aiming to create with a more critical viewpoint that will allow me to solve various problems.

What is your philosophy?

My philosophy lies in the words of leprosy poet, Kaito Akashi, "It doesn't have light anywhere if it doesn't burn voluntarily like the fish that lives in the deep sea."

What inspires you?

I am inspired from all of my relations.

See page 187

The Library
University College for the Creative Arts
at Epsom and Farnham

Mitsuo Katsui *Graphic Designer.* Mitsuo Katsui was born in Tokyo 1931. He graduated from the University of Tokyo Department of Education in 1955. He has worked in all fields of graphic design. Among many achievements, he has provided art direction for the Osaka International Expo, Okinawa Ocean Expo., and the Tsukuba Science Exposition. His work strives to open a new realm of communication through the modes of expression that technology provides. Awards that he has received include the: JAAC Awards, Mainichi Industrial Design Award, Kodansha Cultural Publishing Prize, the Minister of Education Prize for the Arts, a Purple Ribbon Medal, the Masaru Katsumi Award, Memorial Prize of Hiromu Hara. He has also received numerous gold prizes from International organizations and events such as: Brno Book, the Warsaw, Lahti, Mexico Poster Biennials, and the New York ADC. He is an emeritus Professor of Musashino Art University, a JAGDA director, and member of the Tokyo and New York Art Directors Clubs, and AGI. *Credits: Design Firm* Katsui Design; *Art Director/Designer* Mitsuo Katsui; *Client* Komori Corporation. See page 187.

2004 FINANCIAL HIGHLIGHTS

Dollars in thousands, except per share amounts		2004		2003		2002
SUMMARY OF OPERATIONS						
Net sales	$	6,054,536	$	5,207,459	$	5,083,523
Operating income		777,788		644,989		621,921
Operating margin		12.9%		12.4%		12.2
Income from continuing operations	$	474,702	$	397,933	$	364,428
Net income (loss)		474,702		397,933		(154,543)
Return on capital (continuing operations)		15.8%		16.6%		16.9
FINANCIAL POSITION						
Working capital	$	1,606,354	$	1,419,281	$	1,391,606
Current ratio		1.7 to 1		2.8 to 1		2.4 to 1
Cash flow from operations	$	738,256	$	543,794	$	648,564
Debt to capital ratio		26.5%		33.7%		29.6%
Common stockholders' equity		2,513,241		1,951,307		1,657,648
PER COMMON SHARE						
Income from continuing operations–diluted	$	4.21	$	3.61	$	3.24
Net income (loss)–diluted		4.21		3.61		(1.38)
Dividends		1.05		1.01		.97
Book value		22.56		18.04		15.28

BARBARA NARDINI-ZITELLA *Sales Account Executive, Wrangler & Lee Brands Canada*
A Banner Year: 2004 was definitely the most energizing year in my 25-year career.
The success of Lee in Canada has been overwhelming and I'm very proud to have been
part of it. BRIAN WILLIAMS *VP, Wrangler & Lee Brands Canada & Puerto Rico*
2005 and Beyond: We have aggressive plans to fuel growth with exciting initiatives for
the retail community and great products for consumers.

LIVING THE BRAND *VF Corporation 2004 Annual Report*

BERNA GOLDSTEIN *Director of Merchandising, Bestform & Curvation, VF Intimates*
How Berna Sees Her Job: A merchandiser is really the hub of a wheel. *How Berna Thinks:*
"What if" instead of business as usual. *Upward Curve:* Not only did we expand our
assortment for the Curvation™ brand, we were also able to raise our retail price points.
RAY NADEAU *VP, General Manager, Bestform & Curvation, VF Intimates A Typical Ray Day:*
Focusing on the priorities that drive growth. *A Ray of Understanding:* My strength is knowing
our consumer and retailer needs, and finding "white space" opportunities.

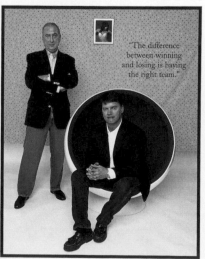

ART DECESARO (L.) *VP, General Manager, Vassarette, VF Intimates Personal Compulsion:*
Staying Number One. *Method:* By thinking outside of the box in both product innovation
and marketing. *Outside the Box Idea:* Our introduction and sponsorship of the first female
NASCAR race driver in the truck series. MILES BOHANNAN *Director of Marketing,*
Vassarette, VF Intimates Part of the Job: Staying at the top of my game despite competitive
pressure. *Top Two Qualities:* Open-mindedness and tenacity. *Keeping Growth on Track:*
We initiated a focused direct mail piece aimed at Hispanic consumers.

David Schimmel *VF Corporation*

We provide energy efficient, longlife Solid State Lighting technology which replaces conventional lighting and helps save the environment through energy conservation.

TIR has over twenty years of experience developing specialty lighting systems and a multi-disciplinary research team focused on making the technological advancements required to reach our goal of Solid State Lighting for general illumination, everywhere.

TIR 04

TIR Systems Ltd. 2004 Annual Report

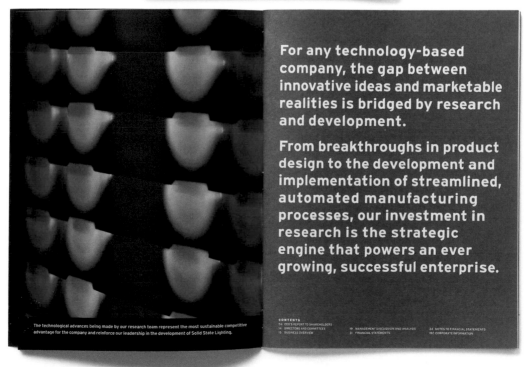

The technological advances being made by our research team represent the most sustainable competitive advantage for the company and reinforce our leadership in the development of Solid State Lighting.

For any technology-based company, the gap between innovative ideas and marketable realities is bridged by research and development.

From breakthroughs in product design to the development and implementation of streamlined, automated manufacturing processes, our investment in research is the strategic engine that powers an ever growing, successful enterprise.

SamataMason *TIR Systems Ltd.*

STRETCHING THE BOUNDARIES

COLOURSCAN

IN OUR
SERVICE

IN OUR
CAPABILITIES

IN OUR
FACILITIES

IN OUR
WORK

DORLING KINDERSLEY

With their strong tradition of design and reproduction excellence, Dorling Kindersley demand the very best in a colour separation house. The high-quality illustrated reference books they are famous for have set superior benchmark standards that Colourscan has been able to match, time after time. With many of their titles to our credit, Dorling Kindersley have been utilising our services for nearly two decades now, becoming in the process our biggest client, and cementing our reputation internationally for premium quality work. For us this is a very successful partnership of which we are very proud.

2

QUALITY

An unblemished reputation is something like a medal – tough to earn, but once you've got it, you wear it with a smile. When it comes to quality, we have earned a reputation as one of the most renowned digital image service providers in South East Asia. Which is why 60 percent of our output is for international markets, and many global customers award us their business, including leading international publishers such as Dorling Kindersley, Harper Collins, Murdoch Books and Reader's Digest. Each of these customers represents a unique quality benchmark. We aim to match them all.

2

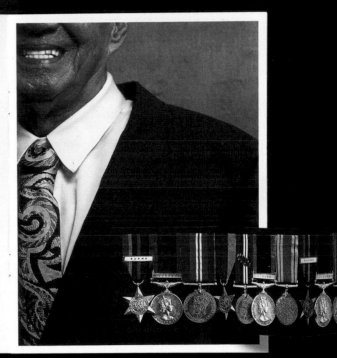

READER'S DIGEST

Having produced books that inform and entertain people of all ages and cultures, Reader's Digest has a long-established reputation as one of the world's pre-eminent publishers. Colourscan's fifteen-year track record of work for the Australian Reader's Digest illustrates the broad scope of our capabilities, as well as our international standards. Be it books on DIY, computing, gardening, nature, health, travel or geography, Colourscan has played an integral role in the production of many titles over the years. That Reader's Digest has continually expressed satisfaction with our services is a further testament to our skills.

9

(this spread) **Equus Design Consultants Pte Ltd** *Colourscan Co Pte Ltd*

through their words and actions. When prospective customers come to visit us at our West Michigan headquarters and facilities, they not only gain an understanding of what makes a great place to work, or learn, or heal—they get a glimpse of what makes Herman Miller a very special place. And they usually become our customers.

The people of Herman Miller have a renewed energy, the pipeline is bursting with exciting new products, and we believe that we have a business model and strategy well suited to win in the marketplace and to deliver superior value to our customers and to you, our shareholders. Yes, the future looks much brighter!

Finally, we want to acknowledge the great work of the leadership team, who guided us through a difficult period with decisive action and unswerving allegiance to our corporate values. The leadership team is a gifted group of women and men who will encourage and cultivate the momentum at every turn in the days ahead. We consider it an honor to serve with each of them and our employee-owners—and in turn to serve our shareholders, our dealers, and our customers.

Sincerely

Michael A. Volkema
Chairman of the Board

Brian C. Walker
President and Chief Executive Officer

Facilities

Concrete examples of what we believe

Though Herman Miller's facilities have won many awards over the years, they really express in a way you'll never forget the powerful appeal of a well-designed work environment. They comfort the people who work in them and inspire the people who visit. Good architecture, like good office furniture, puts people first.

New Office Landscape

Planning offices for innovation

In a business world where competitive pressures run high and the demand for innovative products and services increases day by day, what kind of workplace will attract and keep the brightest and most creative employees?

How can the workplace raise the creative quotient of every person working there and stimulate and capture the creative sparks when people work together? We'd like to talk to you about your own brand of the many new office landscapes that lie ahead.

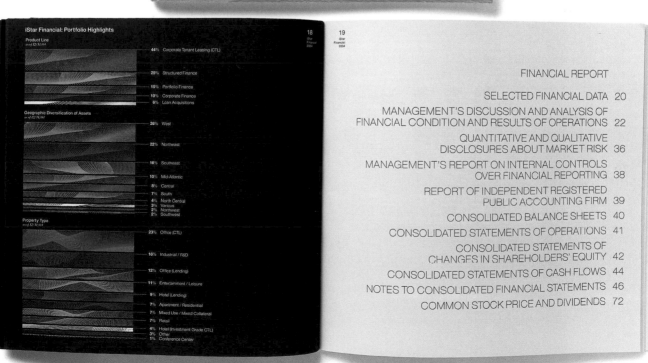

iStar Financial
A Plan for Growth...
A Strategy for Success

Phase 1
Foundation

We began our company in 1993 to capture what we believed were significant opportunities in the underserved segments of the high-end real estate market. As a private company for our first five years, we built a solid foundation for iStar. We added marquee clients, many of whom are still our customers today. We learned many important lessons about the high-end marketplace, formed our views on many markets and asset classes and developed our competitive advantages, namely our ability to cross over seamlessly between the real estate markets, capital markets and corporate finance markets. We also began identifying those customers who were most interested in iStar's highly personalized, high-integrity approach to the business.

Our mission remains the same today as it was at our inception: to be the premier provider of flexible financing solutions to underserved segments of the high-end real estate market while delivering attractive risk-adjusted returns to our valued shareholders. And we have not changed the core values that guide the way we do business, operating with a high degree of integrity, honesty and customer service.

Phase 2
Expansion

Moving into the public markets kicked off phase two, which began in earnest with the $1.5 billion acquisition of TriNet Corporate Realty Trust, which was then the largest triple net lease company in the public markets.

Success led to a natural expansion of our business as we established the company's reach with our customers. We focused on educating the market on iStar's unique approach to real estate financing, clearly differentiating our model from the more prevalent syndication, securitization and commercial finance models that then existed.

We made a number of other strategic corporate acquisitions to complement our organic growth and extend our business franchise during this phase. We took a number of important steps that have helped make iStar Financial the leading publicly traded finance company focused on the commercial real estate industry. In 2004, we received "investment grade" ratings from all three major rating agencies, significantly strengthening our cost advantage in the marketplace. At the end of 2004, we had approximately $7.1 billion in diverse loan and lease assets under management.

Our financial results during this phase have been excellent, demonstrating our commitment to our shareholders. For example, we grew our revenues by 168%, increased our total assets by approximately 90% and delivered total cumulative shareholder returns, including dividends, of 308%.

Phase 3
Evolution

Today, we continue to look at the various changes in the market and make what we believe are prudent, strategic decisions to better position and realign the company to adjust to these dynamics. We are going to utilize the same type of forward thinking that served us so well in phases one and two, while remaining true to the strengths and market position we have clearly staked out with our customers. We are executing our plans to move the business forward with what we believe is a natural evolution of our business. Over the next five years, we expect to focus on expanding our market-leading platforms, adding key personnel, building strategic relationships and working on delivering the most comprehensive capital solutions to the marketplace.

iStar core values >

creative capital solutions

acceleration

careful acquisitions

strategic business relationships

new business sources

Inception
Foundation
Expansion
Evolution

4 iStar Financial 2004

5 The evolution of iStar Financial

a plan for growth a strategy for success

iStar Financial
2004 Annual Report

iStar Financial: Portfolio Highlights

Product Line
as of 12/31/04

- 44% Corporate Tenant Leasing (CTL)
- 25% Structured Finance
- 15% Portfolio Finance
- 10% Corporate Finance
- 6% Loan Acquisitions

Geographic Diversification of Assets
as of 12/31/04

- 29% West
- 22% Northeast
- 16% Southeast
- 10% Mid-Atlantic
- 8% Central
- 7% South
- 4% North Central
- 3% Various
- 2% Northwest
- 2% Southwest

Property Type
as of 12/31/04

- 23% Office (CTL)
- 16% Industrial / R&D
- 12% Office (Lending)
- 11% Entertainment / Leisure
- 9% Hotel (Lending)
- 7% Apartment / Residential
- 7% Mixed Use / Mixed Collateral
- 7% Retail
- 4% Hotel (Investment Grade CTL)
- 3% Other
- 1% Conference Center

18 iStar Financial 2004

19 iStar Financial 2004

Addison *iStar Financial*

Econ 101
STATION CASINOS, INC. 2004 ANNUAL REPORT

Kuhlmann Leavitt, Inc *Station Casinos, Inc.*

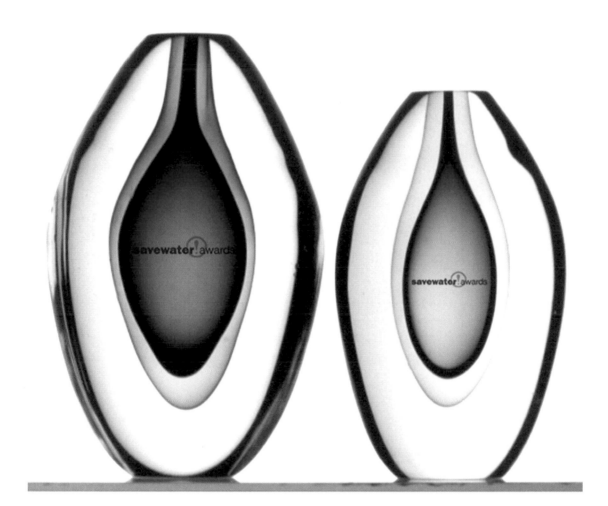

Sweet Design *Yarra Valley Water*

Inspiration
2004

cca

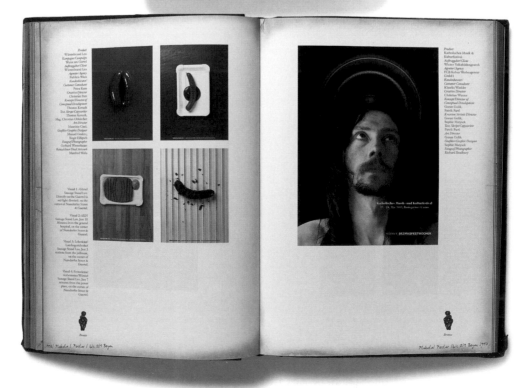

All North American entries – using a Sappi paper as the predominant stock – are initially separated into regions (Mid-Atlantic, Great Lakes, Midwest, Northeast, South and West) and categories (annual reports, books, brochures, catalogs, magazines and general). From there, Sappi Printer of the Year judges use a point system to grade each entry for technical excellence, overall impact of the piece, and difficulty of execution, in order to determine the regional silver winners in each category. These finalists then represent their regions in vying for the North American Gold Awards in the six categories. Gold winners are invited to serve as North American delegates at the Sappi International Printer of the Year celebration, where an international panel of judges picks the regional Gold Award winners and the recipient of the coveted Sappi International Printer of the Year Award.

GOLD WINNERS

sappi

Sappi Printer of the Year

2004

North American Awards Catalog

GENERAL
PRINTER
Jaco-Bryant Printers
REGION
South
ENTRY
Point of Combustion
DESIGNER
Combustion
PAPER
HannoArt Silk Cover 80lb
HannoArt Silk Cover 100lb

MAGAZINES
PRINTER
RR Donnelley
REGION
Mid-Atlantic
ENTRY
New Orleans Saints, 2003
Official Team Yearbook
DESIGNER
Holland Creative Services
PAPER
Somerset Gloss Text 60lb

Melinda Lawson *Sappi Fine Paper*

Eric Chan Design Co. Ltd *Hong Kong Heritage Museum*

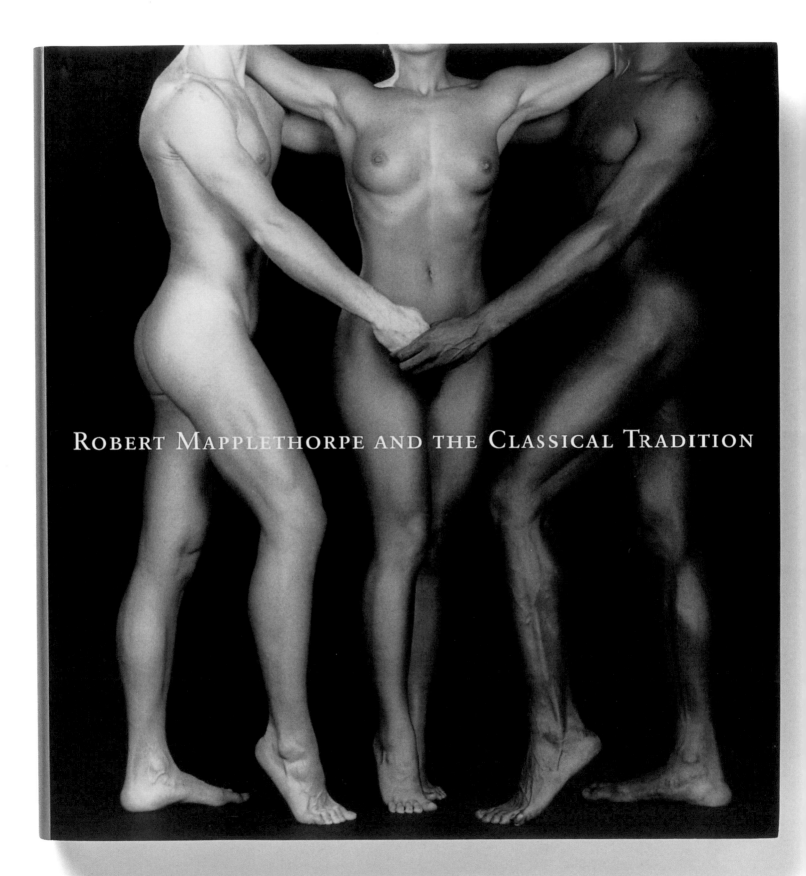

ROBERT MAPPLETHORPE AND THE CLASSICAL TRADITION

CLASSICAL ALLEGORY IN PHOTOGRAPHY
JENNIFER BLESSING

Allegory in plastic art, like allegory in literature, presumes the existence of a level of meaning beyond that which is readily apparent. While we may admire the form, the grace, of a sculpted nude, when we learn its name, say Apollo or Hermes, our comprehension of the significance of the form blossoms to include a narrative that lies beyond the plainly visual. Allegory is therefore an addition, a supplemental signification. Rather than what you see is what you get, you get much more than what you at first see. In classical antiquity, sculptures of mortal beings with symbolic attributes—perhaps a trident or cornucopia—represent divinities whose machinations give explanatory logic to existential riddles, from the changing of the seasons to the nature of evil. The roots of allegory, therefore, are fundamentally theological or metaphysical.

In the case of plastic art, the allegorical interpretation is usually derived from a literary text. During the Renaissance (so named for its revival of the antique) lessons of classical sculpture were incorporated into biblical narratives. The ancient artwork was sheared of its mythological meaning through ignorance or by layering it with a new Christian interpretation via Neoplatonic philosophy; who is God in Michelangelo's Sistine Chapel ceiling but Zeus with another name? In turn, Mannerist prints reflect the Renaissance fascination with the classical body and continue the transcendence of iconographic distinctions. Mythological and biblical subjects had become stylistically interchangeable, with both gods and saints demonstrating the epitome of physical perfection. Scenes of naked maidens gamboling in their bath, whether Artemis spied by Actaeon or Susannah and the Elders, betray a purely sensual, base delight in corporeality despite the lofty and presumably moral message conveyed by their allegorical titles.

Aesthetic theory of the last approximately two hundred years has held allegory in contempt, primarily because it is seen as extraneous to the form of the work itself.[1] A given image of a draped woman might be labeled interchangeably with any number of abstract concepts like Justice or Clemency or Fortune. The late eighteenth and early nineteenth centuries witnessed a last gasp of classically inspired allegorical history painting, such as Jacques-Louis David's *Oath of the Horatii* (1784–85), in which an antique antecedent is constructed to suggest the heroic dynamism of contemporary political culture. A new belief—in democracy, individuality, and the common man—is now the impetus for allegory. In mid-nineteenth-century France the critical art establishment distinguished between modernists and historicists. Modernists (with the Impressionists as their apotheosis) were essentially realists who painted the transitory moments of lived experience. The historicists were fundamentally allegorists, endeavoring to create timeless works of art by illustrating literary and genre subjects. Gustave Courbet's "realist

(page 25)
ROBERT MAPPLETHORPE
Ermes, 1988
Gelatin-silver print
24 x 20 inches (61 x 50.8 cm)
Robert Mapplethorpe Foundation

27

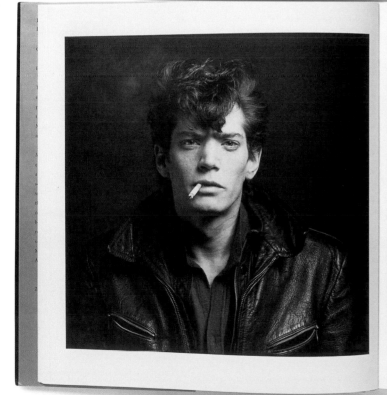

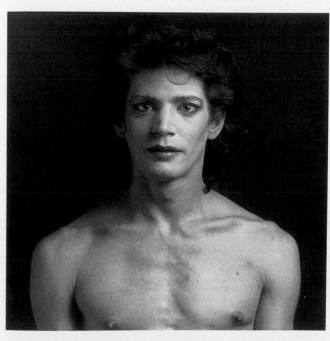

PLATES

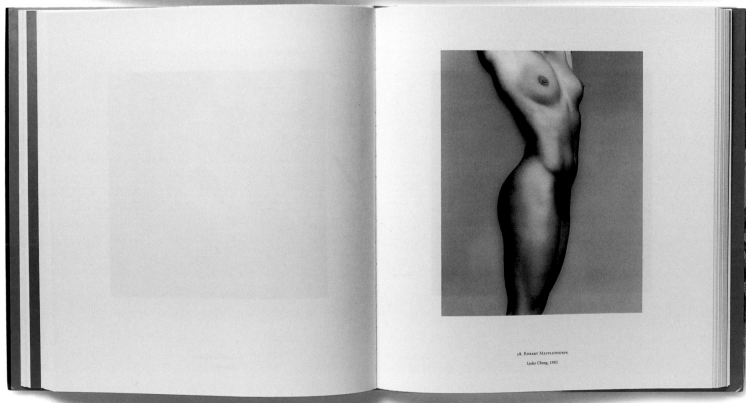

38. Robert Mapplethorpe

Lydia Cheng, 1985

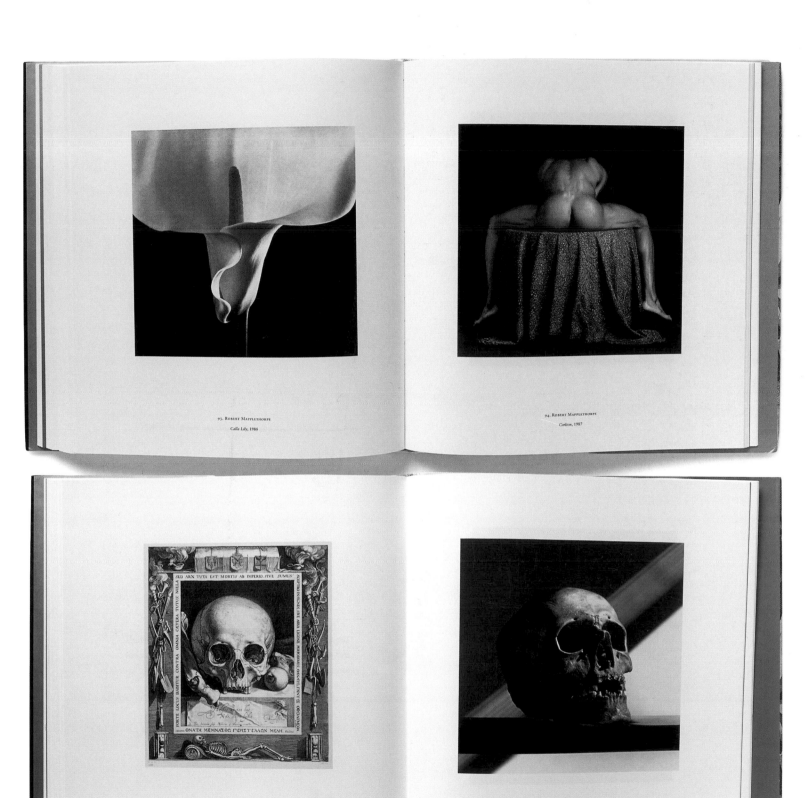

93. ROBERT MAPPLETHORPE

Calla Lily, 1988

94. ROBERT MAPPLETHORPE

Carlton, 1987

116. JAN SAENREDAM AFTER ABRAHAM BLOEMAERT

Allegory of Vanity, 16th century

117. ROBERT MAPPLETHORPE

Skull, 1988

Sam Smidt/*Sam Smidt*

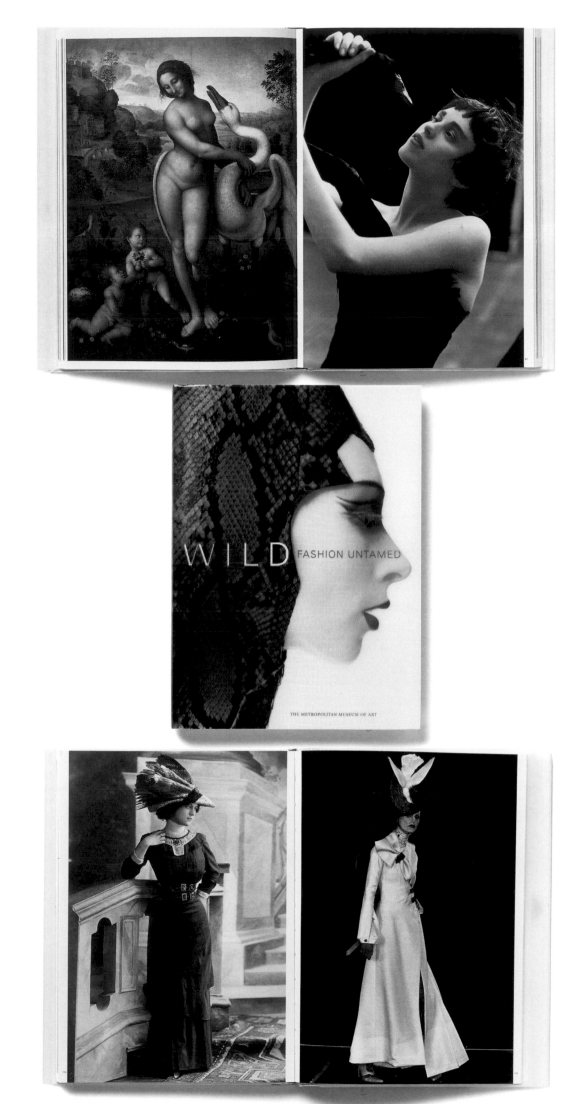

Matsumoto Incorporated *The Metropolitan Museum of Art*

THE

BALTHAZAR

COOKBOOK

by

KEITH McNALLY,

RIAD NASR & LEE HANSON

Foreword Robert Hughes

Photographs by Christopher Hirsheimer & Ron Haviv

Clarkson Potter/Publishers
— NEW YORK —

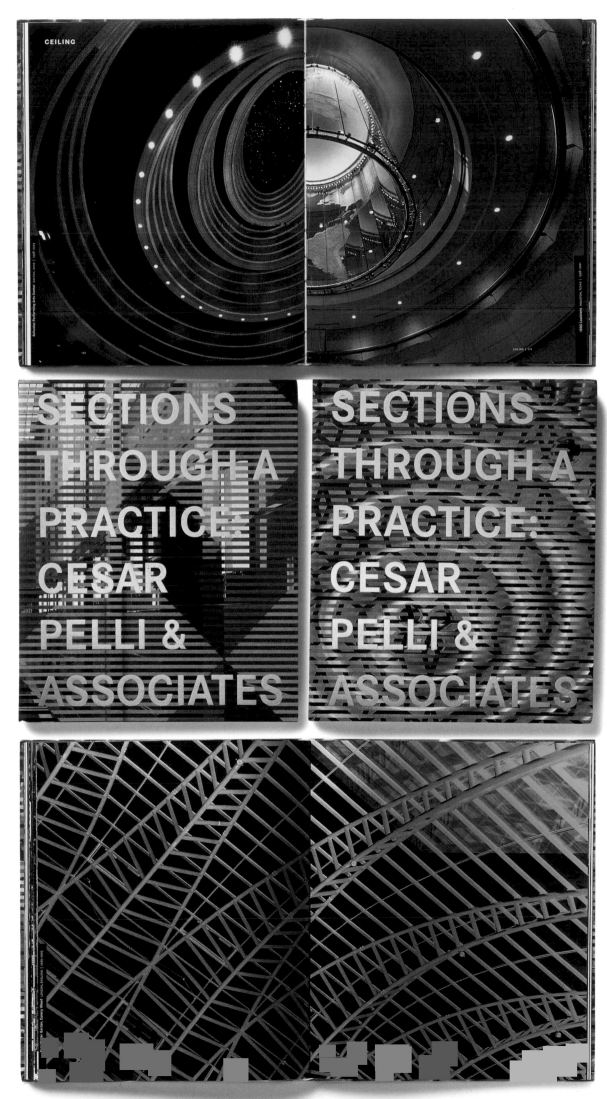

Cesar Pelli & Associates *Cesar Pelli & Associates, Inc*

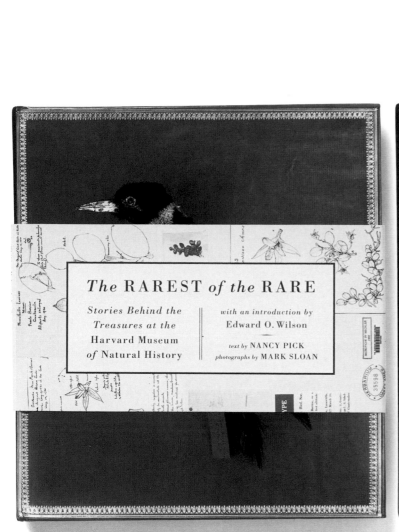
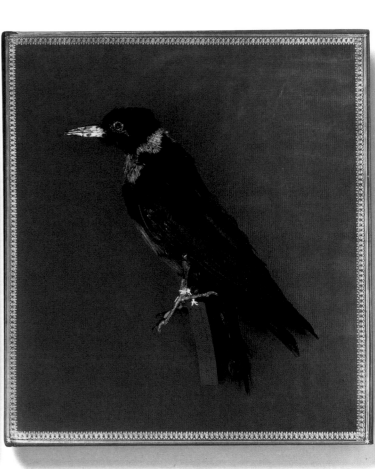

The RAREST of the RARE

Stories Behind the Treasures at the Harvard Museum of Natural History

with an introduction by Edward O. Wilson

text by NANCY PICK
photographs by MARK SLOAN

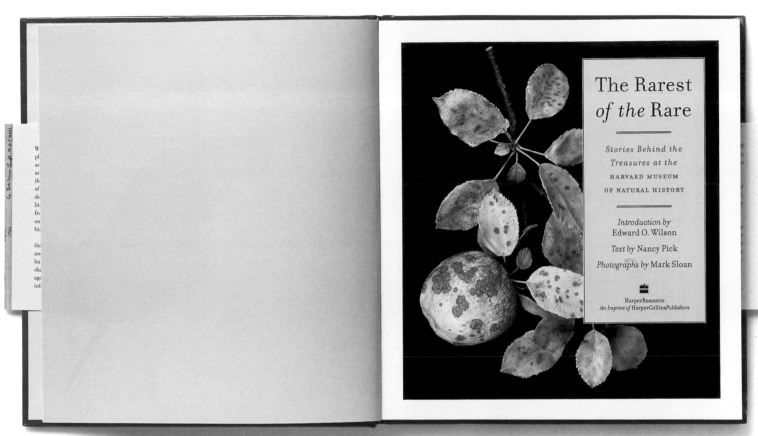

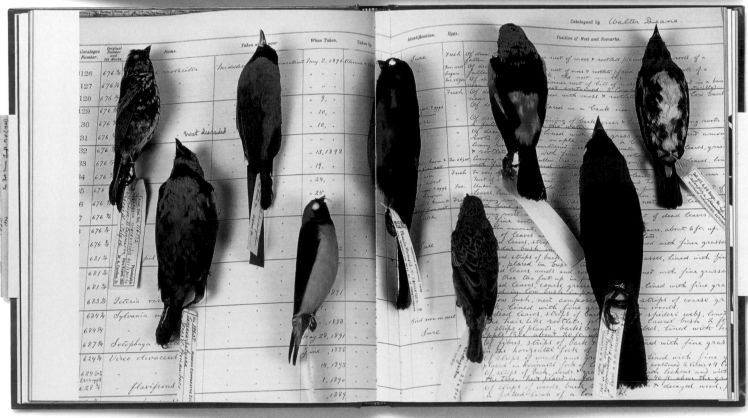

(this spread and next) **Mucca Design** *Harper Collins*

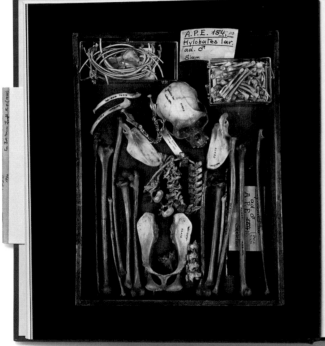

Contents

Microminerals, collected in the early 1900s by Clarence Bement.

Introduction BY EDWARD O. WILSON

For the slice of time they preserve in human events, we visit battlefields and historical monuments. For panoramas of contemporary life-forms, we travel to zoos, botanical gardens, and wildlife reserves. For knowledge of science and the humanities, we go to libraries and art galleries.

And for all of the above together, we visit natural history museums. At the Harvard Museum of Natural History, which draws on some of the oldest and most richly stocked collections in America, a rock and mineral display combines scientific significance with beauty to chronicle the history of the earth's crust. Close by, selections from the vast collection of fossils span the more than 3.5 billion years in the history of life. The specimens are the actual remains, not pictures or artifacts. They give you a feel of how it would have been to walk through the ancient forests or descend into the oceans lapping the archaic shores. No images, no animations however brilliantly constructed can quite replace this touch of the real thing. They are the closest approach humanity can contrive to an actual time machine.

You may then choose to examine contemporary faunas, with specimens picked by the curators to represent the vast living diversity of life (travel around the world and a dozen ecosystems in an hour!) and the most beautiful and dramatic (see the rare North Atlantic right whale collected at Cape Cod by Alexander Agassiz in 1865!), placed close together for your delectation. In these collections we also

Skeleton of white-handed gibbon (Hylobates lar), collected during Harvard's Asiatic Primate Expedition (APE) in Thailand, 1937.

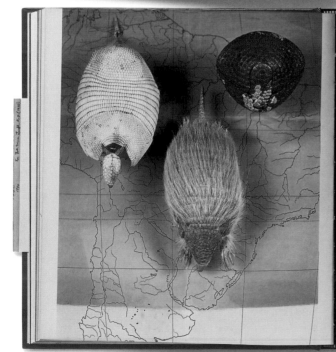

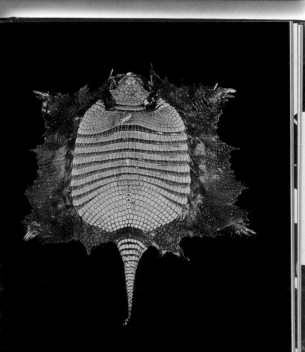

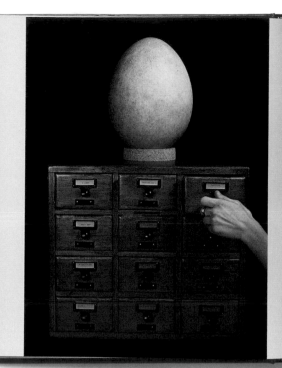

Elephant Bird Egg

Egg of Aepyornis maximus (ee-pee-OR-nis), acquired in 1913.[4]

"Well . . . you've heard of the Aepyornis?"

"Rather. Andrews was telling me of a new species he was working on only a month or so ago. Just before I sailed. They've got a thigh-bone, it seems, nearly a yard long. Monster the thing must have been!"

"I believe you," said the man with the scar. "It was a monster. Sinbad's roc was just a legend of 'em."

—H. G. Wells, "Aepyornis Island"[5]

The *Aepyornis*—commonly called the elephant bird—produced the largest eggs of any animal known on earth. The eggs of this extinct bird were far larger than the largest known dinosaur eggs. Elephant bird eggs make ostrich eggs look puny.

The egg pictured here is 12.2 inches tall by 8.6 inches wide and holds almost 2.5 gallons. By volume, it is as large as about 180 large chicken eggs, or about 7 ostrich eggs. When fresh, an elephant bird egg would have weighed about twenty pounds.

Elephant birds were limited to the island of Madagascar. Several species are known to have existed, but only the largest, *Aepyornis maximus*, lived on the island concurrently with human beings. They became increasingly rare as their habitat—grasslands and open forests—declined

under pressure from plantations and other settlements.

Huge and flightless, elephant birds became extinct around 1700. No illustration of them has survived. But based on its skeleton, the elephant bird resembled an enormous ostrich, measuring up to eleven feet tall and weighing some eleven hundred pounds. By comparison, a large ostrich is about eight feet tall and weighs about three hundred pounds.

The elephant bird may well have been the inspiration for a mythical bird called the roc, known from the tales of the *Thousand and One Nights*. In those stories, Sinbad the Sailor tells of his encounter with a gigantic bird whose young were fed on elephants. A fictional elephant bird also appears in *Horton Hatches the Egg*, by Dr. Seuss (Theodor Seuss Geisel), whose real-life father was curator of a Springfield, Massachusetts, zoo.

Whole intact elephant bird eggs like this one are extremely rare. In 1933, when the last survey was made, only nineteen were known in the world.

Tasmanian Tigers & Other Extinct Species 103

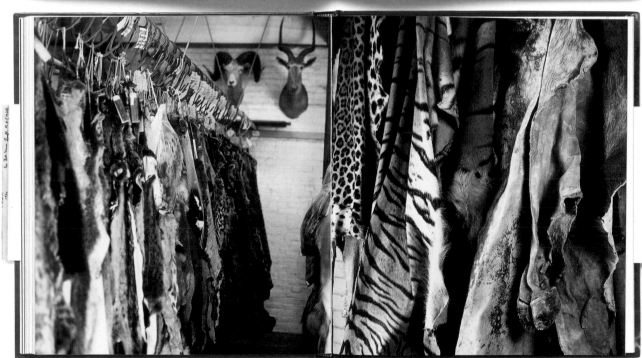

Blue Butterflies and Ants

Jalmenus evagoras (jal-MEE-nus), various dates.[10]

This lovely Australian butterfly, the imperial blue, interacts with ants in fascinating ways. Ants "milk" its caterpillars as if they were tiny cows. When an ant taps the caterpillar with its antennae, the caterpillar releases sugary drops from a gland on its back. The ant drinks up the secretions, which are highly nutritious. As many as twenty-five ants may cover a single caterpillar.

In return for this food, the ants protect the caterpillars from dangers such as predatory wasps and parasitic flies. This type of cooperative relationship, in which both parties benefit from interacting with each other, is called mutualism.

The caterpillars of imperial blues are also unusual because they sing. Their "songs" are actually vibrations. When amplified to make them audible, they sound like hisses and grunts. Studies by Harvard's Naomi Pierce have shown that certain of these songs facilitate communication with ants. The caterpillars produce hisses, for example, only in the first five minutes after being discovered by a worker ant. (Ants, although nearly deaf to airborne sounds, are quite sensitive to vibrations.)

Studying the interactions of blue butterflies and ants is the specialty of Pierce, a distinguished entomologist (insect expert) who oversees a busy research laboratory. She and her graduate students examine such questions as why some species of

blue butterflies interact with many kinds of ants, while others associate with only one ant species.

Her lab also studies the evolutionary consequences of specialization. Imperial blue butterflies cannot survive just anywhere. Their habitat must support their attendant ants, as well as the food plants eaten by their caterpillars. Such specialization puts constraints on blue butterflies, making them prone to faster rates of evolution. The results may include speciation—the formation of new species—or extinction.

The demise of one species of blue butterfly, the Xerces blue, may have been linked to its dependence on ants. (See "Fallen Butterfly," page 116.) The Xerces blue had a limited range, near San Francisco, California. Early declines in its population coincided with the introduction of the invasive Argentine ant, *Linepithema humile*, that displaced many native Californian ant species. By the early 1940s, the Xerces blue had become extinct.

130 *The Rarest of the Rare*

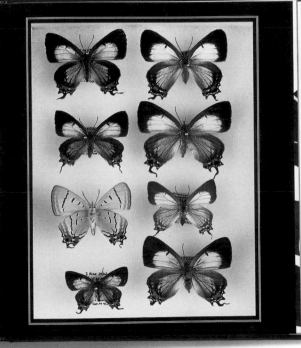

TWENTIETH CENTURY FOX

INSIDE THE PHOTO ARCHIVE

FOREWORD BY MARTIN SCORSESE

20th
CENTURY
FOX

A NEWS CORPORATION COMPANY

Pentagram Design *Harry N. Abrams*

Holden Maps / Scuola Holden

PUNTEGGIATURA

Volume primo

AA. VV.
I SEGNI

Holden Maps / Scuola Holden

LUCA SCARLINI

EQUIVOCI E MIRAGGI

Pratiche d'autobiografia oggi

BRUNO FORNARA

GEOGRAFIA DEL CINEMA

Viaggi nella messinscena

Holden Maps / Scuola Holden

MARCO VACCHETTI

STORIE DELL'ARTE

La narrazione nelle immagini

Holden Map

Holden Maps / Scuola Holden

GABRIELE VACIS

AWARENESS

Dieci giorni con Jerzy Grotowski

Holden Maps / Scuola Holden

KEN DANCYGER JEFF RUSH
IL CINEMA OLTRE LE REGOLE
Nuovi modelli di sceneggiatura
A cura di Gino Ventriglia

ART CENTER COLLEGE OF DESIGN **IMAGEMAKERS**

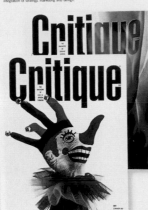

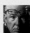

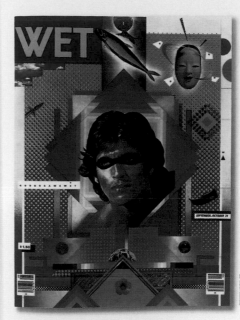
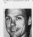
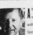

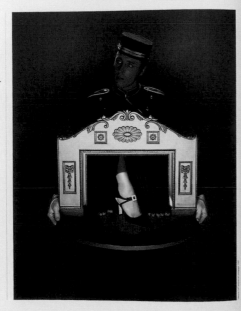
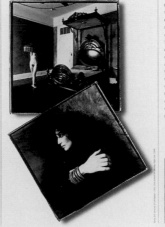
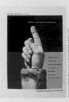

(this spread and next) **Pentagram** *Art Center College of Pasadena*

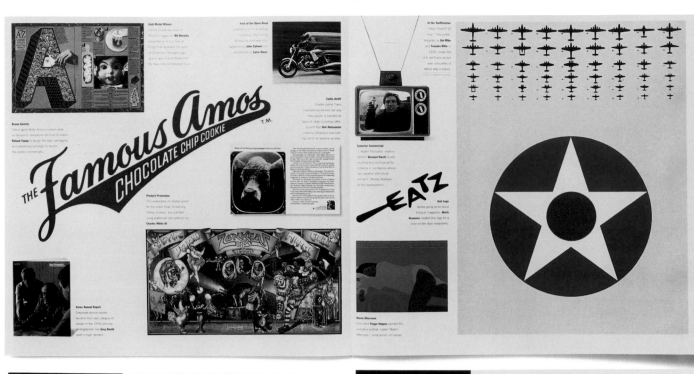

THE Famous Amos CHOCOLATE CHIP COOKIE ™

EATZ

THE LATE '90s / DOT-COM GOLD RUSH

In the second half of the '90s, dot-com mania seized American business and the gold rush was on, with venture capitalists speculating on dot-com IPOs and half-baked business plans. Cut-off jeans and rumpled t-shirts became the new office attire. Fast foods replaced power lunches, and scooters replaced company cars. With *Wired*, *Fast Company* and *Weekly Standard* predicting the rise of the New Economy, day traders placed their bets on startups from Silicon Valley. Everything moved to the Web. You could go online to find a date, buy groceries and pet food, and download music onto your MP3 while you're at it. Designers turned their focus to creating Web identities and building e-commerce brands. Life was good. The Cold War was long gone. Science was solving the genome puzzle. The Dow was up, and the national debt was down. There was an SUV in every driveway and an Aeron chair at every desk. Latin pop was cool and the Spice Girls were hot. Then the bubble burst.

LIFE Great Pictures of the Century ...and the Stories Behind Them

'80s
THE "YOU CAN HAVE IT ALL" ERA

The '80s became the "Me generation," and the message was "if you got it, flaunt it." In the words of actor Michael Douglas in *Wall Street*, "Greed is good." Leveraged buyouts, hostile takeovers and mega-mergers were as common as billionaires in stretch limos. Valley girls were "like totally" into shopping at the mall. Jane Fonda touted aerobics, and preteens demanded video games and Cabbage Patch dolls. Minivans became the signature car of soccer moms in leg warmers. Cable TV emerged to bring us MTV, showcasing Michael Jackson, Madonna and break dancing, and CNN 24-hour news. The 1980s also saw AIDS take its deadly toll and the environment rise to consciousness. In the arts, Mapplethorpe photographs riled museumgoers and Keith Haring popularized graffiti art. And in design, the launch of the Apple Macintosh computer started a revolution that rivaled Gutenberg's movable type. It put the tools for production completely into the hands of the individual designer, and nothing has been the same since.

LIFE

ZO P

uGotuuuMilk?u

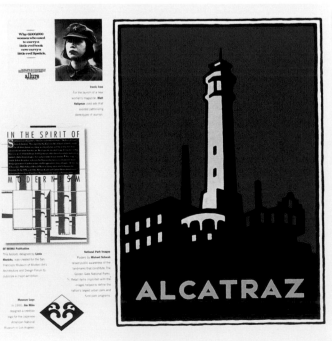

allure

IN THE SPIRIT OF
MODERNISM

ALCATRAZ

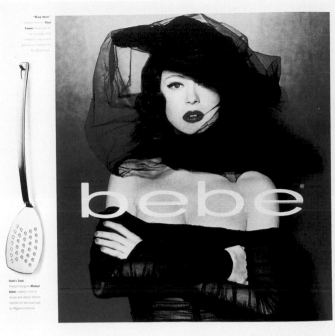

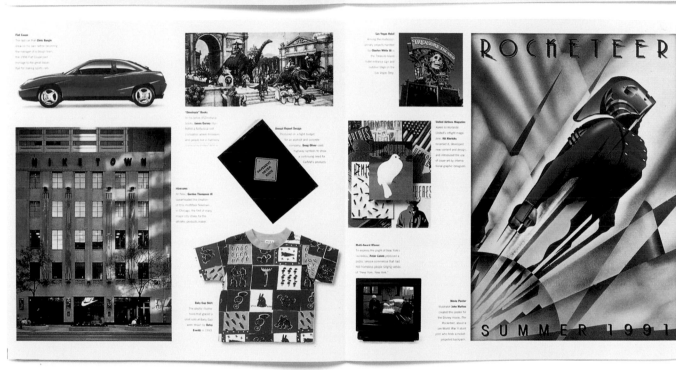

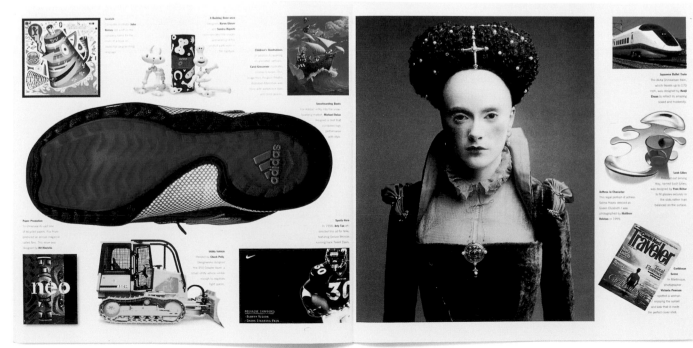

[VANISHING] *a book by* **antonin kratochvil**

de.MO

ANTONIN KRATOCHVIL · VANISHING *maybe this world is another planet's hell aldous huxley*

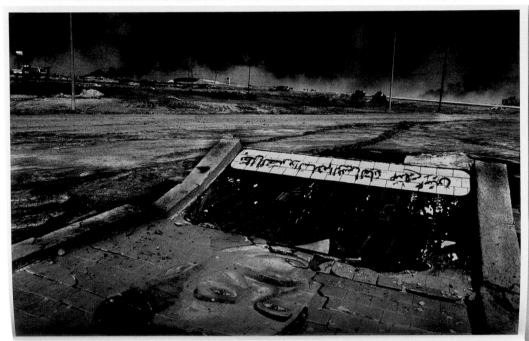

Giorgio Baravalle *de. MO*

MILTON GLASER & MIRKO ILIĆ

THE

DESIGN

OF

DISSENT

FOREWORD BY TONY KUSHNER

(this spread) **ShapiroWalker design** *Foothills Brewing*

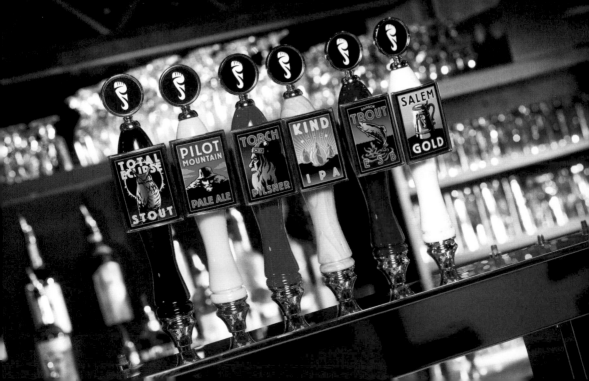

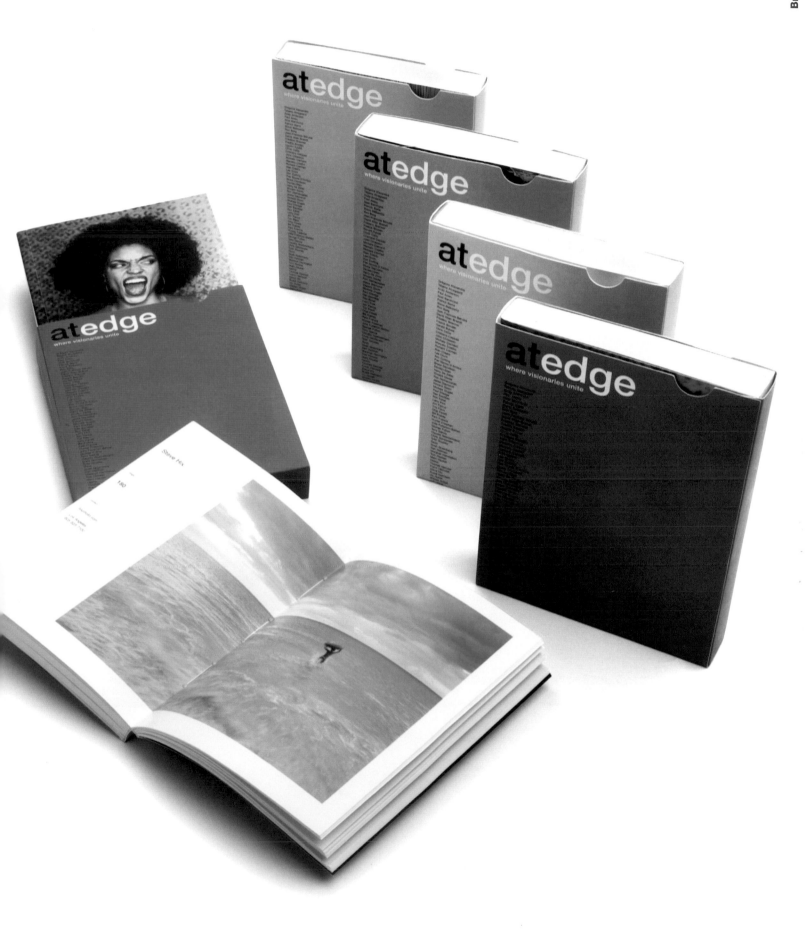

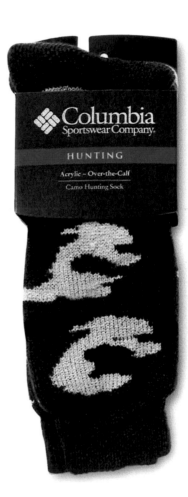

(this spread) **Ford Weithman Design** *Columbia Sportswear*

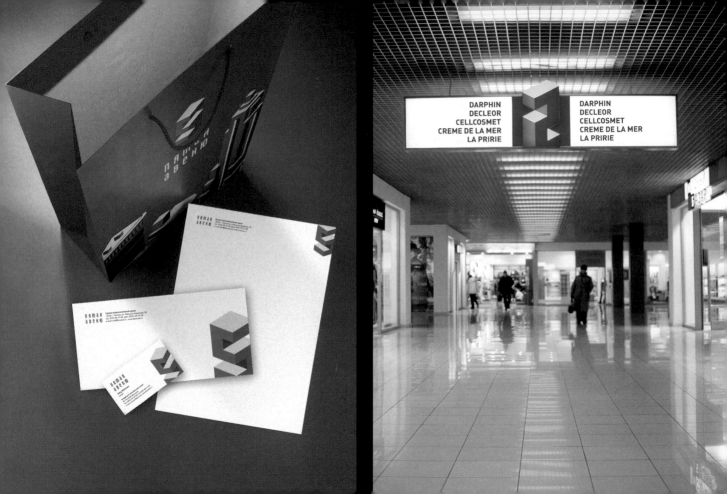

DARPHIN
DECLEOR
CELLCOSMET
CREME DE LA MER
LA PRIRIE

DARPHIN
DECLEOR
CELLCOSMET
CREME DE LA MER
LA PRIRIE

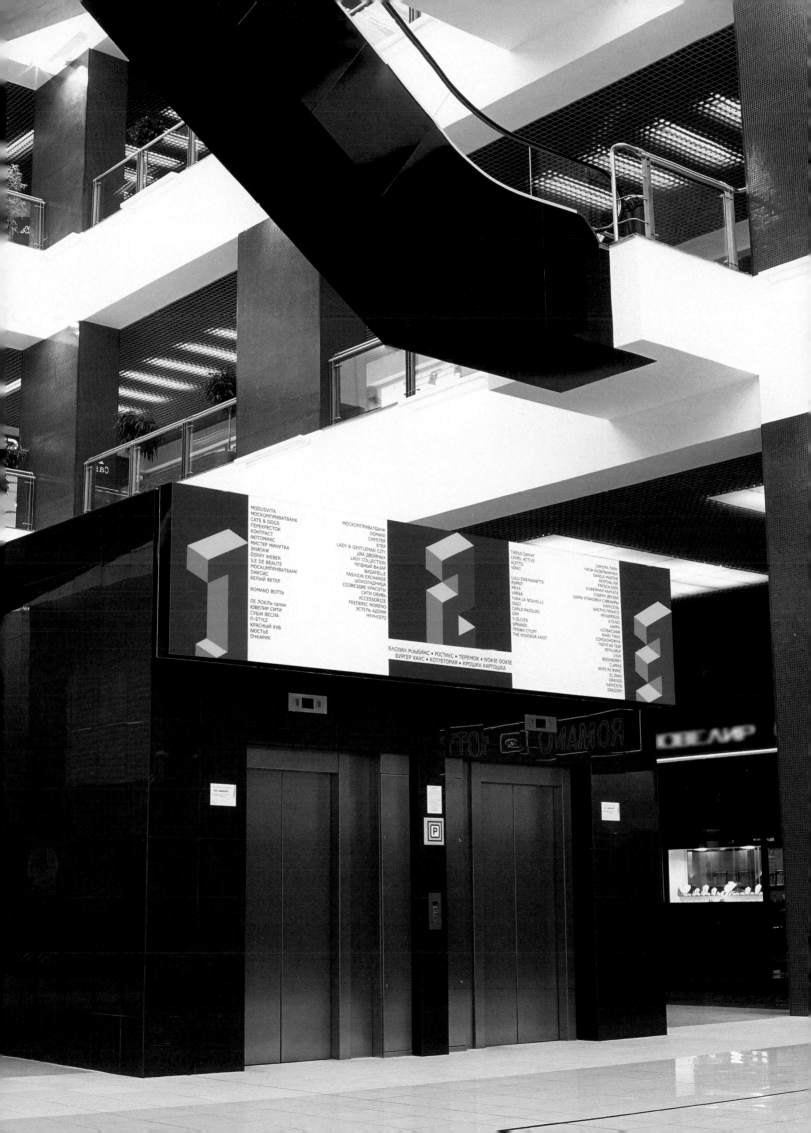

hivemodern.com

hivemodern.com

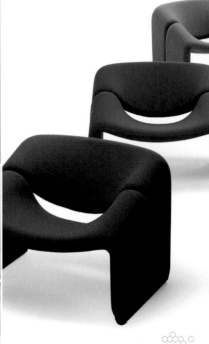

hive

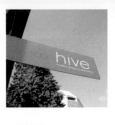

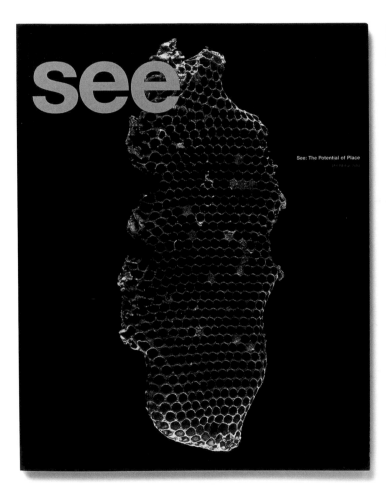

see

See: The Potential of Place

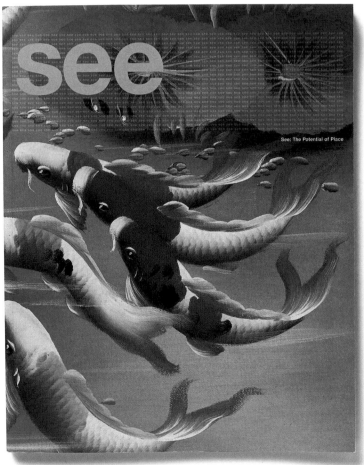

see

See: The Potential of Place

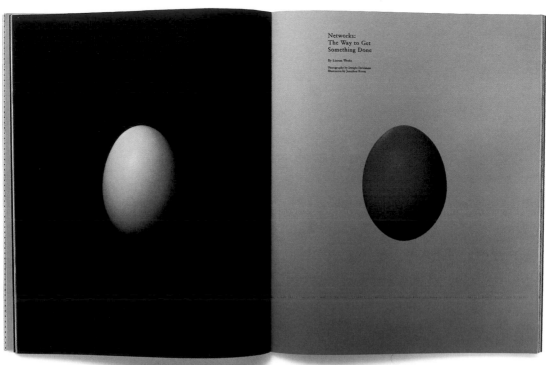

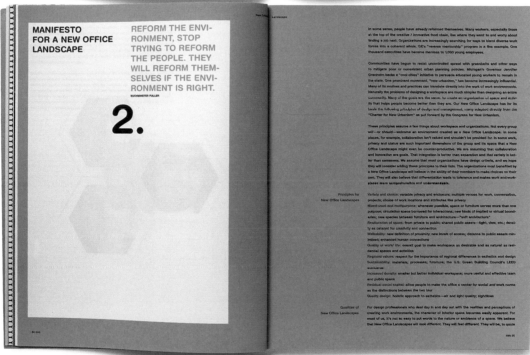

Networks:
The Way to Get
Something Done

By Linton Weeks

Photography by Dwight Eschliman
Illustration by Jonathan Rosen

MANIFESTO FOR A NEW OFFICE LANDSCAPE

REFORM THE ENVIRONMENT, STOP TRYING TO REFORM THE PEOPLE. THEY WILL REFORM THEMSELVES IF THE ENVIRONMENT IS RIGHT.
BUCKMINSTER FULLER

2.

New Office Landscape

In some sense, people have already reformed themselves. Many workers, especially those at the top of the creative / innovative food chain, live where they want to and worry about finding a job next. Organizations are increasingly searching for ways to blend diverse work forces into a coherent whole. GE's "reverse mentorship" program is a fine example. One thousand executives have become mentees to 1,000 young employees.

Communities have begun to resist uncontrolled sprawl with greenbelts and other ways to mitigate poor or nonexistent urban planning policies. Michigan's Governor Jennifer Granholm backs a "cool cities" initiative to persuade educated young workers to remain in the state. One prominent movement, "new urbanism," has become increasingly influential. Many of its motives and practices can translate directly into the work of work environments. Naturally the problems of designing a workspace are much simpler than designing an entire community. Many of the goals are the same, to create an organization of space and authority that helps people become better than they are. Our New Office Landscape has for its basis the following principles of design and management, many adapted directly from the "Charter for New Urbanism" as put forward by the Congress for New Urbanism.

These principles assume a few things about workspaces and organizations. Not every group will—or should—welcome an environment created as a New Office Landscape. In some places, for example, collaboration isn't valued and shouldn't be provided for. In some work, privacy and status are such important dimensions of the group and its space that a New Office Landscape might even be counter-productive. We are assuming that collaboration and innovation are goals. That integration is better than separation and that variety is better than sameness. We assume that most organizations have design criteria, and we hope they will consider adding these principles to their lists. The organizations most benefited by a New Office Landscape will believe in the ability of their members to make choices on their own. They will also believe that differentiation leads to tolerance and makes work and workplaces more comprehensible and understandable.

Principles for New Office Landscapes

Variety and choice: variable privacy and enclosure; multiple venues for work, conversation, projects; choice of work locations and attributes like privacy

Mixed-used and multipurpose: whenever possible, space or furniture serves more than one purpose; circulation space borrowed for interactions; new kinds of implied or virtual boundaries; new species between furniture and architecture—"soft architecture"

Reallocation of space: from private to public; shared public assets—light, view, etc.; density as catalyst for creativity and connection

Walkability: new definition of proximity; new levels of access; distance to public assets minimized; enhanced human connections

Quality of work/ life: overall goal to make workspaces as desirable and as natural as residential spaces and activities

Regional values: respect for the importance of regional differences in aesthetics and design

Sustainability: materials; processes; furniture; the U.S. Green Building Council's LEED standards

Increased density: smaller but better individual workspace; more useful and effective team and public space

Residual social capital: allow people to make the office a center for social and work norms as the distinctions between the two blur

Quality design: holistic approach to aesthetics—air and light quality; sightlines

Qualities of New Office Landscapes.

For design professionals who deal day in and day out with the realities and perceptions of creating work environments, the character of interior space becomes easily apparent. For most of us, it's not so easy to put work to the nature or ambience of a space. We believe that New Office Landscapes will look different. They will feel different. They will be, to quote

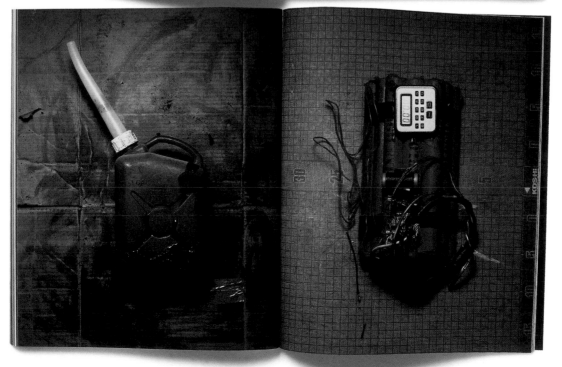

(this spread) **Herman Miller Inc** *Herman Miller Inc.*

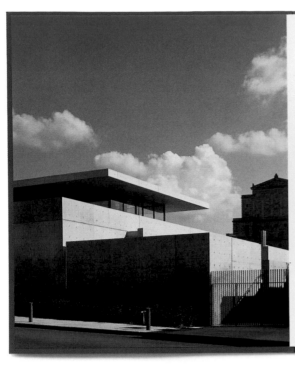

The Pulitzer Foundation for the Arts

Since its inauguration in October 2001, the Pulitzer Foundation for the Arts has welcomed visitors from St. Louis and all over the world. Admission is free: the building is open to the public on Wednesdays from noon to 5 p.m. and on Saturdays from 10 a.m. to 4 p.m. No reservations are necessary, except for groups of five or more.

Conceived by Pritzker Prize-winning architect Tadao Ando, the Pulitzer building is a concrete structure that embraces light, shadow, water and plants to fashion a contemplative setting. The architecture interacts with two works of art created for the space: Ellsworth Kelly's *Blue Black* in the Main Gallery and Richard Serra's *Joe* in the Courtyard.

A resource for the contemplation, enjoyment and study of the visual, literary and performing arts, the Pulitzer presents exhibitions and programs where interaction with artists, scholars and the general public is encouraged. Although a non-collecting institution, it has acquired two works since its opening: Doris Salcedo's *Atrabiliarios* and Scott Burton's *Rock Settee*. Both demonstrate how art establishes close relationships with architecture.

Outside cover – detail of Joe (2000) by Richard Serra; Left – view of the Pavilion from Washington Boulevard.

The Pulitzer Foundation for the Arts

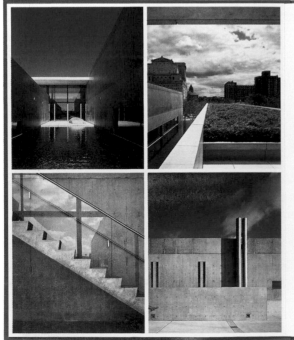

The Pulitzer, the District of Grand Center and Beyond

What is now a foundation with an international reputation began as an initiative of Emily Rauh Pulitzer and her late husband, Joseph Pulitzer, Jr. Ellsworth Kelly and Richard Serra first brought Japanese architect Tadao Ando to the attention of the Pulitzers. The initial project, which was Ando's first free-standing commission in the United States, was to renovate and adapt an existing building. However, by 1995, the project had evolved, and Ando was asked to design a building that became home to a foundation for the arts.

By locating the building in Grand Center, a district formerly home to the performing arts, the Pulitzers were eager to participate in the district's renaissance. From the Mezzanine of the Pulitzer building, visitors can see a neighborhood that not only has distinguished architecture from the twentieth century, but also aims to develop ambitious architectural projects for the 21st century.

The development of the new building project ultimately led to another idea: the creation of an arts complex on the corner of Washington and Spring. The Courtyard of the Pulitzer was conceived as a shared space with the adjacent Contemporary Art Museum St. Louis which opened in September 2003. Serra's powerfully affecting *Joe*, the first of his torqued spirals, acts as a visual hinge for the two institutions which have diverse missions but compatible interests.

The Pulitzer also aspires to be a catalyst for collaborative programming in the St. Louis region and beyond. A recent endowment finances collaborative projects with the Sam Fox Arts Center of Washington University. Programs with the St. Louis Art Museum, the Harvard University Art Museums and the Kunsthaus in Bregenz (Austria) are being developed as well.

Clockwise from the upper left – Watercourt; view from the Mezzanine; view from the Courtyard; stairway leading to the Mezzanine and Terrace.

Michael Thede Design *The Pulitzer Foundation for the Arts*

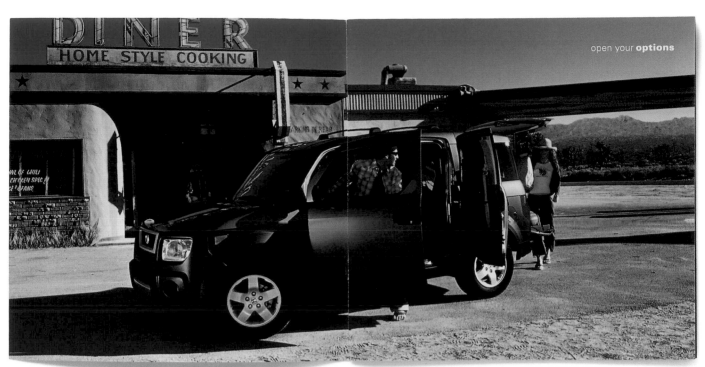

open your **options**

2004 **ELEMENT**

Honda

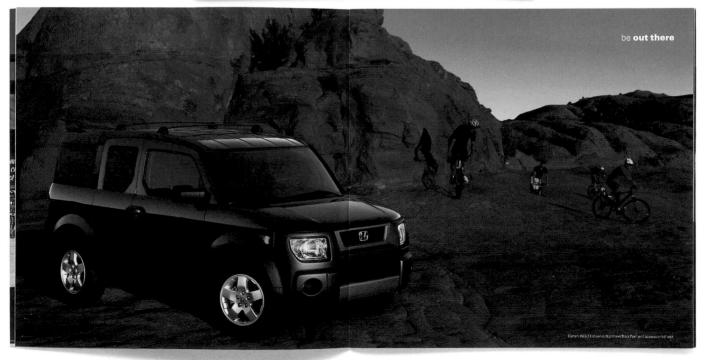

be **out there**

The Designory *Mercedes Benz, USA*

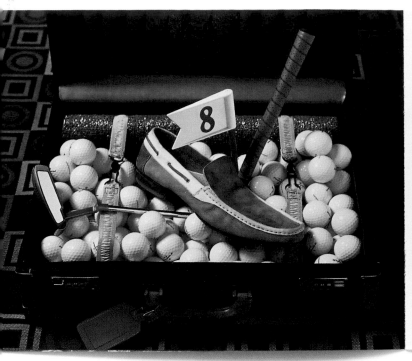

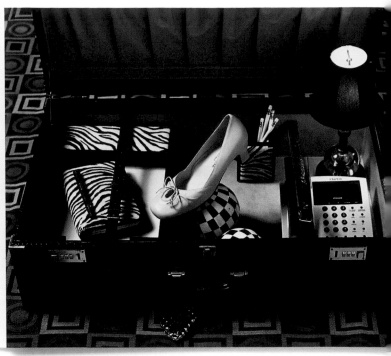

TARYN ROSE

SPRING | 2005

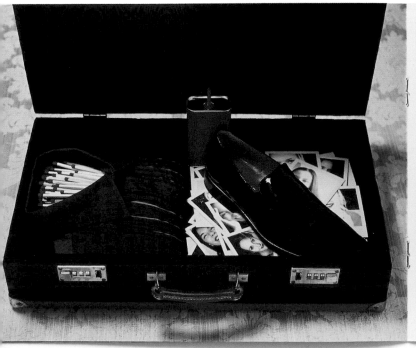

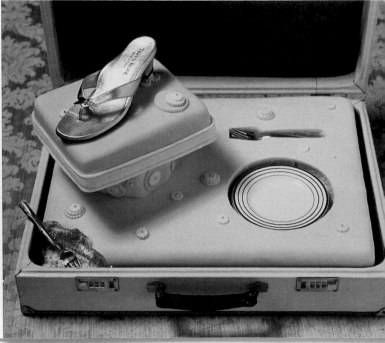

Elixir Design *Taryn Rose*

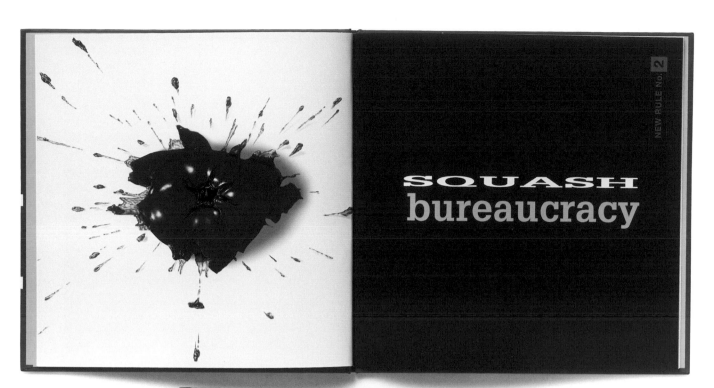

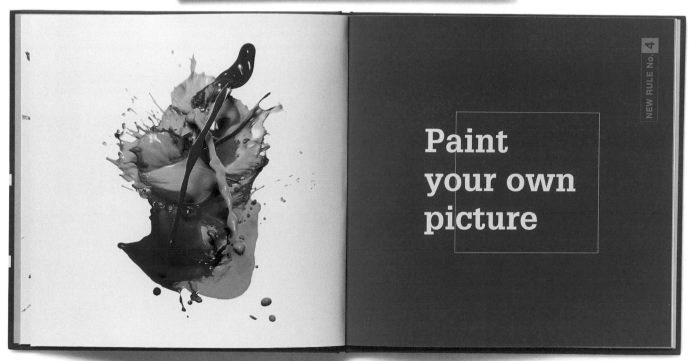

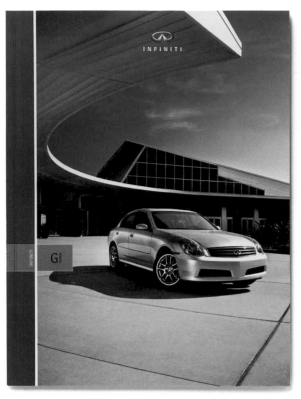

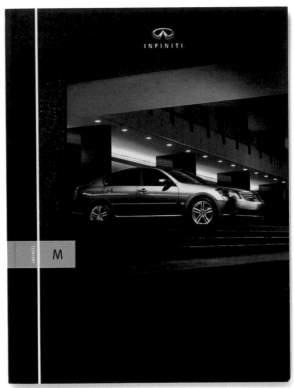

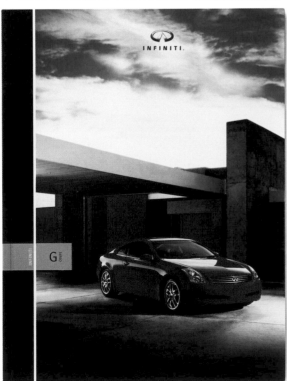

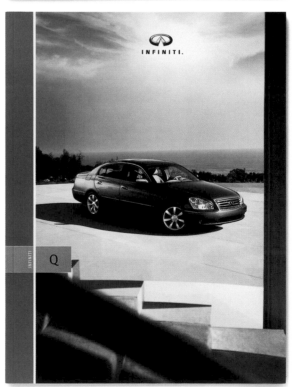

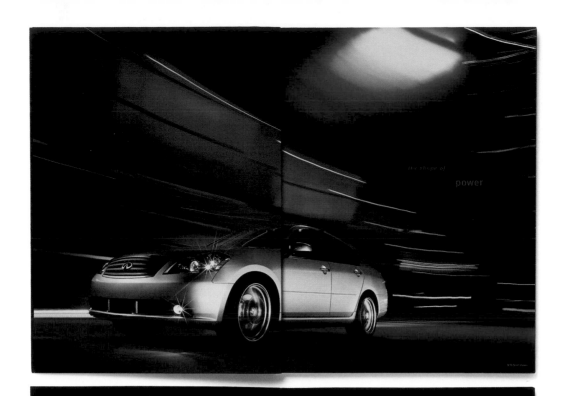

the shape of
power

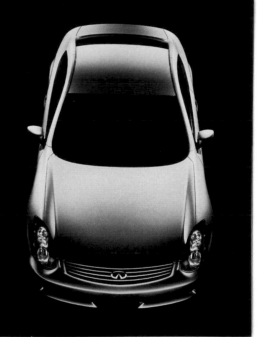

a study in motion
velocity, sensuousness,
agility, passion, tactile
pleasure, urgency,
kinetic energy, rhythm,
desire, gratification,
resonance: interpreted
in aluminum, titanium,
glass, rubber

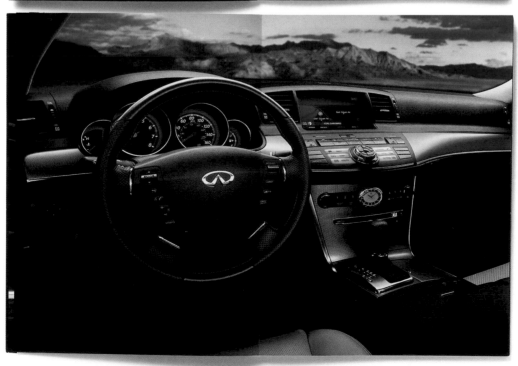

(this spread) **The Designory** *Infiniti Division, Nissan North America*

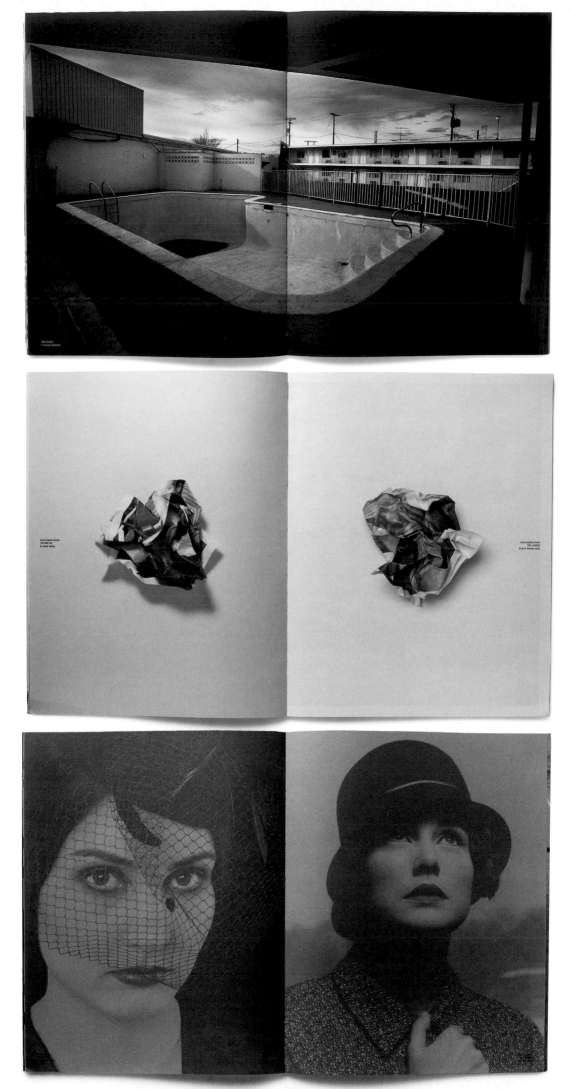

(this spread) **Concrete Design Communications Inc** *Masterfile*

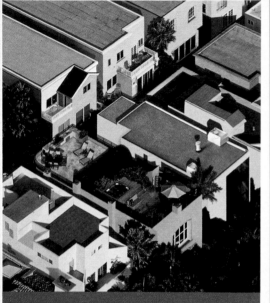

2005 **Acura TL**

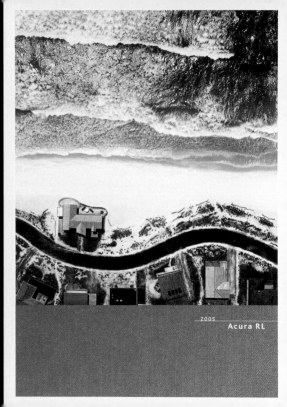

2005 **Acura RL**

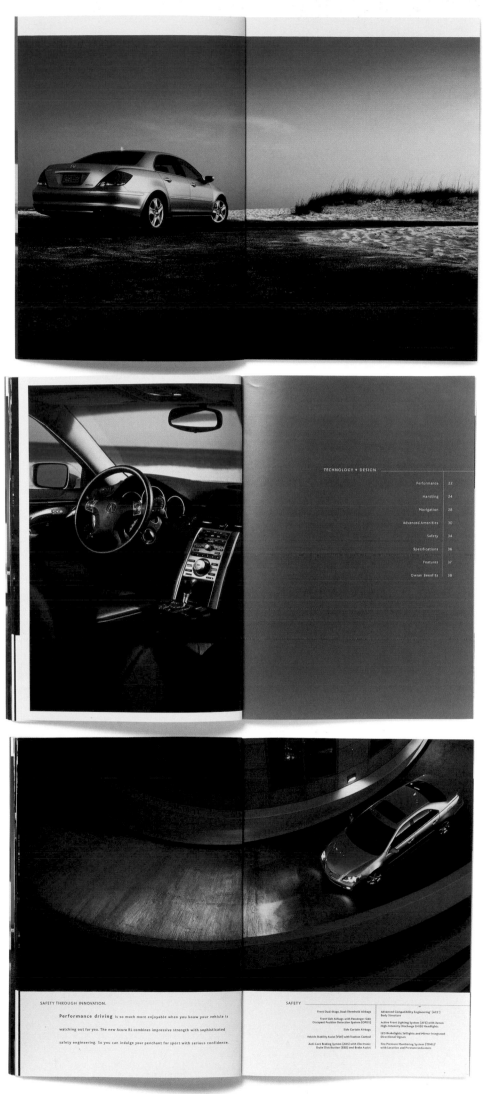

(this spread) **Rubin Postaer & Associates** *Acura*

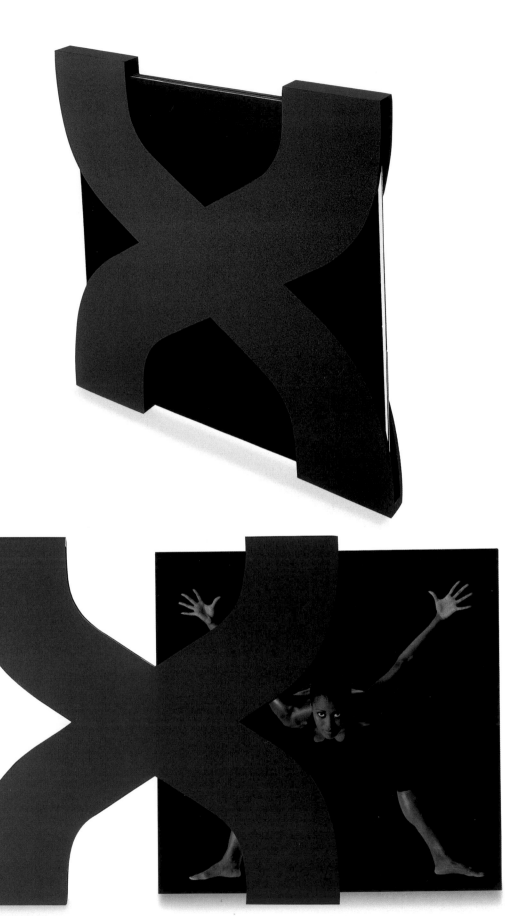

MEADOWLANDS Xanadu

A BOLD NEW VISION

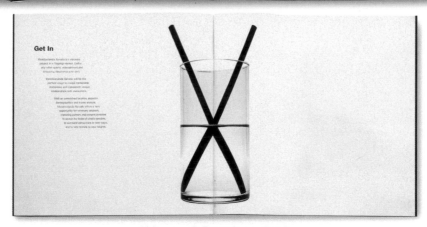

Get In

(this spread) **Desgrippes Gobé**

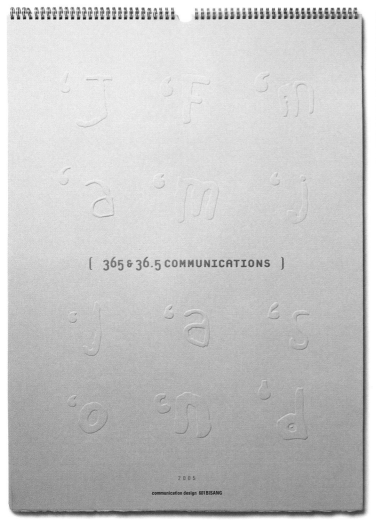

[365 & 36.5 COMMUNICATIONS]

2 0 0 5

communication design 601 BISANG

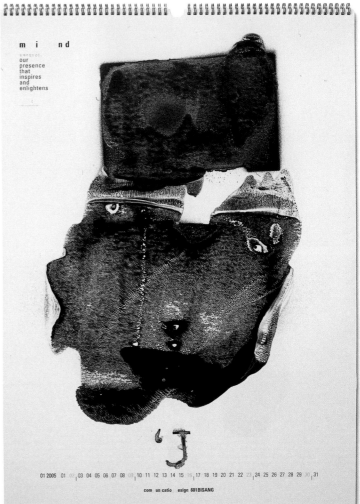

mind

our
presence
that
inspires
and
enlightens

'J

01 2005 01 02 03 04 05 06 07 08 09 10 11 12 13 14 15 16 17 18 19 20 21 22 23 24 25 26 27 28 29 30 31

com un catio esign 601 BISANG

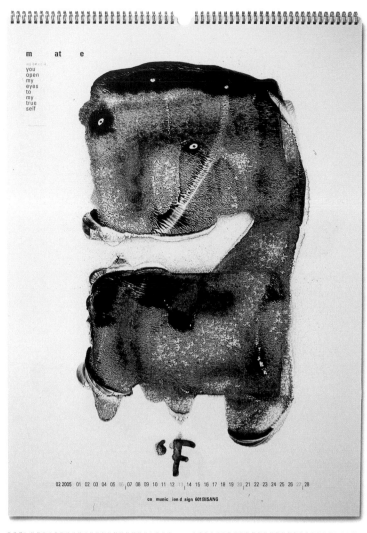

m a t e

you
open
my
eyes
to
my
true
self

'F

02 2005 01 02 03 04 05 06 07 08 09 10 11 12 13 14 15 16 17 18 19 20 21 22 23 24 25 26 27 28

co_munic_ion d_sign 601BISANG

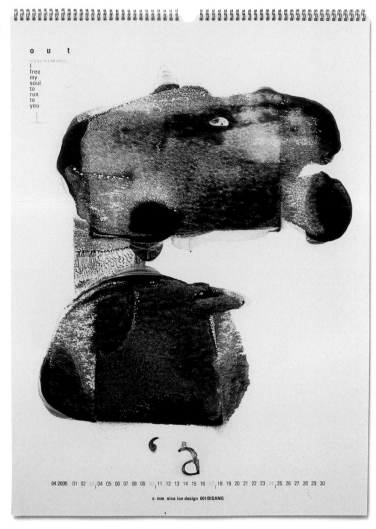

o u t

I
free
my
soul
to
run
to
you

'a

04 2005 01 02 03 04 05 06 07 08 09 10 11 12 13 14 15 16 17 18 19 20 21 22 23 24 25 26 27 28 29 30

c_mm_nica_ion design 601BISANG

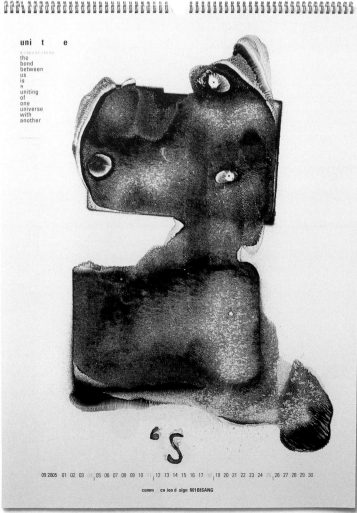

uni t e

tho
bond
between
us
is
a
uniting
of
one
universe
with
another

'S

09 2005 01 02 03 04 05 06 07 08 09 10 11 12 13 14 15 16 17 18 19 20 21 22 23 24 25 26 27 28 29 30

comm_ca ion d_sign 601BISANG

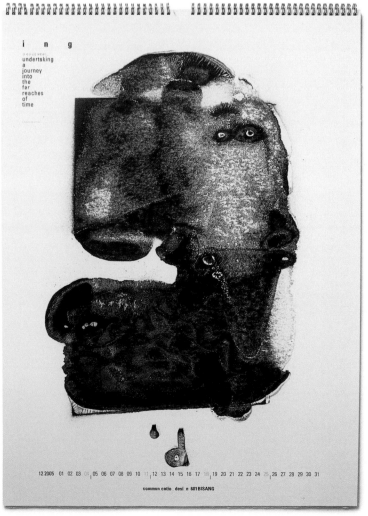

i n g

undertaking
a
journey
into
the
far
reaches
of
time

d

12 2005 01 02 03 04 05 06 07 08 09 10 11 12 13 14 15 16 17 18 19 20 21 22 23 24 25 26 27 28 29 30 31

commun_catio_desi_n 601BISANG

(this spread) **601Bisang** *601Bisang*

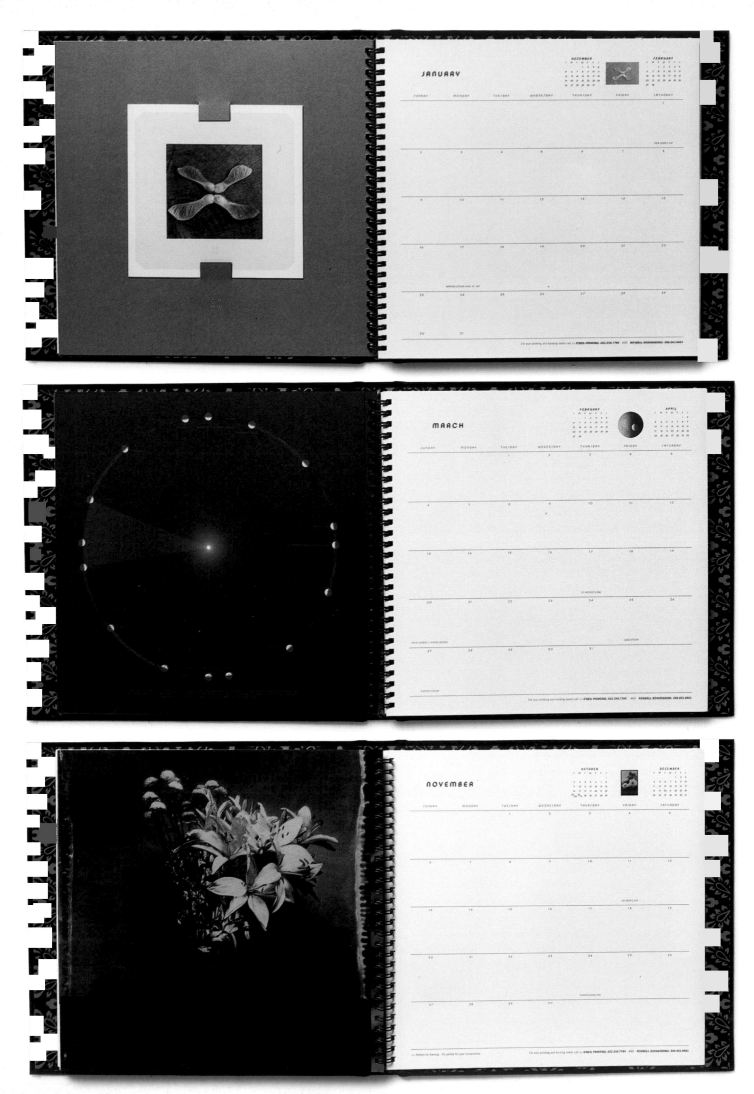

(this spread) **Rule29** *O'Neil Printing and Rule 29*

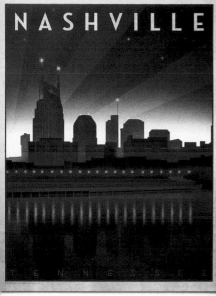

NASHVILLE

TENNESSEE

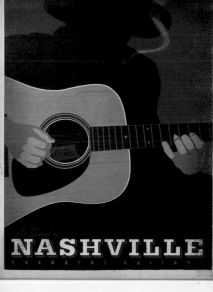

The Sound of
NASHVILLE
CHAMBERS GUITARS

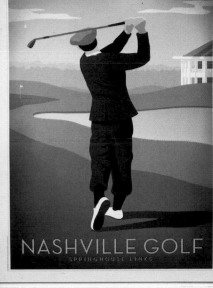

NASHVILLE GOLF
SPRINGHOUSE LINKS

ANDERSON THOMAS DESIGN & McQUIDDY PRINTING PRESENT

SPIRIT OF NASHVILLE 2005
Calendar & Poster Collection

Every month features a new 18" x 24" ready-to-frame work of art! Carefully tear away each poster to reveal the next. There are 14 posters in all.

FEATURES 28 POSTERS

JANUARY

SUNDAY	MONDAY	TUESDAY	WEDNESDAY	THURSDAY	FRIDAY	SATURDAY
						1
2	3	4	5	6	7	8
9	10	11	12	13	14	15
16	17	18	19	20	21	22
23	24	25	26	27	28	29
30	31					

MARCH

SUNDAY	MONDAY	TUESDAY	WEDNESDAY	THURSDAY	FRIDAY	SATURDAY
		1	2	3	4	5
6	7	8	9	10	11	12
13	14	15	16	17	18	19
20	21	22	23	24	25	26
27	28	29	30	31		

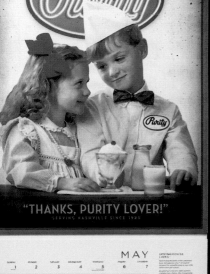

Purity

"THANKS, PURITY LOVER!"
SERVING NASHVILLE SINCE 1925

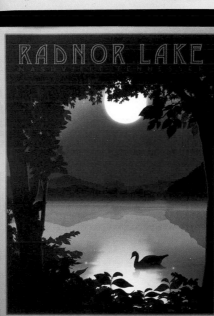

RADNOR LAKE
NASHVILLE TENNESSEE

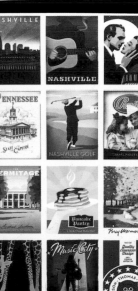

MAY

SUNDAY	MONDAY	TUESDAY	WEDNESDAY	THURSDAY	FRIDAY	SATURDAY
1	2	3	4	5	6	7
8	9	10	11	12	13	14
15	16	17	18	19	20	21
22	23	24	25	26	27	28
29	30	31				

JUNE

SUNDAY	MONDAY	TUESDAY	WEDNESDAY	THURSDAY	FRIDAY	SATURDAY
			1	2	3	4
5	6	7	8	9	10	11
12	13	14	15	16	17	18
19	20	21	22	23	24	25
26	27	28	29	30		

AUGUST

SUNDAY	MONDAY	TUESDAY	WEDNESDAY	THURSDAY	FRIDAY	SATURDAY
	1	2	3	4	5	6
7	8	9	10	11	12	13
14	15	16	17	18	19	20
21	22	23	24	25	26	27
28	29	30	31			

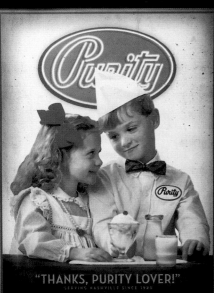

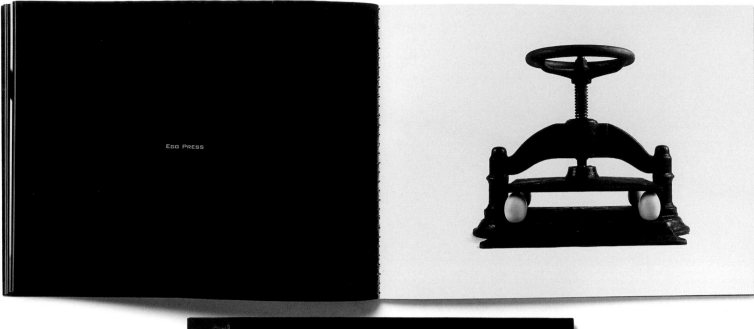

EGG PRESS

WOODY PIRTLE
object lesson

#1.

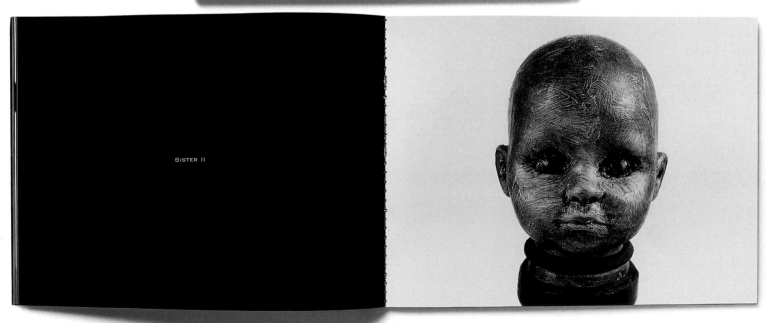

SISTER II

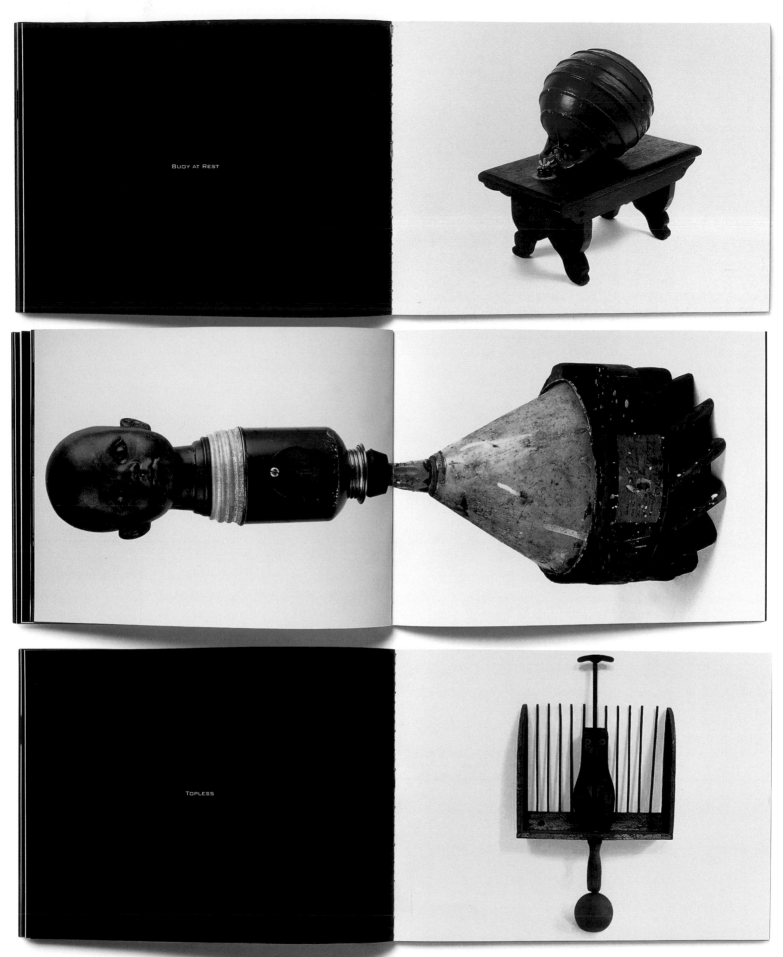

BUOY AT REST

TOPLESS

(this spread) **Pentagram Design** *AIGA Dallas-Fort Worth Chapter*

In my professional career I've had four major challenges/successes: as a designer at Porsche AG, as founder of Freeman Thomas and Associates, as chief designer at Volkswagen/Audi AG, and as head of DaimlerChrysler's Advanced Design Center California. Each has tested my philosophy, talent, and education. Art Center prepared me well for each situation. I was encouraged to think freely and openly but with discipline and accountability. I was exposed to the world's best students, instructors, and industry leaders. Art Center revealed my strengths, weaknesses, and potential. It also encouraged my curiosity. I could not wait for the next day of class.

Art Center is unique in that it integrates the mystique of Southern California with an international perspective, intellect, and attitude. Art Center influences and is a part of all the major movements in global design. It is, quite simply, "where the pebble hits the pond." Art Center's rich history continues to inform its foundation as it evolves and reinvents itself with each new generation, helping to make it the best design school in the world.

Freeman Thomas '83

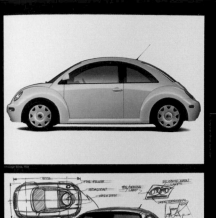

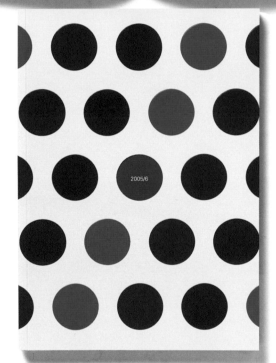

2005/6

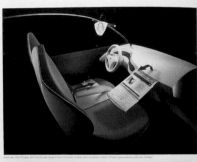

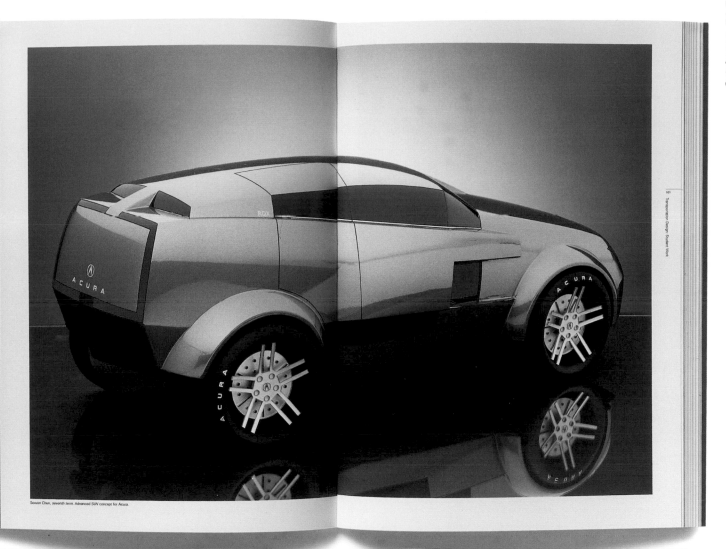

Sewon Chun, seventh term. Advanced SUV concept for Acura.

When I came from Switzerland to study at Art Center College of Design, I was looking forward to being thrown into the middle of many different art and design disciplines, as well as being exposed to challenging and provocative ideas and perspectives. My educational journey at Art Center very much matched my expectations. The depth and diversity of those creative experiences in industrial design, graphics, photography, and film helped shape my approach to design, and continues to inform my work and the work of fuseproject, the industrial design and brand strategy consultancy I founded that works across numerous disciplines and media. Art Center is also where I developed the skills, desire, and guts (an often-overlooked quality) to apply ideas beyond the traditional boundaries of industrial design, to continually stretch those boundaries, to constantly learn how design can tell stories and connect with people's lives. From being inspired during my years at this unique learning institution, I hope to inspire others to evolve the design field with their own points of view.

Yves Béhar '86

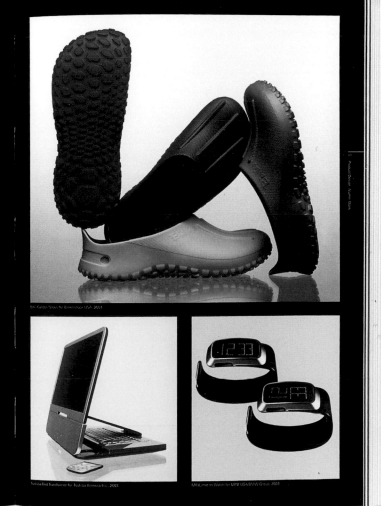

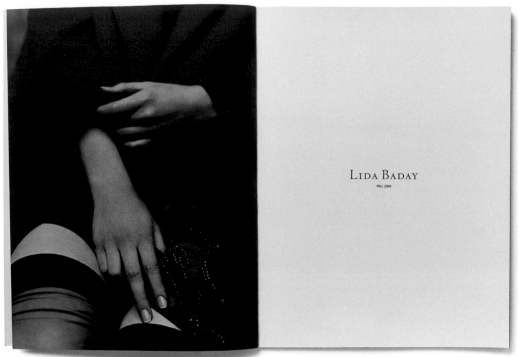

LIDA BADAY

FALL 2004

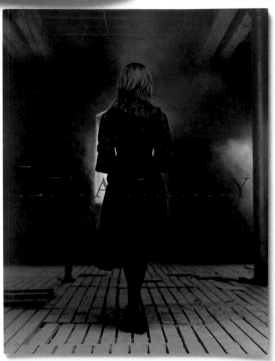

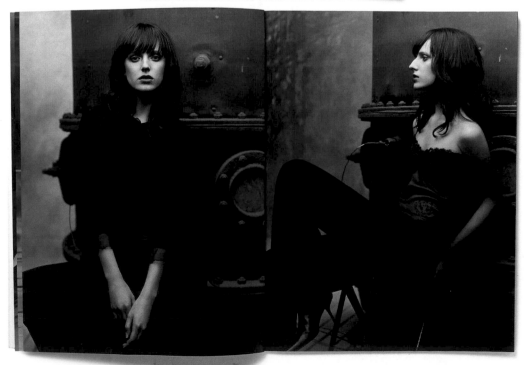

Concrete Design Communications Inc. *Lida Baday*

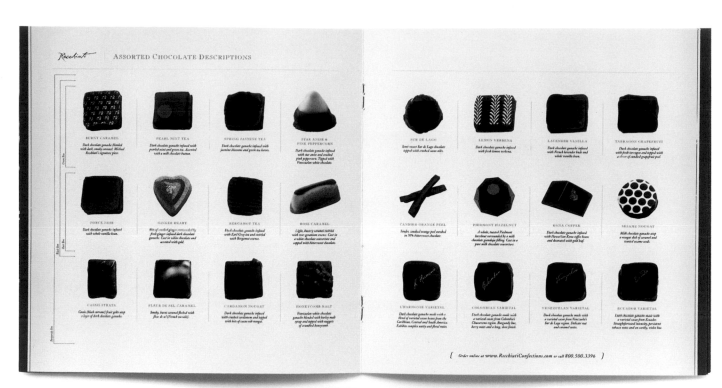

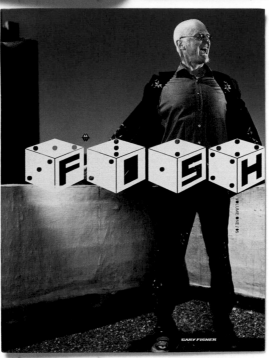

FOSH

VOLUME NINE / #5

GARY FISHER

2 4

They're a weird draw, these 24-hour races. Full-on carnivals that blow into town for a day, spin wildly around a rickety axle, and then disband and move on before the dust settles.

You know you're in it for fun, though, when you find yourself signing your name underneath the words "waive, release, discharge, and hold harmless." Especially when the words are all bunched together like that and you know they're going to apply for the next 24 sleep-deprived hours. You have no one to blame but yourself.

Some come for the win. Others come for the whip. Many come because these friends needed a fourth. And then there's the Solos, a whole different story altogether. Sequestered together in the dark on the quiet side of camp.

From any angle, it's an ungodly display of fortitude. A world that exists on a different plane. The round-the-clock bustle of the transition pit. The hangers out and hangers on, huddled around campfires. People sunk in chairs, pounded dumb by exhaustion. Stirring in disbelief when informed that their turn is coming around again.

It's three a.m. An hour that's been noted by hospitals as a popular time to die. What's true for patients is true for pedalers and partiers too: three a.m. is the pivot point.

The time of the night when you need to decide whether you're in or out. Hold 'em or fold 'em. Walk away or run.

And there you are, out in the darkness of Lap 18. Passing Mile 9 with your headlamp sputtering on the verge of a full-blown crapout. Or is it you? You're seeing things in your periphery that probably aren't there. You're not seeing eye-level branches that most certainly are.

Of course the voice doesn't help:

"Hey. You on the bike. You're riding in circles. There's beer back at camp. There's bedrolls. Stop now. Go back and lie one on. Sleep it off. And then don't even do this again. Nothing is meant to be done for 24 hours in a row."

It's a strong argument. But one that you've got completely ruled out by Lap 20. Because noon happens. Every day. And this next one is going to be especially good.

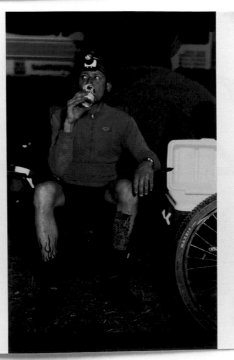

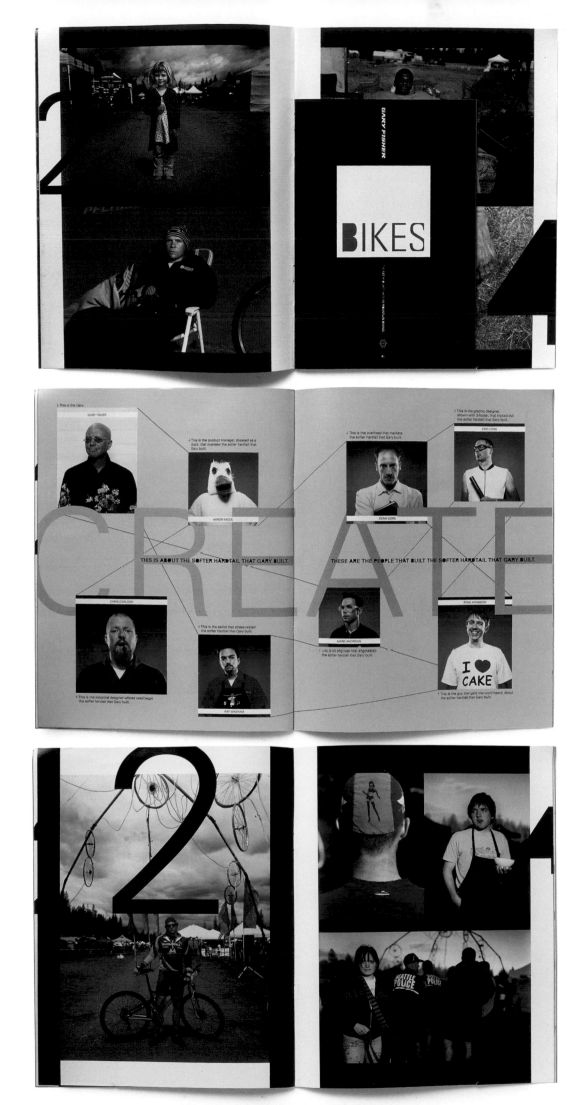

(this spread) **Travis Ott** *Gary Fisher Bicycles*

g

KASIA GASPARSKI
JEWELLERY · 03

Pleks *Kasia Gasparski*

Zen™

Whether you are planning a personal powder room or a corporation's executive bathroom, your stylistic options are indeed many. Start with a design that sets the proper mood for the entire room. Then choose colors, textures and lighting that enhance the atmosphere but also reflect your personal tastes.

Zen Above-Counter Basin.

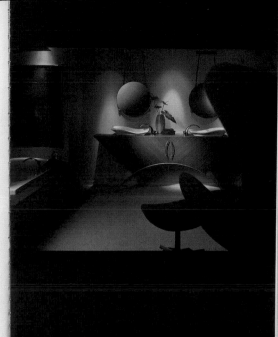

PORCHER

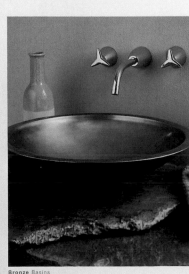

Temperantia™ Bronze Above-Counter Basin
Circular-shaped with symmetrical lip and smooth exterior. Requires above-counter basin faucet. Shown with Stemma™ Wall-Mount Faucet.
32356
15½" diameter, 4 ½" high. Available in Bronze and White Bronze.

Liberum™ Bronze Above-Counter Basin
Semi-diamond-shaped with asymmetrical lip and hand-textured exterior. Requires above-counter basin faucet. Shown with Affaire Basin Faucet.
32366
17" x 14" x 6½". Available in Bronze and White Bronze.

Bronze Basins

Bronze basins have a living finish and they vary in appearance and darken over time with lighting conditions.

Designer Resources Collection

Sun Mask

Kwakwaka'wakw
Vancouver Island, British Columbia
ca. 1880

wood, red, green and black pigments
height: 22"
with attachment: 32"

PROVENANCE:
Reportedly presented to Dr. William Shaw of Campbell River, BC
by Chief Billy Assu of the We Wai Kai band as a token of thanks
for the medical treatment provided to his wife, then by descent
through the family.

REFERENCES:
Macnair 1984, fig. 37 and pg. 149
University of British Columbia 1975, fig. 16

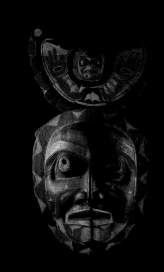

By the late nineteenth century Kwakwaka'wakw artists had
perfected the complex articulated mask as a performance
device in a wide variety of forms. Masks were created with
a wide range of moving parts and appendages that changed
shape to reveal an alternate appearance. These movements
were calculated for their dramatic effect, and for their ability
to illustrate both basic movement, an opening mouth for
example, and the concept of transformation, from one
animal to another or from animal to human. Transformation
is central to the mythic origin stories of families and
ancestors that the dances are intended to convey.

This exceptional mask features a corona composed of
seven triangular sections of wood, initially appearing as a
half-circular form above the mask, with a small mask-like
face at its center. At the high point of the dance, the
crescent would be 'unrolled' down the outer rim of the
mask. This would create a series of 'rays' extending out
around the perimeter, with the small maskette still poised
above the central image. This movement was likely
intended to illustrate the rays of the sun, with the main
image personifying the sun.

The dramatic impact of witnessing a traditional
Kwakwaka'wakw performance that would include an
articulated mask can hardly be exaggerated. The mask
would come alive, the moving parts encouraging the viewer
to suspend their sense of reality and see the mask as a
living being. The movements of a skilled dancer compliment
the actions of the mask, the entire presentation conveying
the timeless relationship between people and the natural
and spiritual worlds.

2

3

Donald Ellis Gallery

Portrait Mask

Tlingit
Southeastern Alaska
ca. 1860

wood, pigment, copper, sealskin, mirror
height: 8 3/4"

PROVENANCE:
Heye Foundation, Museum of the American Indian, New York, NY,
No. 14/7332 acquired 1926, deaccessioned 1962

George and Rosemary Lob, New York, NY

REFERENCE:
Sotheby's 1967, lot 226

Northwest Coast masks carved with naturalistic features
are often referred to as portrait masks due to their
supposed resemblance to actual individuals. In the
imposing mask shown here, a Tlingit attribution is strongly
suggested by the carver's rendering of the eye sockets, the
formation of the cheeks and the prominent lips. Among
the broad range of Tlingit styles, this mask most likely
originated with one of the southern groups, perhaps the
Sanya or Tongass peoples of southeastern Alaska. The
mask may have been the property of a Tlingit shaman, who
incorporated copper and other exotic materials to represent
a particular spirit that assisted him in his work. The sclera
of deceased individuals, sometimes high ranking ones from
other tribes, appear regularly in Tlingit shaman's masks.

The pronounced raised grain on the face, together
with the sealskin facial hair, sensitively conveys the
impression of an older individual with somewhat wrinkled
skin. The shape of the mouth suggests that the subject
is speaking or singing, though only the owner's family
would have known exactly what is portrayed in this striking
and powerful image.

40

41

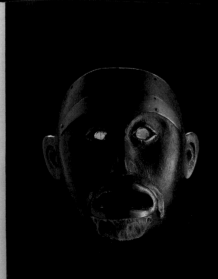

Dagger and Sheath
Cree or Cree/Metis
Northern Ontario or Manitoba
ca. 1840

porcupine quills, hide, moose hair, steel, bone
dagger length: 13 1/2"
sheath length: 11 1/2"

REFERENCES:
Coe 1977, pl. 104
Furst 1982, pl. 220

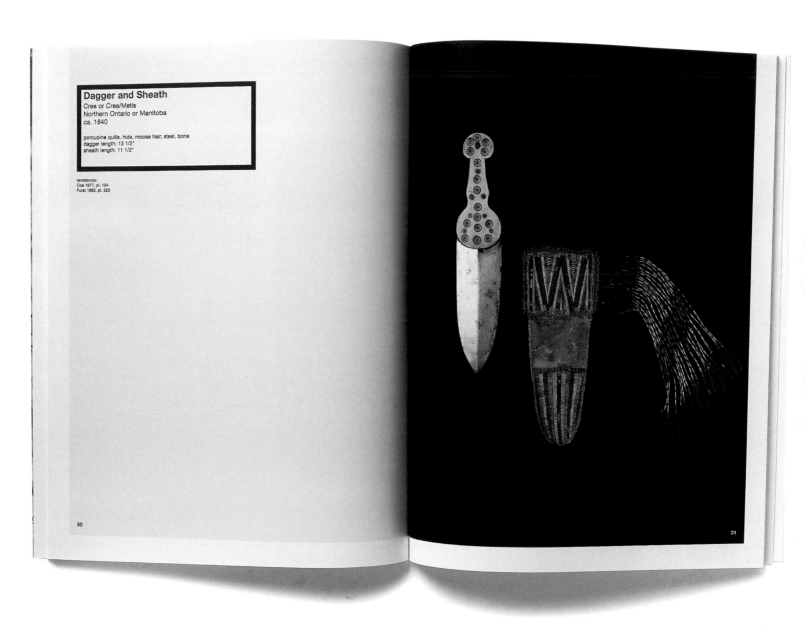

30

31

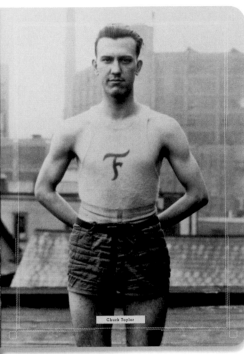

Chuck Taylor®

Chuck Taylor didn't just put his signature on the patch of the All Star—he put it on the game itself. His contributions to basketball and American sports made him a legend in his own time and propelled his name beyond the sports pages and into the vernacular of popular culture. These days, Chucks represent something more than athletic shoes. Born in the early years of basketball and gradually transformed into a badge of identity and originality, today their color and style choices are as diverse as the people who wear them. To try to define today's All Star defeats its purpose—it's up to you to define the pair you wear.

★

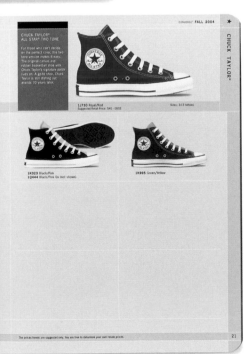

CHUCK TAYLOR®
ALL STAR® TWO TONE

For those who can't decide on the perfect color, the two-tone version makes it easy. The original canvas and rubber basketball shoe with Chuck Taylor's signature patch lives on. A go-to shoe, Chuck Taylor is still doling out assists 70 years later.

1J730 Royal/Red
Suggested Retail Price: $40 - 0002 Sizes: 3-13 (whole)

1K023 Black/Pink
1Q444 Black/Pink Ox (not shown) 1K995 Green/Yellow

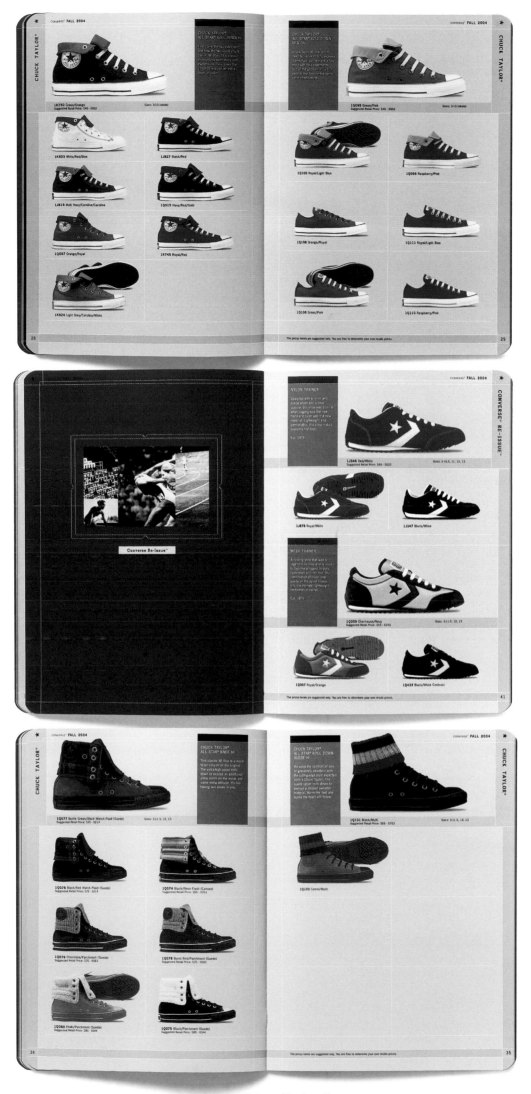

(this spread) **Sandstrom Design** *Converse*

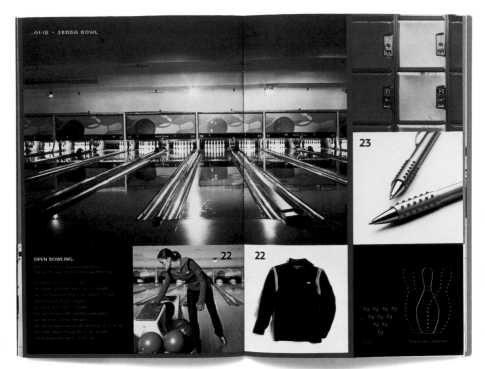

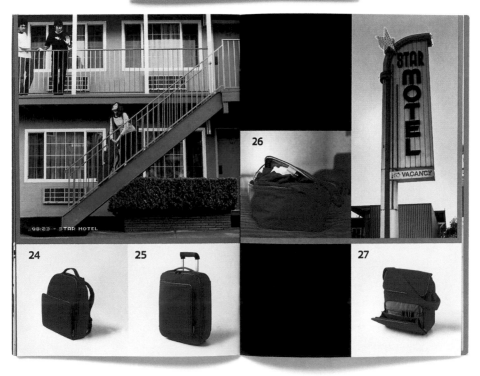

50,000feet, Inc. *MINI*

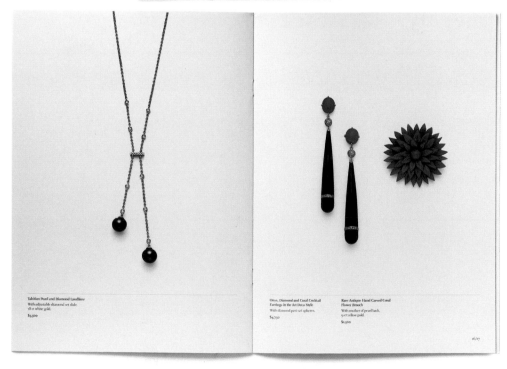

Tahitian Pearl and Diamond Lavalliere
With adjustable diamond set slide.
18ct white gold.
$3,900

Onyx, Diamond and Coral Cocktail
Earrings in the Art Deco Style
With diamond pavé set spheres.
$4,750

Rare Antique Hand Carved Coral
Flower Brooch
With mother of pearl back.
9ct yellow gold.
$1,500

Andrew Hoyne *Kozminsky*

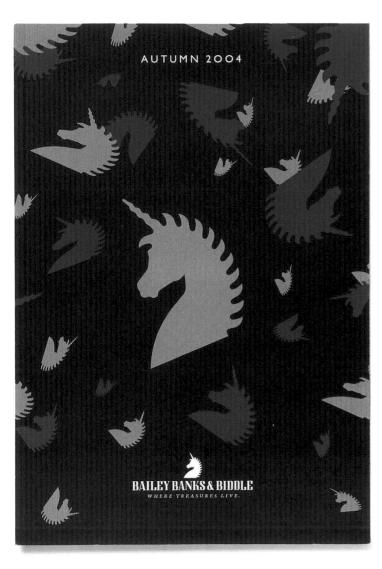

(this spread) **thompsondesign** *Bailey Banks and Biddle*

INTRODUCING THE DAVID YURMAN
MADISON CABLE™ TIMEPIECE COLLECTION
White mother-of-pearl dial with diamond bezel
on signature cable bracelet $4,500.
Pink mother-of-pearl dial on Madison chain bracelet $1,900.
White mother-of-pearl dial with diamond attachments on black
alligator strap $2,300. Sterling silver and steel case.

opposite page:
DAVID YURMAN JEWELRY IN STERLING SILVER
Deco Ring™ in amethyst and diamonds $1,650.
Deco Ring™ in citrine and diamonds $1,100.
Mixed chain necklace in sterling silver and 18k $1,750.
Pavé Diamond Albion™ earrings $1,850.
Pavé Diamond Albion™ enhancer $4,500.

CASCADING STEMS OF DELICATE DIAMONDS
Diamond bracelet designs in 18k gold. Starting at $3,100.

DISTINCT DESIRE AND ELEGANCE: DIAMOND RIGHT HAND RINGS
Featured rings in white and yellow diamonds in 18k gold. Starting at $1,500.

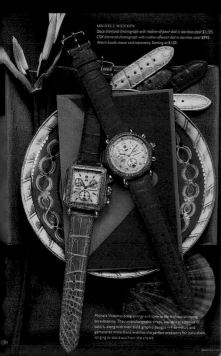

MICHELE WATCHES
Deco diamond chronograph with mother-of-pearl dial in stainless steel $1,195.
CSX diamond chronograph with mother-of-pearl dial in stainless steel $995.
Watch bands shown sold separately. Starting at $150.

Michele Watches bring energy and style to life without skimping
on substance. Their interchangeable straps, available in a myriad of
colors, along with their bold, graphic designs in fine metals and
gemstones make these watches the perfect accessory for individuals
longing to stand out from the crowd.

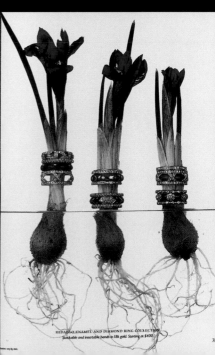

HIDALGO ENAMEL AND DIAMOND RING COLLECTION
Stackable and insertable bands in 18k gold. Starting at $400.

31

BAZAAR

TERI
HATCHER

New
Season
Best of
The
Best
Fashion

THE NEWSLETTER OF THE SCHOOL OF ARCHITECTURE AND PLANNING AT MIT

P LA59

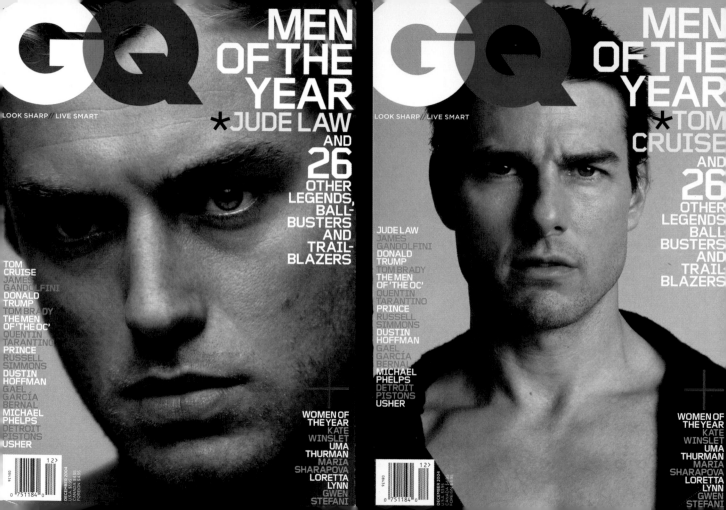

GQ

MEN OF THE YEAR
*JUDE LAW

LOOK SHARP // LIVE SMART

AND **26** OTHER LEGENDS, BALL-BUSTERS AND TRAIL-BLAZERS

TOM CRUISE
JAMES GANDOLFINI
DONALD TRUMP
TOM BRADY
THE MEN OF 'THE OC'
QUENTIN TARANTINO
PRINCE
RUSSELL SIMMONS
DUSTIN HOFFMAN
GAEL GARCÍA BERNAL
MICHAEL PHELPS
DETROIT PISTONS
USHER

WOMEN OF THE YEAR
KATE WINSLET
UMA THURMAN
MARIA SHARAPOVA
LORETTA LYNN
GWEN STEFANI

DECEMBER 2004
U.S.A. $3.95
CANADA $4.95
FOREIGN $4.95

0 751184

12>

GQ

MEN OF THE YEAR
*TOM CRUISE

LOOK SHARP // LIVE SMART

AND **26** OTHER LEGENDS BALL-BUSTERS AND TRAIL-BLAZERS

JUDE LAW
JAMES GANDOLFINI
DONALD TRUMP
TOM BRADY
THE MEN OF 'THE OC'
QUENTIN TARANTINO
PRINCE
RUSSELL SIMMONS
DUSTIN HOFFMAN
GAEL GARCÍA BERNAL
MICHAEL PHELPS
DETROIT PISTONS
USHER

WOMEN OF THE YEAR
KATE WINSLET
UMA THURMAN
MARIA SHARAPOVA
LORETTA LYNN
GWEN STEFANI

DECEMBER 2004
U.S.A. $3.95
CANADA $4.95
FOREIGN $4.95

0 751184

12>

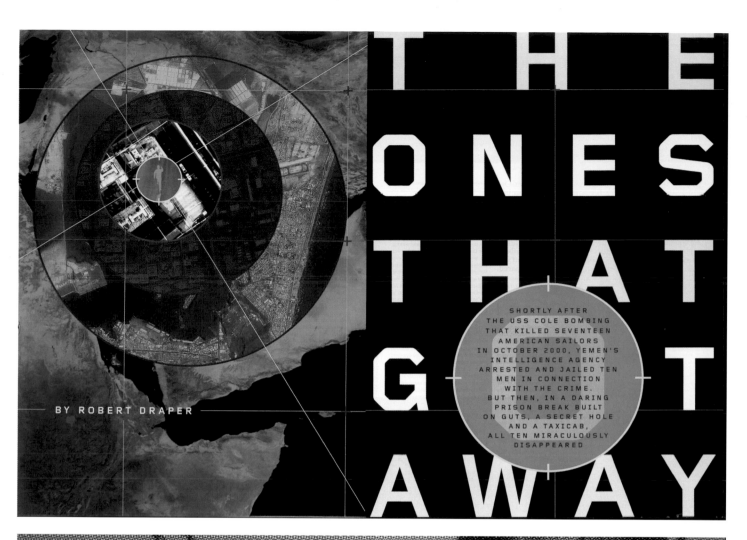

THE ONES THAT GOT AWAY

BY ROBERT DRAPER

SHORTLY AFTER THE USS COLE BOMBING THAT KILLED SEVENTEEN AMERICAN SAILORS IN OCTOBER 2000, YEMEN'S INTELLIGENCE AGENCY ARRESTED AND JAILED TEN MEN IN CONNECTION WITH THE CRIME. BUT THEN, IN A DARING PRISON BREAK BUILT ON GUTS, A SECRET HOLE AND A TAXICAB, ALL TEN MIRACULOUSLY DISAPPEARED

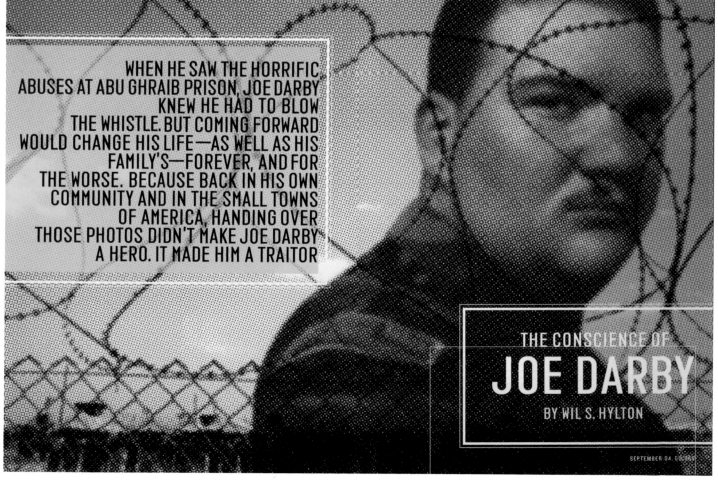

WHEN HE SAW THE HORRIFIC ABUSES AT ABU GHRAIB PRISON, JOE DARBY KNEW HE HAD TO BLOW THE WHISTLE. BUT COMING FORWARD WOULD CHANGE HIS LIFE—AS WELL AS HIS FAMILY'S—FOREVER, AND FOR THE WORSE. BECAUSE BACK IN HIS OWN COMMUNITY AND IN THE SMALL TOWNS OF AMERICA, HANDING OVER THOSE PHOTOS DIDN'T MAKE JOE DARBY A HERO. IT MADE HIM A TRAITOR

THE CONSCIENCE OF
JOE DARBY
BY WIL S. HYLTON

SEPTEMBER 04. GQ 183

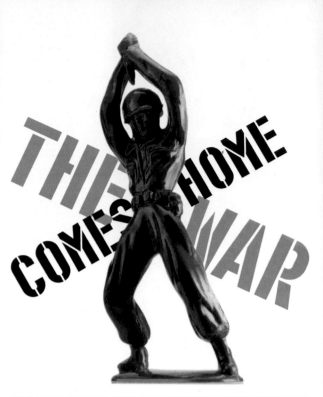

THERE COMES HOME WAR

THEY SAW AND DID. WHAT HAPPENS WHEN WE SEND SOLDIERS OFF TO FIGHT FOR US,
BUT THEN ABANDON THEM WHEN THEY RETURN WITH THEIR DEMONS? BY KENNETH CAIN

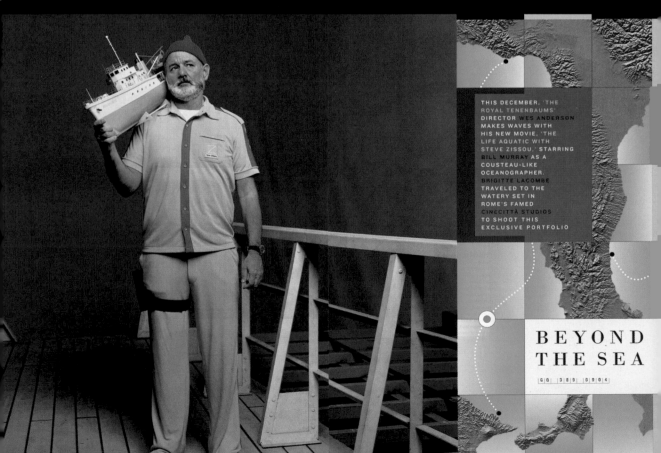

THIS DECEMBER, 'THE ROYAL TENENBAUMS' DIRECTOR WES ANDERSON MAKES WAVES WITH HIS NEW MOVIE, 'THE LIFE AQUATIC WITH STEVE ZISSOU,' STARRING BILL MURRAY AS A COUSTEAU-LIKE OCEANOGRAPHER. BRIGITTE LACOMBE TRAVELED TO THE WATERY SET IN ROME'S FAMED CINECITTÀ STUDIOS TO SHOOT THIS EXCLUSIVE PORTFOLIO

BEYOND
THE SEA

GQ.389.0904

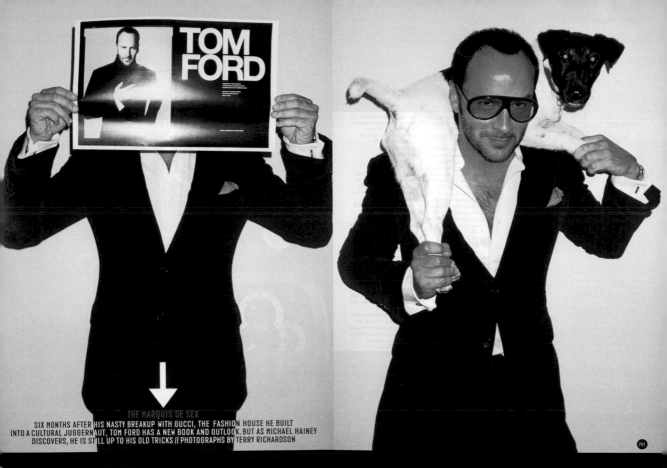

TOM FORD

THE MARQUIS DE SEX

SIX MONTHS AFTER HIS NASTY BREAKUP WITH GUCCI, THE FASHION HOUSE HE BUILT
INTO A CULTURAL JUGGERNAUT, TOM FORD HAS A NEW BOOK AND OUTLOOK. BUT AS MICHAEL HAINEY
DISCOVERS, HE IS STILL UP TO HIS OLD TRICKS // PHOTOGRAPHS BY TERRY RICHARDSON

OFF

CLEARED FOR TAKE—

LIKE THE
LEGENDARY TWA
TERMINAL
AT JFK, THE
GRAY FLANNEL SUIT
IS A TREASURE
OF MODERN DESIGN.
AND THIS FALL,
DESIGNERS ARE
MAKING THEM LIGHTER,
TRIMMER, AND MORE
COMFORTABLE—
THE PERFECT SUIT
FOR THE MAN ON
THE MOVE.
PHOTOGRAPHS
BY
STEVE HIETT

D&G
TWO-BUTTON SUIT
$1,130
SHIRT, $38, BY VAN HEUSEN.
WOOL TIE, $105,
BY BERGDORF GOODMAN.
SHOES, $265, BY MIU MIU.
WHERE TO BUY IT?
SEE PAGE 423.

Dot Magazine 11

JAN/FEB 2005
DISPLAY UNTIL MAR 7

DESIGN ARCHITECTURE ART

AZURE

**BRUCE
MAU'S
MASSIVE
CHANGE**

**EXPERIMENTAL
DUTCH
ARCHITECTURE**

**SMART
FLOORING**

**THE
BEST
OF
THE
FALL
SHOWS**

**PLUS
LIFE
SUPPORT
FOR
PLASMA
SCREENS**

3
GREAT
HOUSES

U.S./CAN $6.95
WWW.AZUREMAGAZINE.COM
PM40048073.R09064

02

7 78624 70029 2

CANADA POST
REGISTRATION # 6577

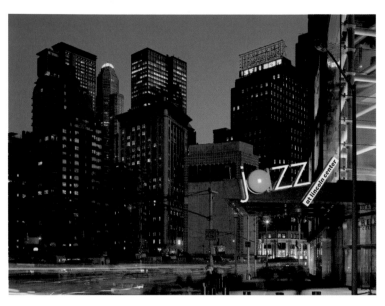

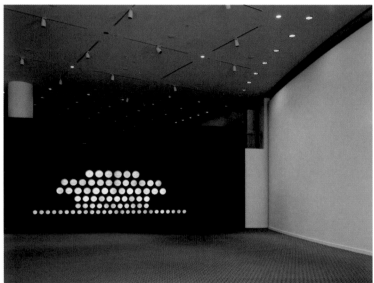

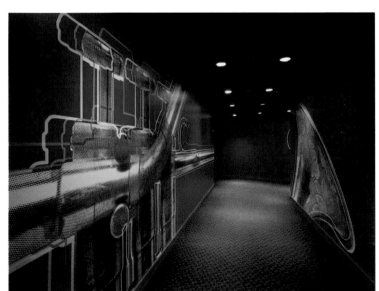

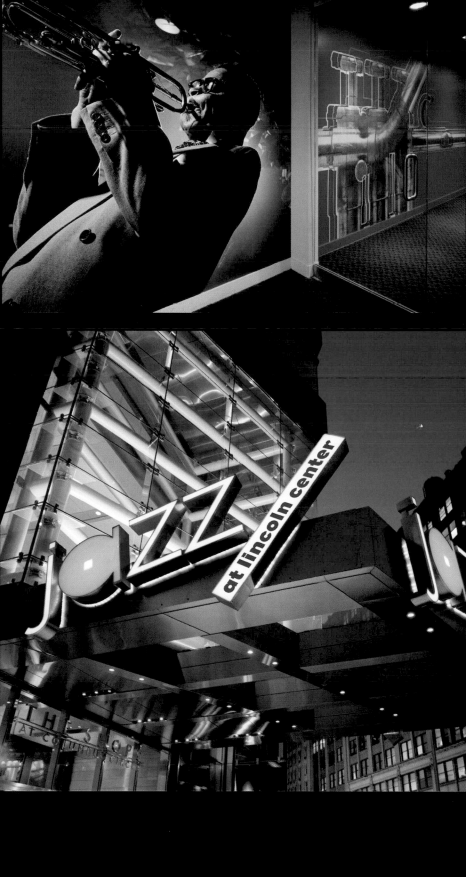

(this spread) **Pentagram Design** *Jazz at Lincoln Center*

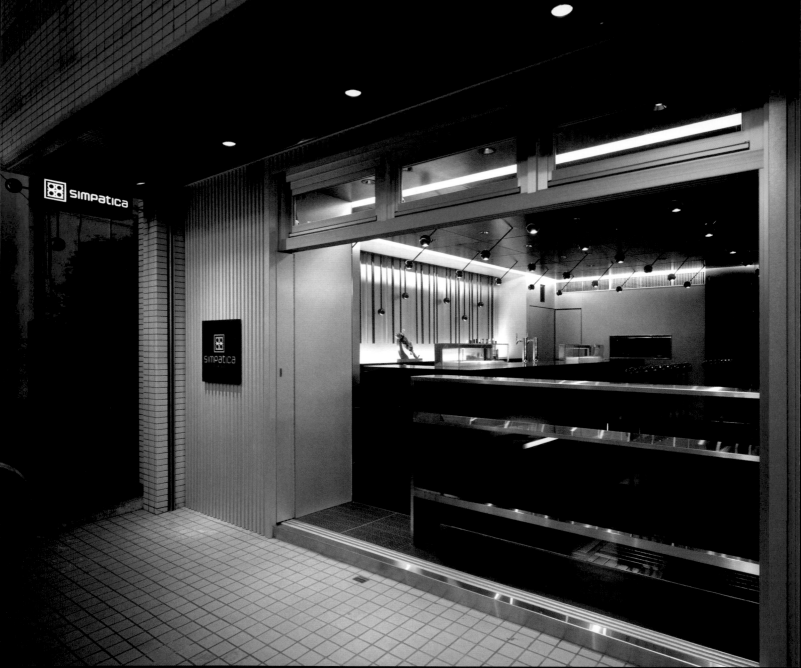

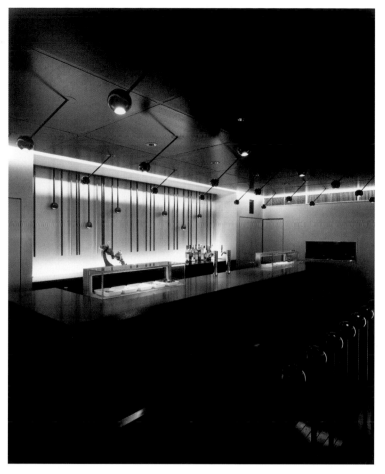

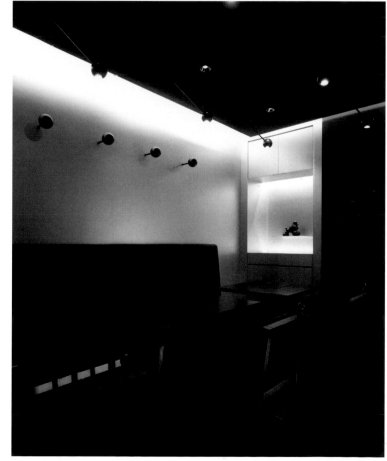

(this spread) **Love the Life** *Atsushi & Eri Ikeda*

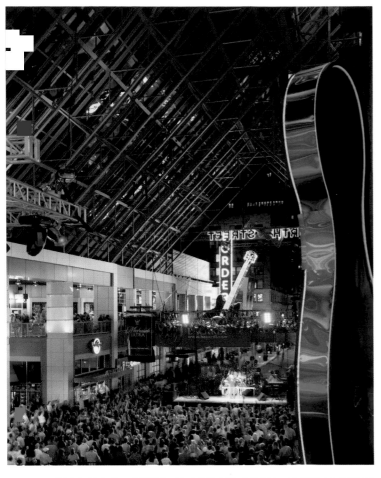
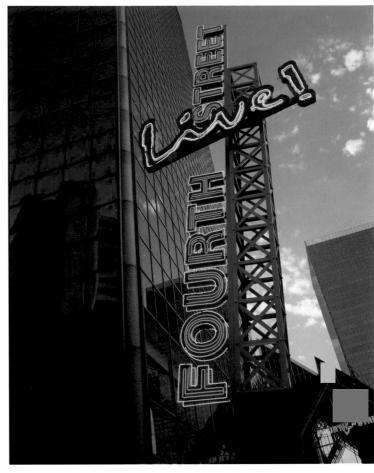
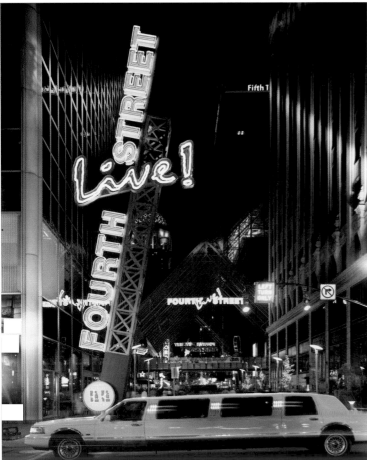
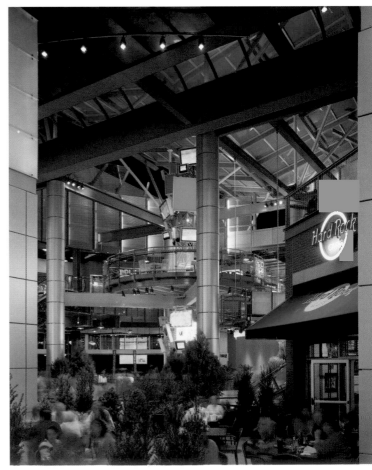

(this spread) **Selbert Perkins Design Collaborative** *The Cordish Company*

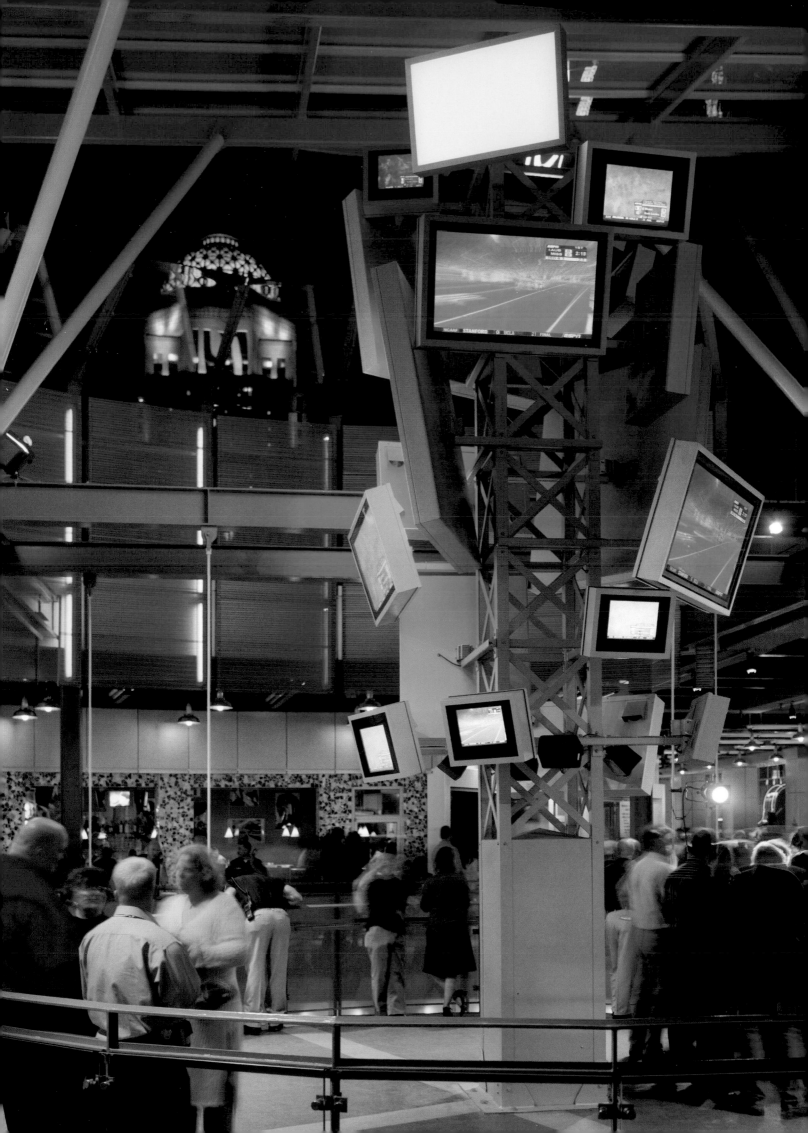

アダプトできるワークスペースアダプトできるワークスペースアダプトできるワークスペースアダプタビリアンパッシングト
ESPACOSDETRABALHOADAPTABLEAIRESDETRAVAILADAPTABLESADAPTABLEWORKSPACELUOGHIDILAVOROADATTABILITANPASSUNGSFAHIGEARBEITSBEREICHEESPACOSDETRABAJO
ESPACOSDETRABALHOADAPTABLEAIRESDETRAVAILA
DESIGNEDPERFORMANCEDESEMPENHOPROJETADOEXECUTIONCON
ESIGNEDPERFORMANCEDESEMPENHOPROJETADOEXECUTIONCONCUEPRESTAZIONIPROGETTATEENTWORFENELEISTUNGFUNC
FORMANCEDESEMPENHOPROJETADOEXECUTIONCONCUEPRESTAZIONIPROGETTATEENTWORFENELEISTUNGFUNCIONAMIENTODISENADOESIGNEDPERFORMANCEDESEMPENHOPROJETADOEXECUTIONCONCUEPRESTAZIONIPR
ESPACOSDETRABALHOADAPTABLEAIRESDETRAVAILADAPTABLESADAPTABLEWORKSPACELUOGHIDILAVOROADATTABILITANPASSUNGSFAHIGEARBEITSBEREICHEESPACOSDETRABAJO

HAWORTH
SMED
interfaceAR

art.collection
Castelli
Comforto
dyes

AIR, WHEN I W
NT IT, WHEN I NEED
Toulouse Frankf
WHEN I W
WHEN I NEED

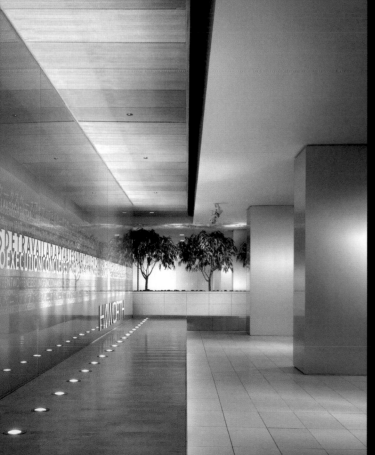

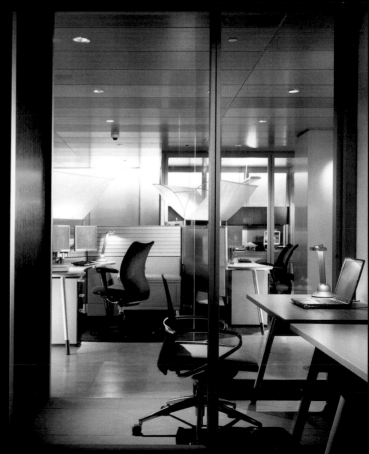

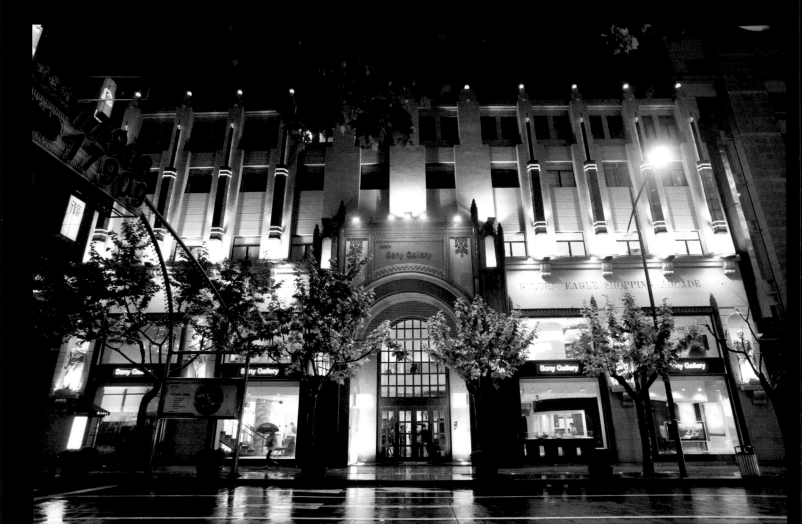

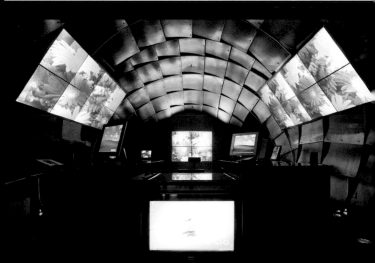

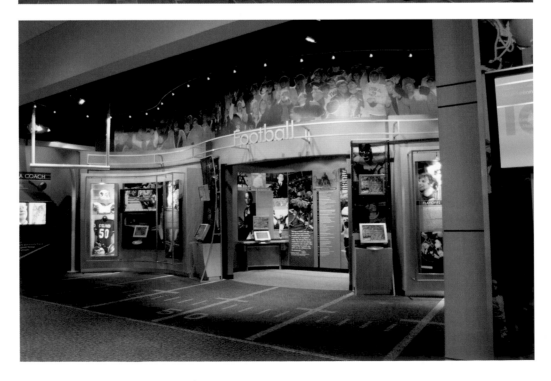

(this spread) **SynthesisDesign,LLC** *Iowa High School Athletic Association*

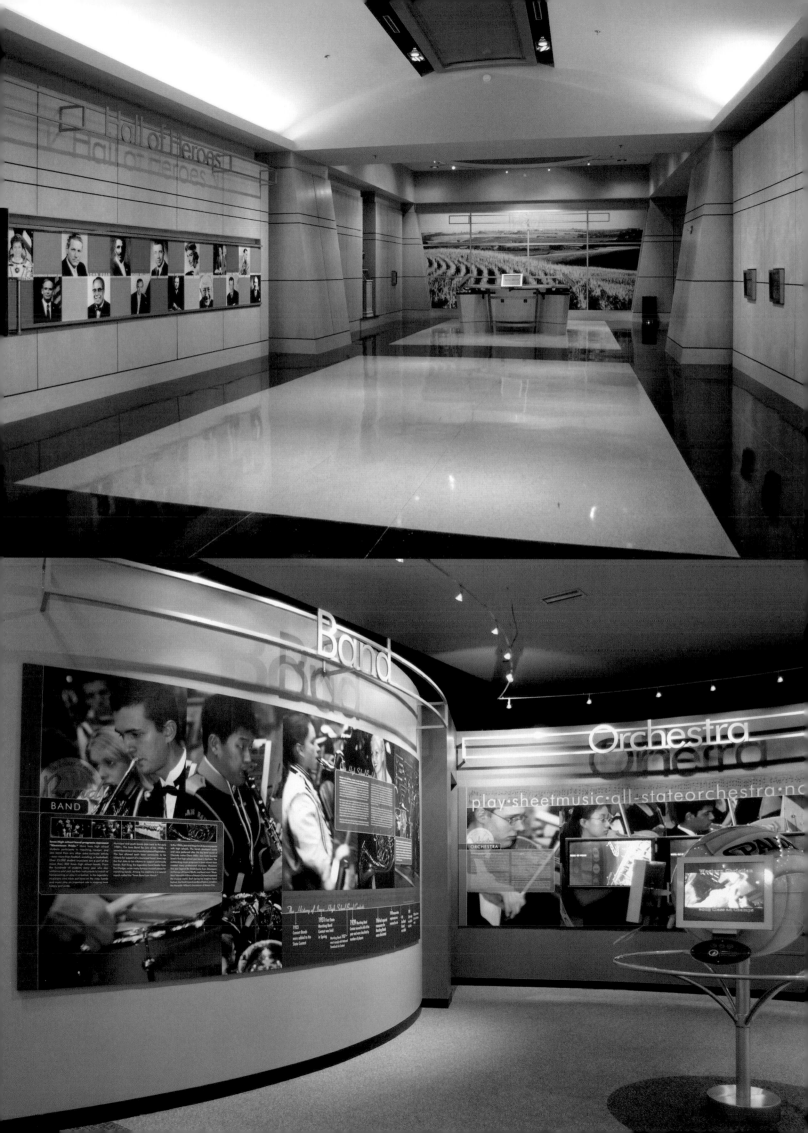

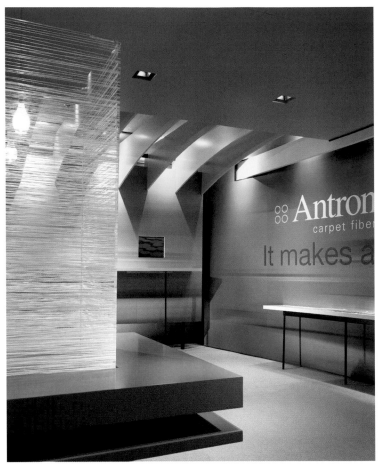

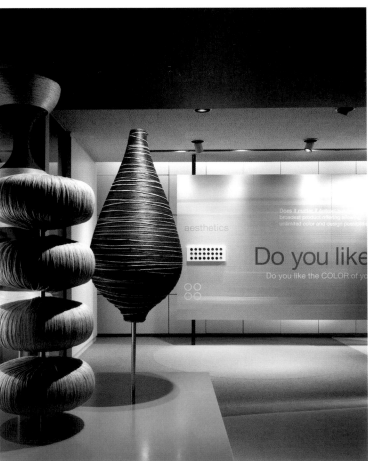

(this spread) **Perkins+Will | Eva Maddox Branded Environments** *Antron*

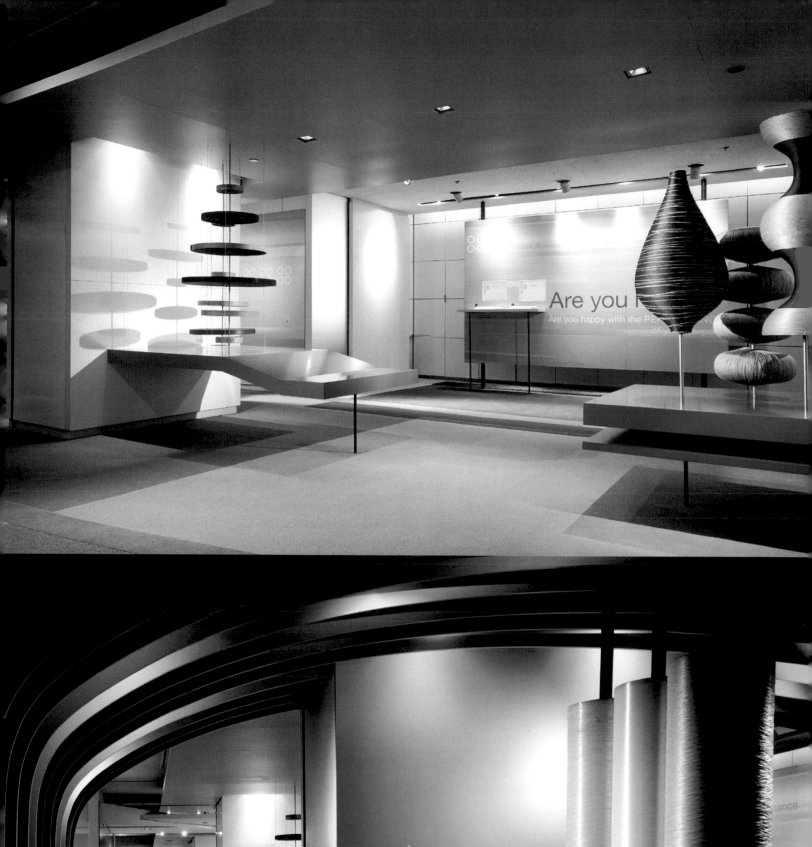

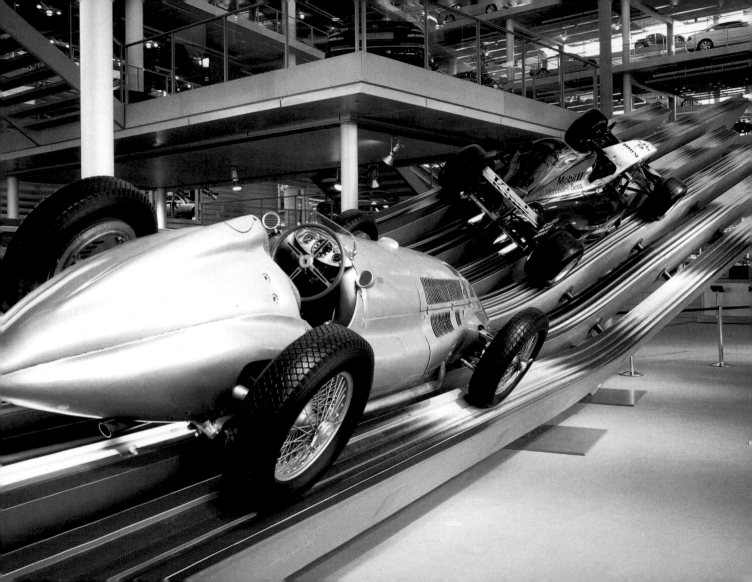

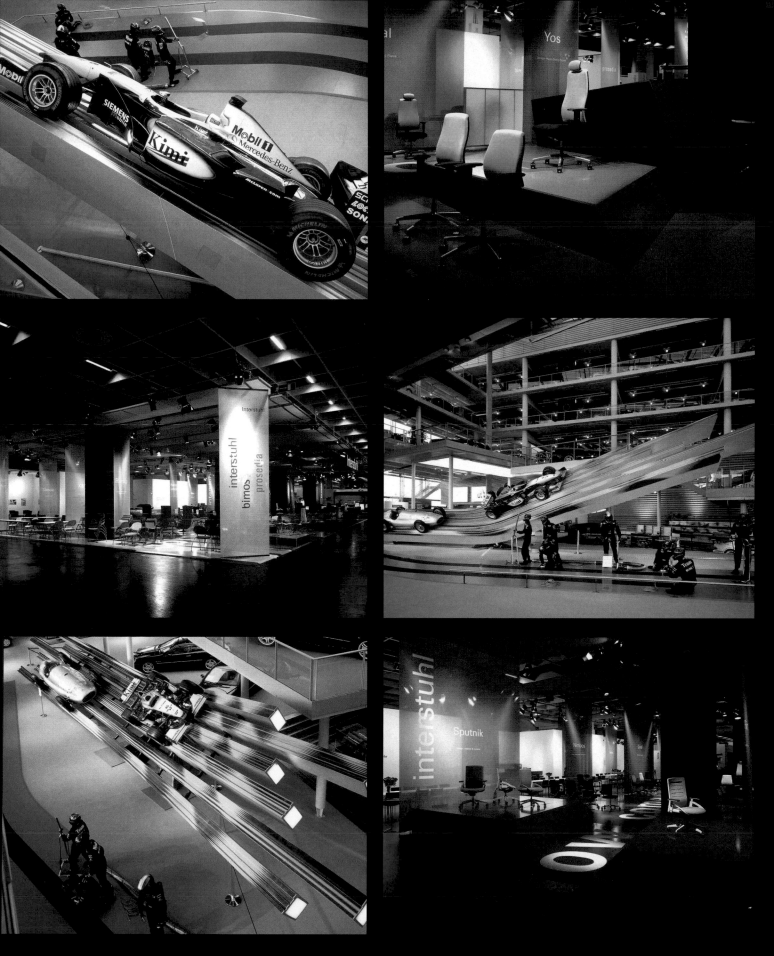

(this spread) **design hoch drei GmbH & Co.KG** *DaimlerChrysler AG | Interstuhl Büromöbel GmbH*

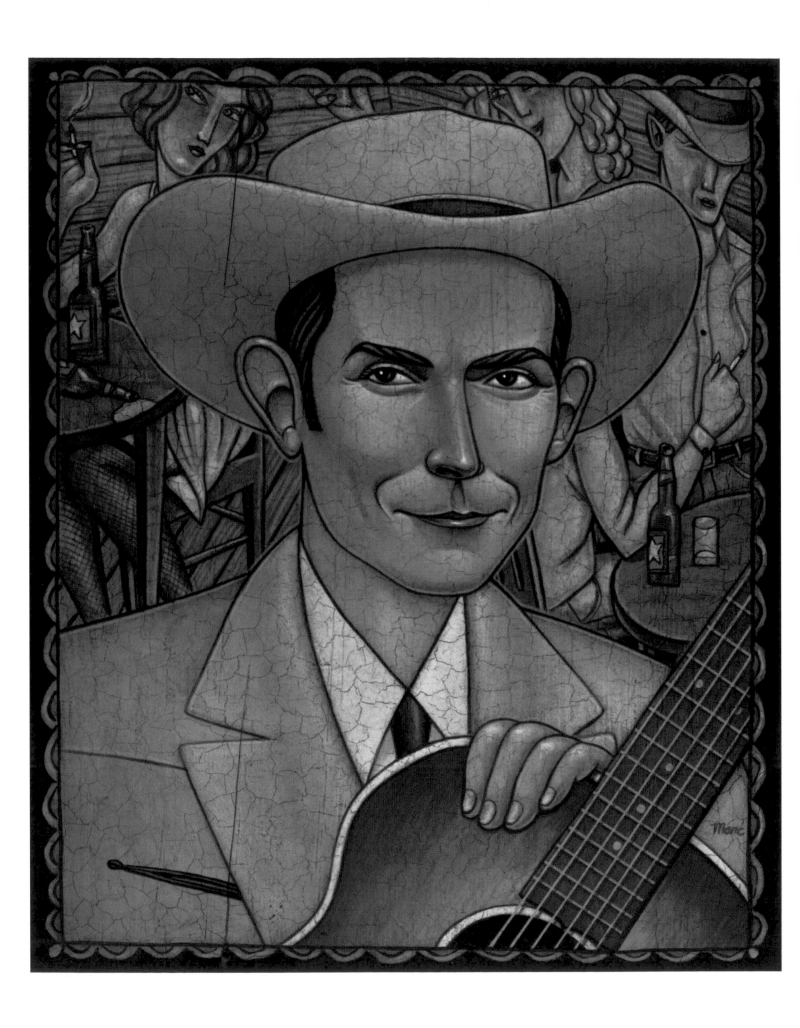

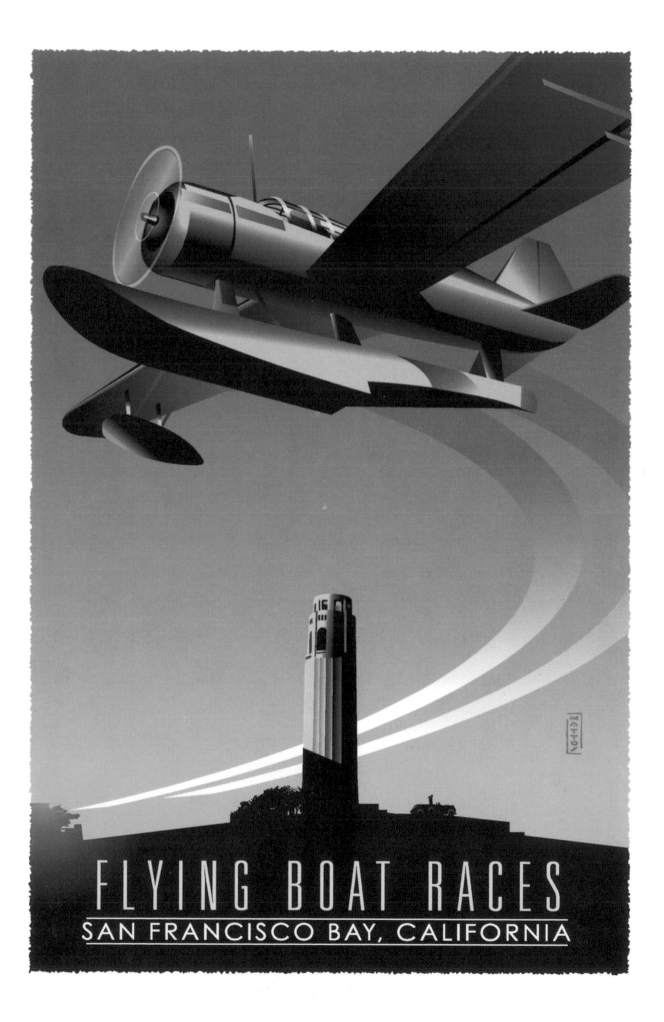

John Mattos Illustration *Stabinl Morykin Gallery*

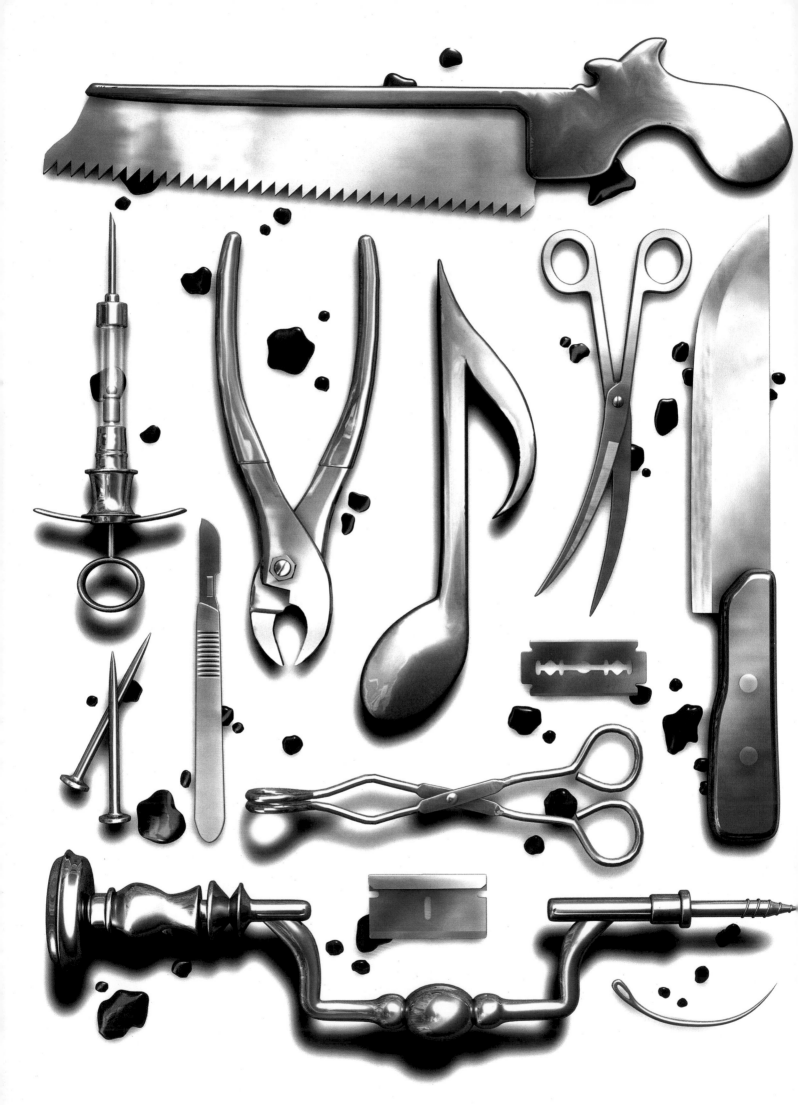

Our life shall not be sweated
from birth until life closes.
Hearts starve as well as bodies;
give us bread but give us roses

1 9 7 4 ~ 1 9 9 9

BREAD & ROSES 25th

Marco Ventura *The New York Times Magazine*

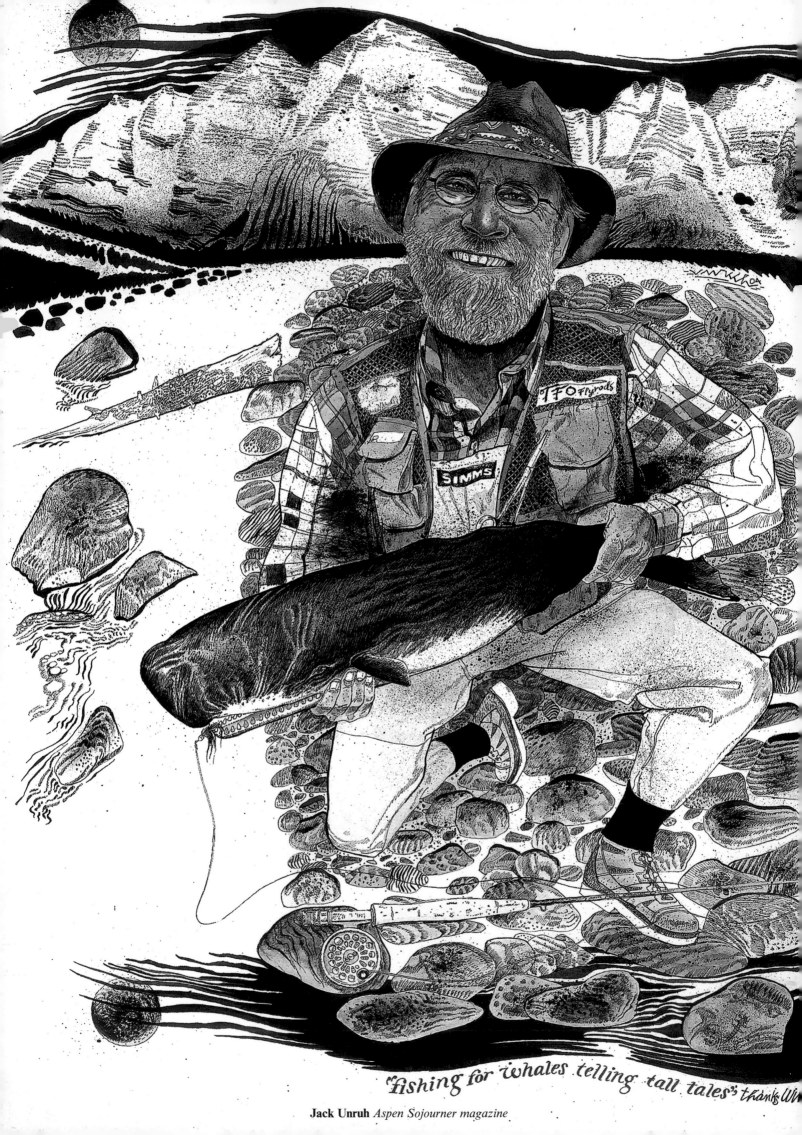

"fishing for whales telling tall tales" thanks W

Jack Unruh *Aspen Sojourner magazine*

Teresa Fasolino *Florian's café*

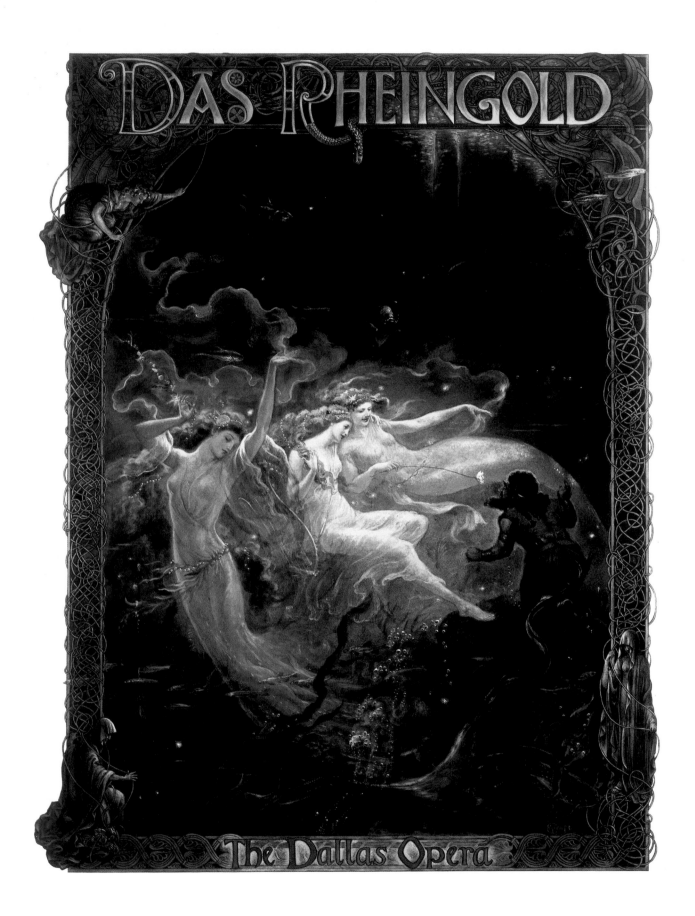

(this page) **Kinuko Y. Craft** *The Dallas Opera*, (opposite) **Anita Kunz** *The New Yorker*

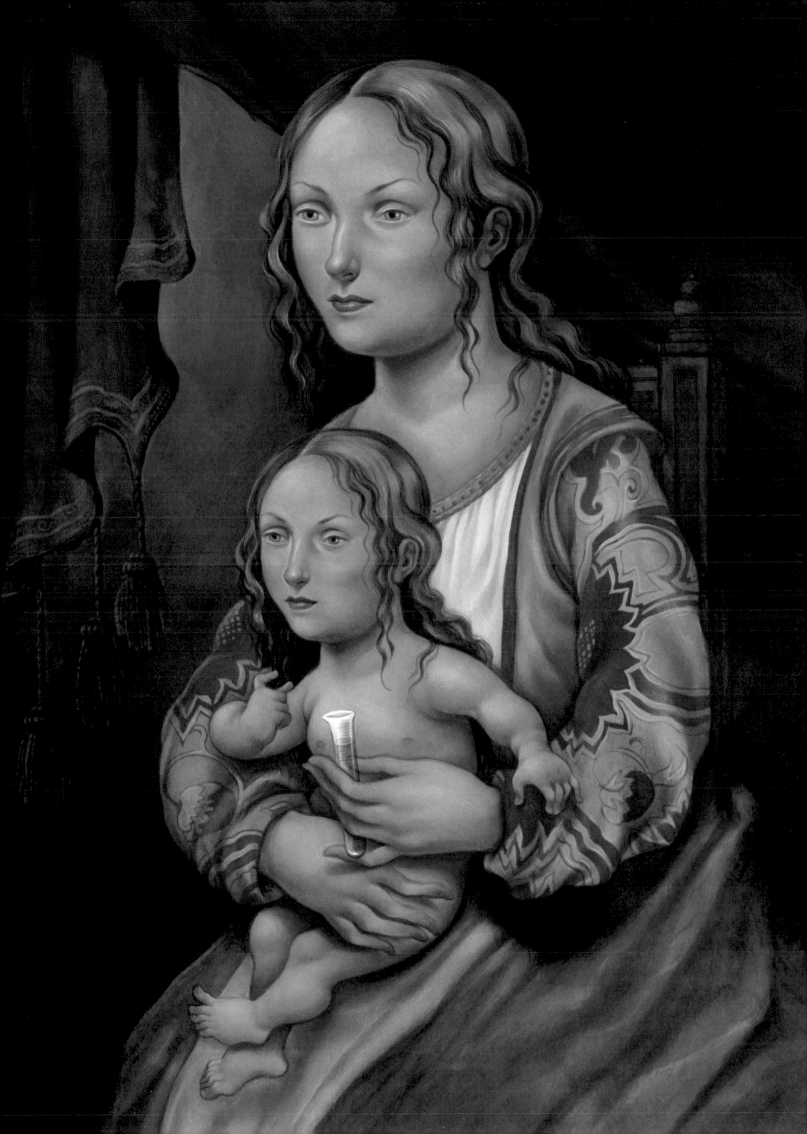

Directors
Images
News & Press
Contact
Client Login

Erich Joiner

back

After graduating from Pasadena's Art Center in 1990, Erich Joiner embarked on a career in advertising. He began as an art director at Goodby Silverstein & Partners (formerly Goodby Berlin & Silverstein) in San Francisco, where he went on to serve as associate creative director/art director until 1995.

As an agency creative, Joiner worked on the Sega, Porsche, Isuzu, and Norwegian Cruise Line

Play Reel

Toyota 'Running Club'
DHL 'Fiedler'
Miller Lite 'Lottery'
Newport FF 'Porno'
Honda 'Dirt Boarder'
Miller Lite 'Viagra'

Directors
Images
News & Press
Contact
Client Login

Contact

SANTA MONICA

2210 Broadway
Santa Monica CA 90404
t. 310.453.9244
f. 310.453.4185

Phillip Detchmendy
Managing Director
phillip@toolofna.com

MID WEST

Dawn Rao
312.202.6799 office
312.848.9337 cell
312.202.9227 fax
dawnrao@earthlink.net

WEST COAST

Stephanie Stephens

Directors
Images
News & Press
Contact
Client Login

Very very short films
with blatant product placement.

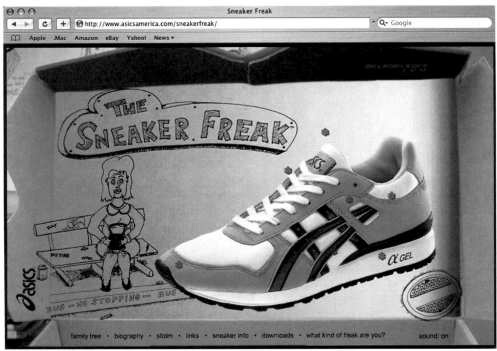

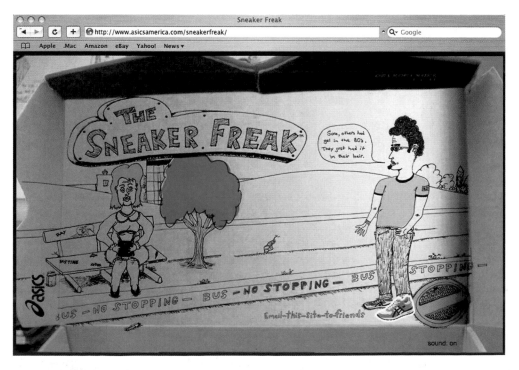

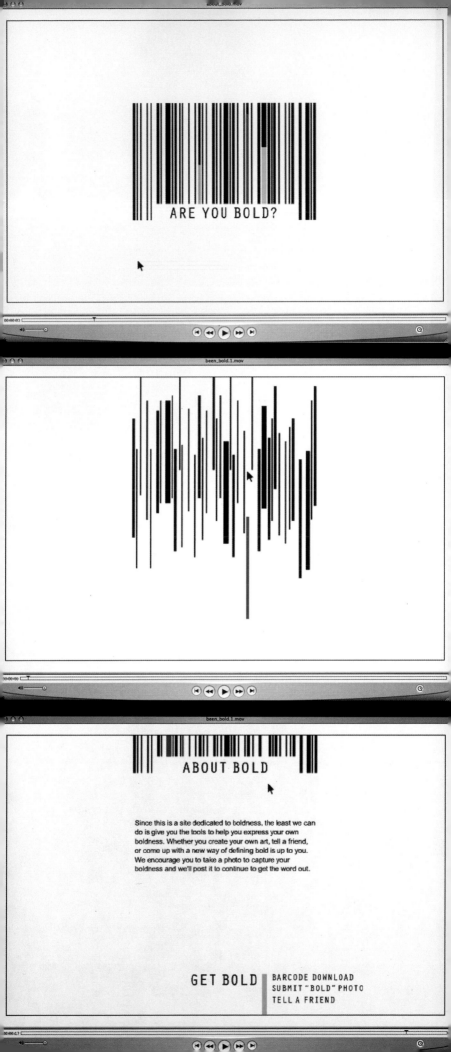

creative thinking + kraft:haus

technical acumen

GLORIOUS COLLISION OF
MAN+
MACHINE

creativity [&] technology

KRAFT:HAUS { love } BIG IDEAS

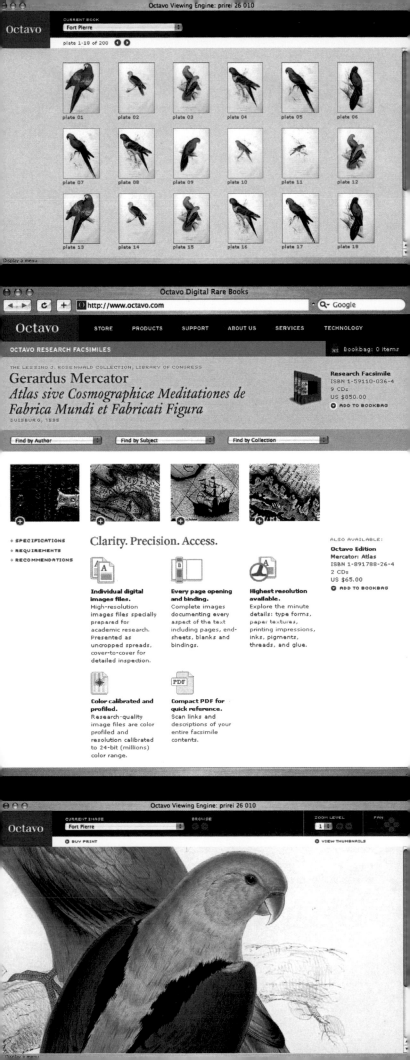

Octavo Viewing Engine: prirei 26 010

CURRENT BOOK
Fort Pierre

plate 1-18 of 200

plate 01　plate 02　plate 03　plate 04　plate 05　plate 06

plate 07　plate 08　plate 09　plate 10　plate 11　plate 12

plate 13　plate 14　plate 15　plate 16　plate 17　plate 18

Display a menu

Octavo Digital Rare Books

http://www.octavo.com　Google

Octavo

STORE　PRODUCTS　SUPPORT　ABOUT US　SERVICES　TECHNOLOGY

OCTAVO RESEARCH FACSIMILES　Bookbag: 0 items

THE LESSING J. ROSENWALD COLLECTION, LIBRARY OF CONGRESS

Gerardus Mercator
Atlas sive Cosmographicæ Meditationes de Fabrica Mundi et Fabricati Figura
DUISBURG, 1595

Research Facsimile
ISBN 1-59110-036-4
9 CDs
US $850.00
ADD TO BOOKBAG

Find by Author　Find by Subject　Find by Collection

Clarity. Precision. Access.

ALSO AVAILABLE:

Octavo Edition
Mercator: Atlas
ISBN 1-891788-26-4
2 CDs
US $65.00
ADD TO BOOKBAG

+ SPECIFICATIONS
+ REQUIREMENTS
+ RECOMMENDATIONS

Individual digital images files.
High-resolution images files specially prepared for academic research. Presented as uncropped spreads, cover-to-cover for detailed inspection.

Every page opening and binding.
Complete images documenting every aspect of the text including pages, end-sheets, blanks and bindings.

Highest resolution available.
Explore the minute details: type forms, paper textures, printing impressions, inks, pigments, threads, and glue.

Color calibrated and profiled.
Research-quality image files are color profiled and resolution calibrated to 24-bit (millions) color range.

Compact PDF for quick reference.
Scan links and descriptions of your entire facsimile contents.

Octavo Viewing Engine: prirei 26 010

CURRENT IMAGE
Fort Pierre

BROWSE

ZOOM LEVEL
1

PAN

BUY PRINT　VIEW THUMBNAILS

Display a menu

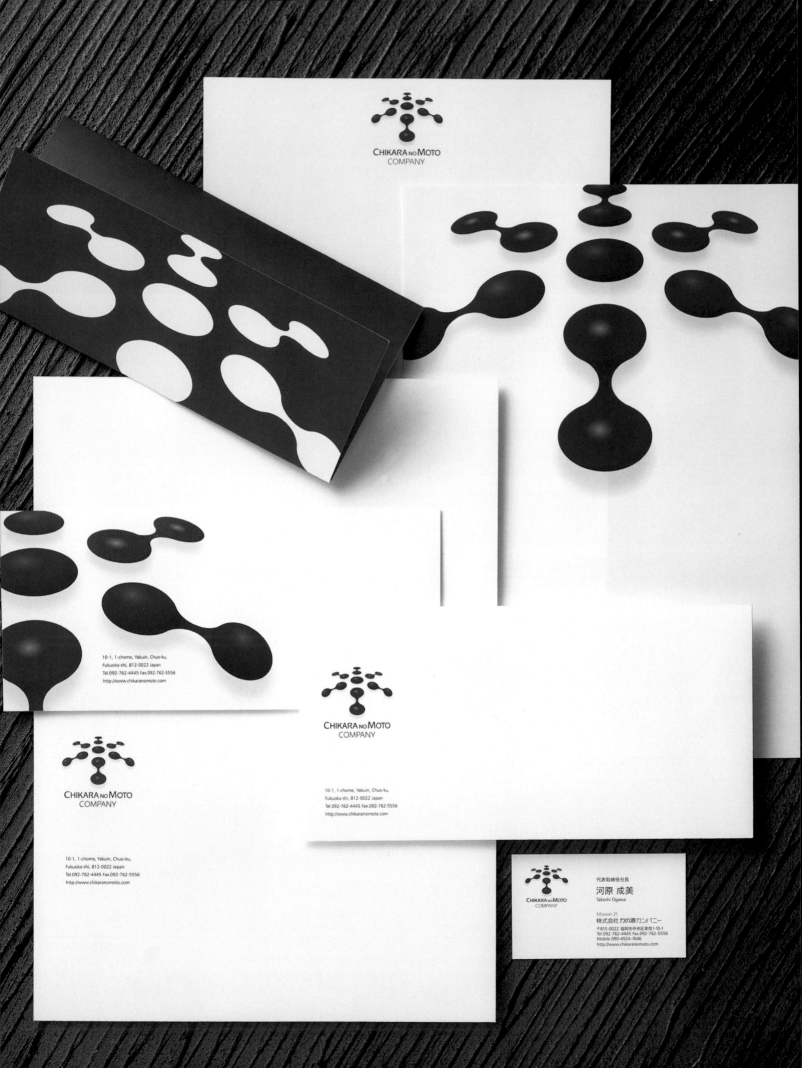

CHIKARA NO MOTO
COMPANY

10-1, 1-chome, Yakuin, Chuo-ku,
Fukuoka-shi, 812-0022 Japan
Tel.092-762-4445 Fax.092-762-5556
http://www.chikaranomoto.com

CHIKARA NO MOTO
COMPANY

10-1, 1-chome, Yakuin, Chuo-ku,
Fukuoka-shi, 812-0022 Japan
Tel.092-762-4445 Fax.092-762-5556
http://www.chikaranomoto.com

CHIKARA NO MOTO
COMPANY

10-1, 1-chome, Yakuin, Chuo-ku,
Fukuoka-shi, 812-0022 Japan
Tel.092-762-4445 Fax.092-762-5556
http://www.chikaranomoto.com

CHIKARA NO MOTO
COMPANY

代表取締役社長
河原 成美
Takeshi Ogawa

Mission 21
株式会社 力の源カンパニー
〒810-0022 福岡市中央区薬院1-10-1
Tel.092-762-4445 Fax.092-762-5556
Mobile 090-4924-1646
http://www.chikaranomoto.com

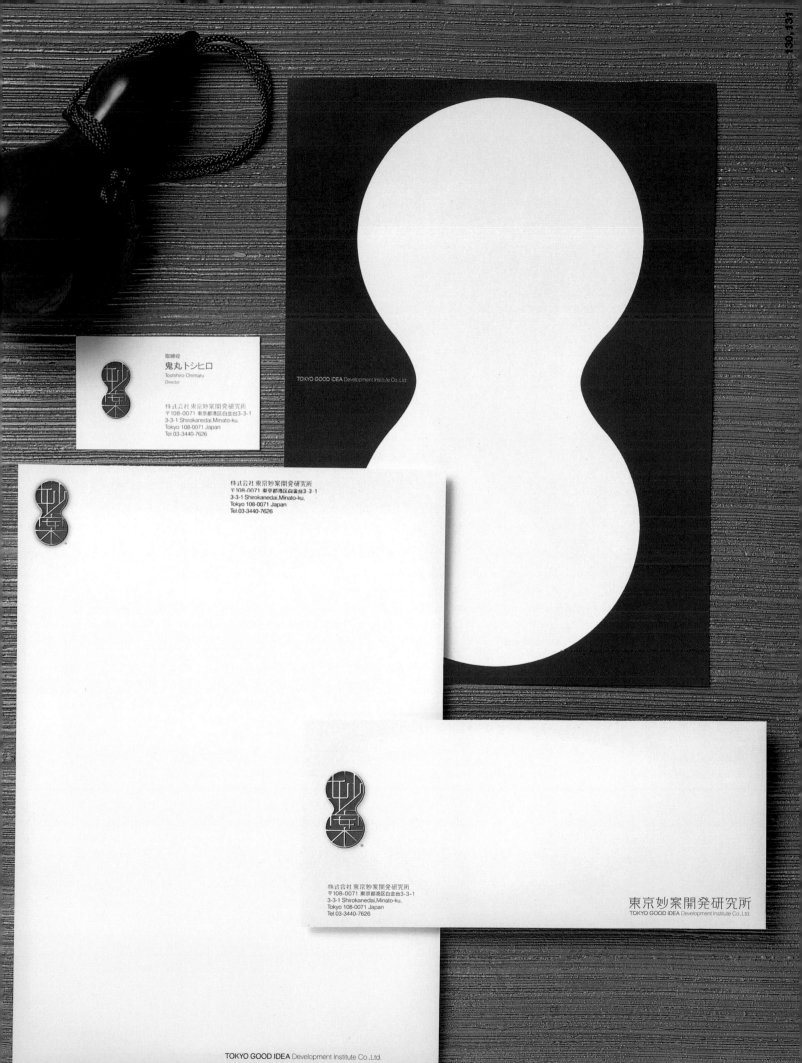

取締役
鬼丸 トシヒロ
Toshihiro Onimaru
Director

株式会社 東京妙案開発研究所
〒108-0071 東京都港区白金台3-3-1
3-3-1 Shirokanedai,Minato-ku,
Tokyo 108-0071 Japan
Tel.03-3440-7626

TOKYO GOOD IDEA Development Institute Co.,Ltd.

株式会社 東京妙案開発研究所
〒108-0071 東京都港区白金台3-3-1
3-3-1 Shirokanedai,Minato-ku,
Tokyo 108-0071 Japan
Tel.03-3440-7626

株式会社 東京妙案開発研究所
〒108-0071 東京都港区白金台3-3-1
3-3-1 Shirokanedai,Minato-ku,
Tokyo 108-0071 Japan
Tel.03-3440-7626

東京妙案開発研究所
TOKYO GOOD IDEA Development Institute Co.,Ltd.

TOKYO GOOD IDEA Development Institute Co.,Ltd.

Graphics & Designing Inc. Tokyo Good Idea Development Institute co.,Ltd.

代表取締役社長
大場 典彦

株式会社 扇屋コーポレーション
東京本社 〒112-0014 東京都文京区関口1-43-5 新目白ビル4F
TEL 03-5155-6926 FAX 03-5155-6372
名古屋事務所 〒450-0002 愛知県名古屋市中村区 名駅5-31-10 リンクス名駅ビル3F
TEL 052-569-8880 FAX 052-569-8881
URL:http://www.o-giya.co.jp
E-Mail:norihiko.ohoba@o-giya.co.jp

Tokyo Branch : 7F Yasuke-Bldg 1-19-6 Sekiguchi,
Bunkyo-ku,Tokyo 112-0014, Japan
TEL:03-5206-7693 FAX:03-5206-7694

OHGIYA CORPORATION

Head Office : 3F Linksmeieki-Bldg 5-31-10 Meieki,
Nakamura-ku,Nagoya, Aichi 450-0002, Japan
TEL:052-569-8880 FAX 052-569-8881
Tokyo Branch : 7F Yasuke-Bldg 1-19-6 Sekiguchi,
Bunkyo-ku,Tokyo 112-0014, Japan
TEL:03-5206-7693 FAX:03-5206-7694

http://www.o-giya.co.jp

http://www.o-giya.co.jp Head Office : 3F Linksmeieki-Bldg 5-31-10 Meieki, Tokyo Branch : 7F Yasuke-Bldg 1-19-6 Sekiguchi,
Nakamura-ku,Nagoya, Aichi 450-0002, Japan Bunkyo-ku, Tokyo 112-0014, Japan
TEL:052-569-8880 FAX:052-569-8881 TEL:03-5206-7693 FAX:03-5206-7694

OHGIYA
CORPORATION

http://www.o-giya.co.jp Head Office : 3F Linksmeieki-Bldg 5-31-10 Meieki, Tokyo Branch : 7F Yasuke-Bldg 1-19-6 Sekiguchi,
Nakamura-ku,Nagoya, Aichi 450-0002, Japan Bunkyo-ku, Tokyo 112-0014, Japan
TEL:052-569-8880 FAX:052-569-8881 TEL:03-5206-7693 FAX:03-5206-7694

OHGIYA
CORPORATION

GRi.D

GRi.D Communications **T 02 6280 0960**
301 Canberra Ave F 02 6280 0970
Fyshwick ACT 2609 E ask@thegrid.net.au
PO Box 7216 www.thegrid.net.au
Canberra BC ACT 2610

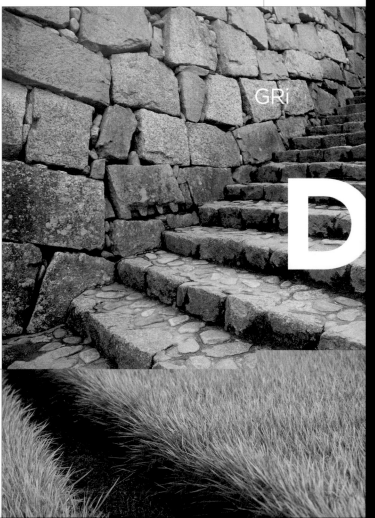

ABN 22 057 797 010

Kathie Griffiths

GRi.D

GRi.D Communications **T 02 6280 0960**
301 Canberra Ave F 02 6280 0970
Fyshwick ACT 2609 M 0438 628 008
PO Box 7216 E kathie@thegrid.net.au
Canberra BC ACT 2610 www.thegrid.net.au

Tanya Grabow

GRi.D

GRi.D Communications **T 02 6280 0960**
301 Canberra Ave F 02 6280 0970
Fyshwick ACT 2609 E tanya@thegrid.net.au
PO Box 7216 www.thegrid.net.au
Canberra BC ACT 2610

Belinda Cooper

GRi.D

GRi.D Communications **T 02 6280 0960**
301 Canberra Ave F 02 6280 0970
Fyshwick ACT 2609 E belinda@thegrid.net.au
PO Box 7216 www.thegrid.net.au
Canberra BC ACT 2610

Liam Camilleri

GRi.D

GRi.D Communications **T 02 6280 0960**
301 Canberra Ave F 02 6280 0970
Fyshwick ACT 2609 E liam@thegrid.net.au
PO Box 7216 www.thegrid.net.au
Canberra BC ACT 2610

ASHUTOSH
PARIKH

LOUDSPEAKER
MANUFACTURERS

ASHUTOSH
PARIKH

LOUDSPEAKER
MANUFACTURERS

MOBILE : 9820006889 ADDRESS : 14 B SAHAKAR DATTMANDIR RD MALAD EAST MUMBAI 400097.

Niket Parekh *Ashutosh parikh*

WORDS AND IDEAS THAT:

provoke convey
clarify urge amuse energize prompt
absorb entice animate engage express narrate inspire activate influence
reconcile motivate convince explain stimulate
focus persuade instigate
connect calm
humor
initiate

612.827.3391
[TIMOTHY HODAPP WRITER]

TIMHODAPP@MAC.COM
WWW.WORDONWORD.COM
116 EAST 49TH STREET
MINNEAPOLIS, MN 55409

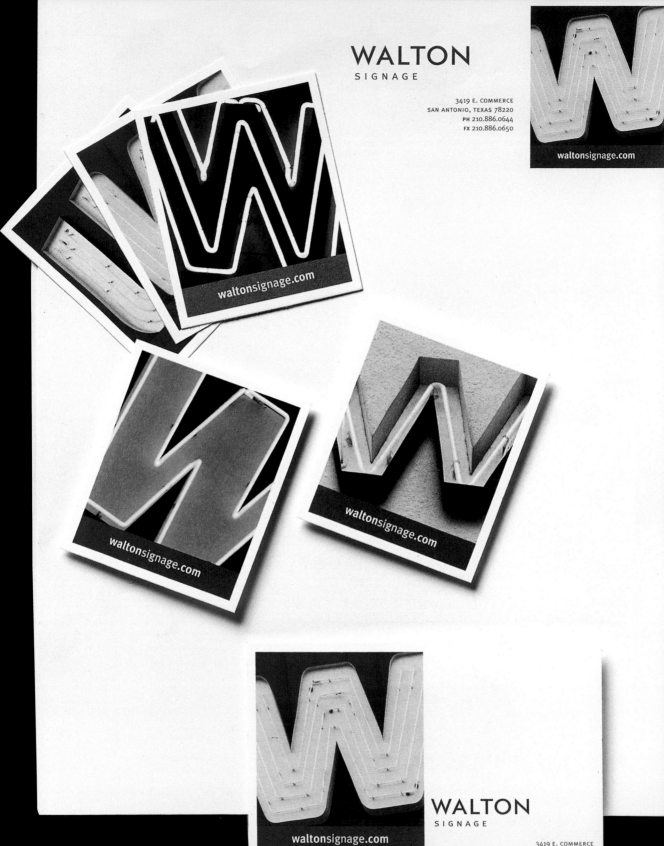

(this page) **The Bradford Lawton Design Group** *Walton Signage* (opposite) **Templin Brink Design** *David Van Dommelen*

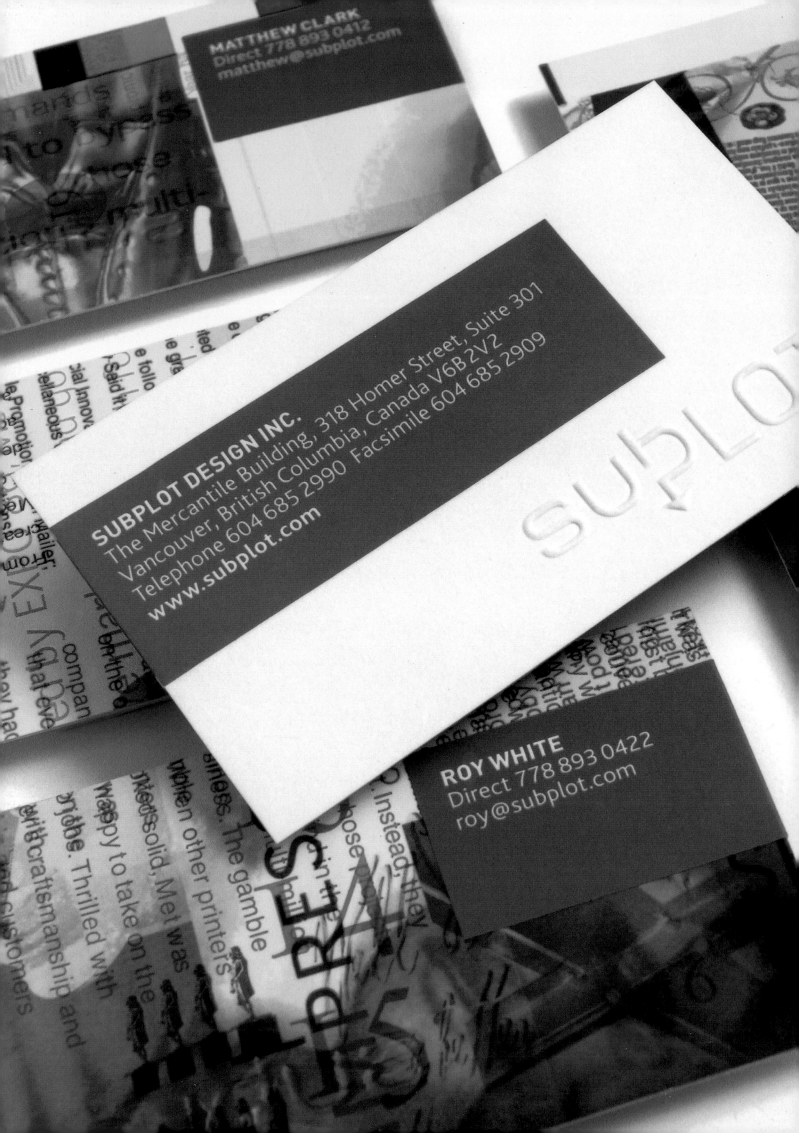

MATTHEW CLARK
Direct 778 893 0412
matthew@subplot.com

SUBPLOT DESIGN INC.
The Mercantile Building, 318 Homer Street, Suite 301
Vancouver, British Columbia, Canada V6B 2V2
Telephone 604 685 2990 Facsimile 604 685 2909
www.subplot.com

subplot

ROY WHITE
Direct 778 893 0422
roy@subplot.com

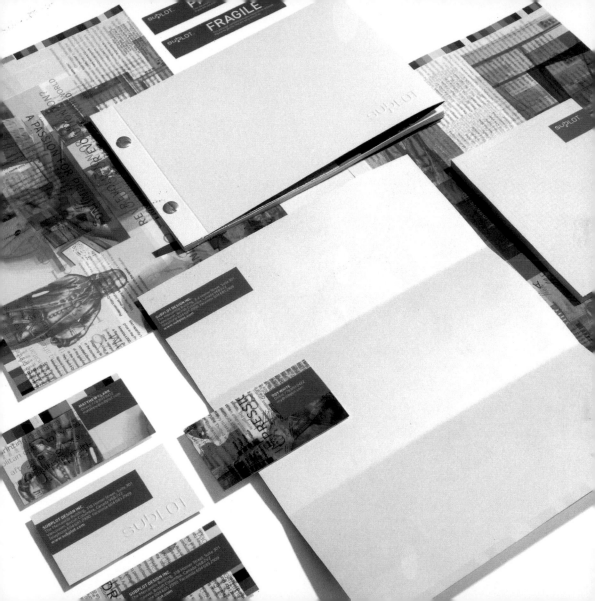

Wink *Copycats*
SullivanPerkins *Food, Friends and Company*
Garfinkel Desin *University of Georgia Office of Public Service and Outreach*
Jeff Pollard Design *Hay Processing Unlimited*
Brad Simon *National Beverage Properties*

[EXPOSUR∃]

Jeff Pollard Design *National Safe Tire Coalition*
Travis Ott *Double Dutch*
The Bradford Lawton Design Group *Frontier Enterprises, inc*
Giorgio Baravalle *TUFTS University*
The Bradford Lawton Design Group *American Advertising Federation San Antonio*

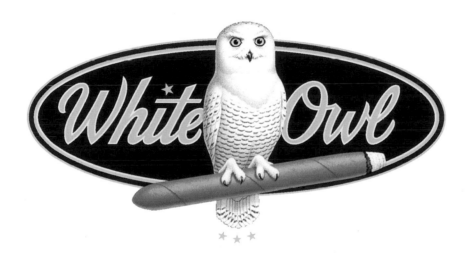

Graphics & Designing Inc.
VIA Holdings Inc.
Chikara no Moto Company
Mercian Copration
Nihon System Inc.
Ohgiya Corporation

KittyKombat Design Studio *Gerda Hofstatter*
The Design Studio of Steven Lee *HotSteel*
Mucca Design *Raymond and Shawn Tang*
Ford Weithman Design *Adidas*
DarbyDarby Creative *Starvn Artist*

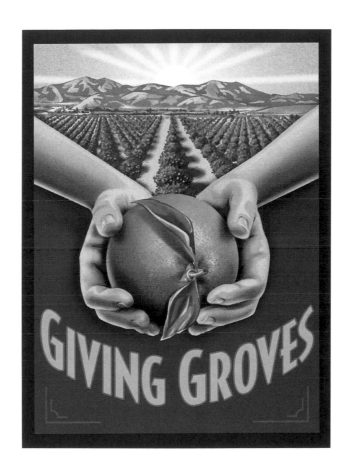

north island

SEYCHELLES

TRUCKS

north island

SEYCHELLES

Duffy & Partners *Duffy & Partners*
Enterprise IG Johannesburg South Africa *Wilderness Safaris*
Duffy & Partners *Toyota*
Enterprise IG Johannesburg South Africa *Wilderness Safaris*
Duffy & Partners *St. Paul Travelers*

Jeff Pollard Design *Laughing Planet*
Jeff Pollard Design *Purebred Productions*
Origin Design *Lingenfelter*
Grafik *Market Salamander*
Pentagram *Picture Licensing Universal System*

Roberts & Co *Fiona Cairns Ltd*

laugh. lounge. taste. chat. quench. listen. live full.
a meal is a whole lot more than food on a fork.

HOULIHAN'S

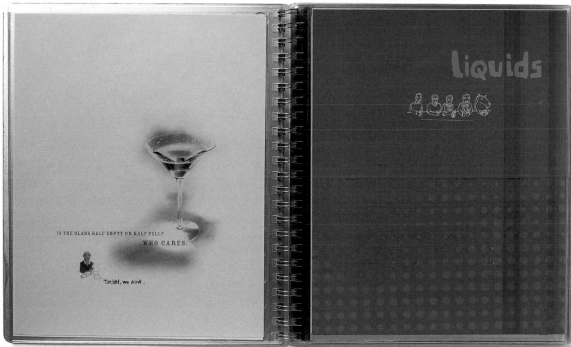

IS THE GLASS HALF EMPTY OR HALF FULL?
WHO CARES.

Tonight, we drink.

liquids

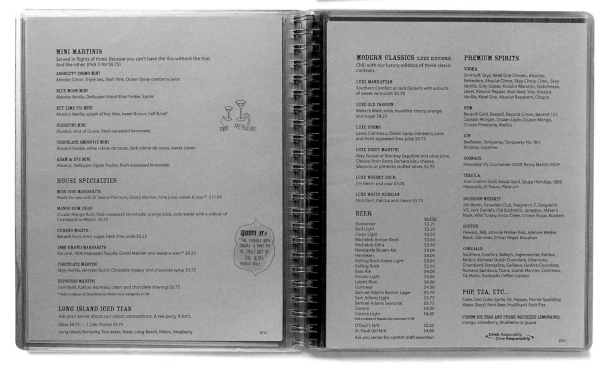

MINI MARTINIS
Served in flights of three. Because you can't have the this without the that.
And the other. (Pick 3 for $6.75)

ABSOLUT® COSMO MINI
Absolut Citron, Triple Sec, fresh lime, Ocean Spray cranberry juice

BLUE MOON MINI
Absolut Vanilia, DeKuyper Island Blue Pucker, Sprite

KEY LIME PIE MINI
Absolut Vanilia, splash of key lime, sweet & sour, half & half

GUAVATINI MINI
Absolut, shot of Guava, fresh-squeezed lemonade

CHOCOLATE SMOOOVIE MINI
Absolut Vanilia, white crème de cacao, dark crème de cacao, sweet cream

ADAM & EVE MINI
Absolut, DeKuyper Apple Pucker, fresh-squeezed lemonade

HOUSE SPECIALTIES

MIOS DIOS MARGARITA
Made for two with El Tesoro Platinum, Grand Marnier, lime juice, sweet & sour * $11.95

MANGO RUM DROP
Cruzan Mango Rum, fresh-squeezed lemonade, orange juice, soda water with a sidecar of Chambord or Midori $5.75

CUBANO MOJITO
Bacardi Rum, mint, sugar, fresh lime, soda $5.25

1800 GRAND MARGARITA
For one. 1800 Reposado Tequila, Grand Marnier and sweet-n-sour * $6.25

CHOCOLATE MARTINI
Skyy Vanilla, Vermeer Dutch Chocolate liqueur and chocolate syrup $5.75

ESPRESSO MARTINI
Stoli Vanil, Kahlua, espresso, cream and chocolate shavings $5.75

* Add a sidecar of Chambord or Midori to a margarita $1.99

LONG ISLAND ICED TEAS
Ask your server about our classic concoctions. A tea party it isn't.

Glass $4.75 ... 1 Liter Pitcher $5.75

Long Island, Kentucky, Tennessee, Texas, Long Beach, Melon, Raspberry

MODERN CLASSICS (LUXE EDITIONS)
Chill with our luxury editions of these classic cocktails.

LUXE MANHATTAN
Southern Comfort or Jack Daniel's with a touch of sweet vermouth $5.75

LUXE OLD FASHION
Maker's Mark, soda, muddled cherry, orange and sugar $6.25

LUXE COSMO
Level, Cointreau, Ocean Spray cranberry juice and fresh squeezed lime juice $6.75

LUXE DIRTY MARTINI
Grey Goose or Bombay Sapphire and olive juice. Choose from Santa Barbara bleu cheese, jalapeno or pimento stuffed olives $6.75

LUXE WHISKY SOUR
Jim Beam and sour $4.75

LUXE WHITE RUSSIAN
Stoli Vanil, Kahlua and cream $5.75

BEER

	bottle
Budweiser	$3.25
Bud Light	$3.25
Coors Light	$3.25
Michelob Amber Bock	$3.50
Michelob Ultra	$3.50
Newcastle Brown Ale	$4.00
Heineken	$4.00
Rolling Rock Green Light	$3.50
Rolling Rock	$3.50
Bass Ale	$4.00
Amstel Light	$4.00
Labatt Blue	$4.00
Guinness	$4.00
Samuel Adams Boston Lager	$3.75
Sam Adams Light	$3.75
Samuel Adams Seasonal	$3.75
Corona	$4.00
Corona Light	$4.00

Add a sidecar of Tequila with your beer $1.99

O'Doul's N/A	$3.25
St. Pauli Girl N/A	$4.00

Ask you server for current draft selection

PREMIUM SPIRITS

VODKA
Smirnoff, Skyy, Ketel One Citroen, Absolut, Belvedere, Absolut Citron, Skyy Citrus, Ciroc, Skyy Vanilla, Grey Goose, Absolut Mandrin, Stolichnaya, Level, Absolut Peppar, Stoli Vanil, Vox, Absolut Vanilia, Ketel One, Absolut Raspberri, Chopin

RUM
Bacardi Gold, Bacardi, Bacardi Limon, Bacardi 151, Captain Morgan, Cruzan Light, Cruzan Mango, Cruzan Pineapple, Malibu

GIN
Beefeater, Tanqueray, Tanqueray No. Ten, Bombay Sapphire

COGNACS
Hennessy VS, Courvoisier VSOP, Remy Martin VSOP

TEQUILA
Jose Cuervo Gold, Sauza Gold, Sauza Hornitos, 1800 Reposado, El Tesoro Platinum

BOURBON/WHISKEY
Jim Beam, Canadian Club, Seagram's 7, Seagram's VO, Jack Daniel's, Old Bushmills, Jameson, Maker's Mark, Wild Turkey, Knob Creek, Crown Royal, Bookers

SCOTCH
Dewars, J&B, Johnnie Walker Red, Johnnie Walker Black, Glenlivet, Chivas Regal, Macallan

CORDIALS
Southern Comfort, Bailey's, Jagermeister, Kahlua, Midori, Vermeer Dutch Chocolate, Disarrono, Chambord, Frangelico, Galliano, Godiva Chocolate, Romana Sambuca, Tuaca, Grand Marnier, Cointreau, Tia Maria, Starbucks Coffee Liqueur

POP, TEA, ETC...
Coke, Diet Coke, Sprite, Dr. Pepper, Perrier Sparkling Water, Barq's Root Beer, Houlihan's Fruit Fizz

FUSION ICE TEAS AND FRESH SQUEEZED LEMONADES:
mango, strawberry, blueberry or guava

Drink Responsibly.
Drive Responsibly.

(this spread) **Arnold Worldwide** *Houlihan's Restaurants, Inc*

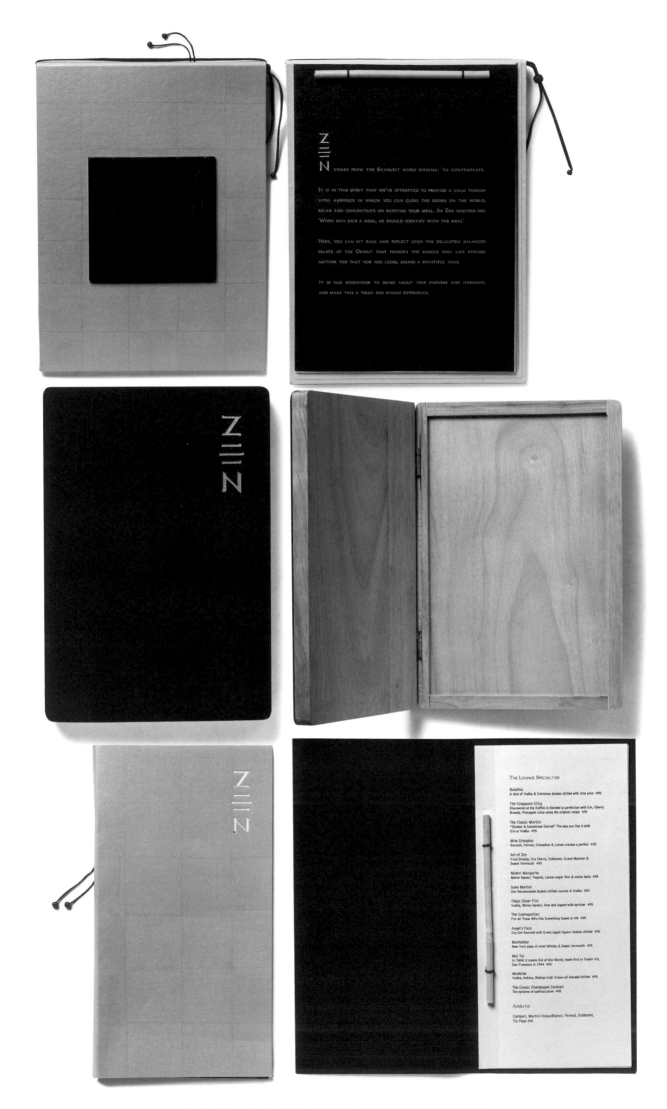

Design Temple Pvt, Ltd. *HOTEL LEELAVENTURE LTD.*

handmade tofu & yuba

BAMBOO-STEAMED TOFU & MOUNTAIN YAM *with crab sauce* 9

FRESH YUBA SASHIMI . 9

DEEP-FRIED YUBA *and eel age-dashi* 10

DEEP FRIED YUBA *and conger eel rolls stuffed with melted cheese* 10

FRESHLY-MADE SCOOPED TOFU	
warm served with homemade ponzu and soy milk, chilled zaru served with salt and condiments	*available nightly at* 6:00, 7:30, 9:00, 10:30 and 12:00 **6**

small cold dishes & salads

DASHI-SOAKED EDAMAME . 5

RAW TUNA and AVOCADO SALAD *with wasabi soy dressing* 8

GRILLED EGGPLANT and UNI *in mustard sauce* 7

"DEVIL'S TONGUE" KONNYAKU SASHIMI 10

JULIENNED BURDOCK ROOT *in lightly spicy soy* 5

EN HOUSE SALAD *of yuba, walnuts and mizuna* 8

CREAMY AVOCADO and BABY SHRIMP SALAD *with shichimi pepper* 8

STEAMED CHICKEN and MUSHROOM SALAD 9

FRESH CABBAGE CRUDITÉ *with assorted EN house miso dips* 13

JUMBO SHRIMP SHABU-SHABU *with spicy sesame dipping sauce* 12

"OMAKASE" TASTING MENUS *by reservation only*		
menu one: 6,0	*menu two:* 8 0	*menu three:* 1 0 0

small hot dishes

NAMA-FU BROILED *with miso paste* 9

SOFT ROLLED DASHI-MAKI OMELET *with crab and mitsuba* 8

EN ORIGINAL CHICKEN SAUSAGE *and poached egg* 7

MOCHI CROQUETTE *filled with sautéed duck and potato* 8

SHRIMP FRITTERS *deep fried with salt* 10

GIN-MUTSU SEA BASS *marinated and deep-fried* 10

CRISPY FRIED CHICKEN *with aromatic rock salt* 10

GRILLED SQUID *with uni miso* . 9

FRESH TUNA SAUTÉ *with shaved dried bonito* 12

PLUMP SOY-SAUTEED OYSTERS *on a bed of watercress* 13

large dishes from the grill & kitchen

STONE GRILLED ORGANIC CHICKEN 13

STONE GRILLED THICK-SLICED BEEF TONGUE 15

FOIE GRAS and POACHED DAIKON STEAK *with white miso-vinegar* 16

SAIKYO MISO GRILLED BLACK COD 12

SEARED MARINATED CHU-TORO *in garlic soy* 18

SAUTÉED DUCK BREAST *with grated daikon in ponzu citrus soy* 16

PORK SHOULDER GRILLED *with sake-kasu and miso* 14

STONE GRILLED WAGYU *with yuzu citrus soy* 24

ASSORTED SEASONAL TEMPURA 17

HOT POT of EN CHICKEN MEATBALLS and *daikon (for at least 2)* 10/person

BERKSHIRE PORK BELLY *braised in sansho miso* 12

DEEP FRIED RED SNAPPER *simmered in soy* 10

rice and noodle dishes

please allow 40 minutes for all rice hot pot dishes

RICE POT *with salmon and salmon roe* 18

RICE POT *cooked with fresh crab meat* 20

GRILLED ONIGIRI RICE BALLS *with takana and jyako (2 pieces)* 6

EN HOUSE SPECIAL GARLIC FRIED RICE 7

CHILLED SOBA NOODLES *with warm duck dipping broth* 11

DAILY MISO SOUP . 5

sushi rolls

SALMON and AVOCADO ROLL . 15

CONGER EEL and CREAM CHEESE ROLL 15

FRIED SHRIMP and TARTAR SAUCE ROLL 13

SPICY CHU-TORO SCALLION and OKRA ROLL 15

CRISPY CRAB TEMPURA ROLL . 17

sashimi *6 pieces*

CHU-TORO 16

KANPACHI YELLOWTAIL . . . 11

SALMON 9

YELLOW JACK 13

OYSTERS *on the half shell* 15

ASSORTED SASHIMI *9 pieces* . . . 20

15 pieces 28

35 pieces 40

sushi

NIGIRI SUSHI SET

for 2-3 people 22

for 4-5 people 30

CHEF'S CHOICE NIGIRI SUSHI SET *for two* 38

MARCH SPECIALS						
DISHES	FLOURLESS OKONOMIYAKI 8 *with mountain yam, shrimp & cabbage*	**SAKE**	CHIYO MUSUBI *Rich and elegant with a sharp aftertaste Goes well with seafood, crab, yellowtail*	**COCKTAILS**	CUCUMBER MARTINI *Hendrix Gin chilled and served with thinly sliced cucumbers, topped with sea salt*	
	BAMBOO STEAMED SALMON 8 *and mushroom Napoleon*		glass 8 / bottle 60		12	
	EDAMAME TOFU 8		HO-YO *Silky smooth, elegant and fruity with fragrance of Japanese pear*		TOKYO MANHATTAN *Blanton Whiskey, Plum Wine, brandied plum, and bourbon charred orange twist*	
	BEEF TONGUE HOT POT 8					
	PORK and POTATO CROQUETTES 8		glass 7 / bottle 50		12	

CHEFS: *Koji Nakano and Yasuhiro Honma*

EN

(clockwise from top) **Kelly English** *Go Jazz;* **Tonka Lujanac** *Vatra;* **Yannick Desranleau, Chloe Lum** *Seripop;* ***Bryan Peterson*** *Red House Records*

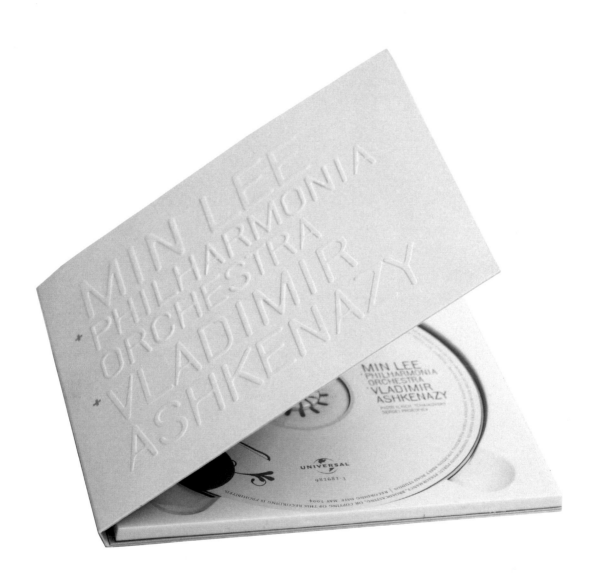

VERTIKAL premium vodka. 700ml e, alc 40% vol.

+ made with highest quality natural spring water vodavoda from banja vrnjci source. bottled by si&si company product of serbia and montenegro.

(opposite) **Suncica** *Arteska International Company*, (this page) **Landor Associates** *SKYY*

Deisgnworks Enterprise IG *Diageo*

Di Donato Associates *Barton Brands, Ltd.*

(this page) **Ceradini Design Inc** *Heublein Inc.,* (opposite) **Identica** *Russian standard*

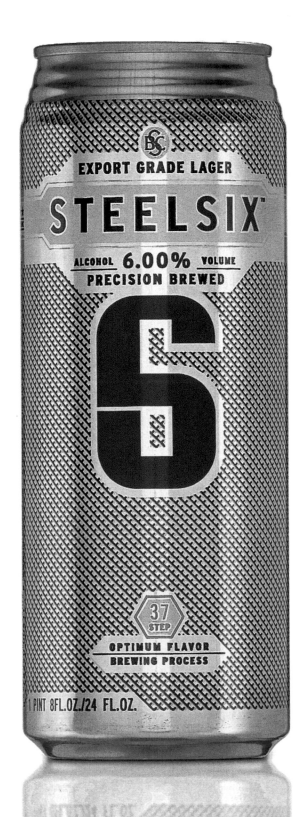

Turner Duckworth *McKenzie River*

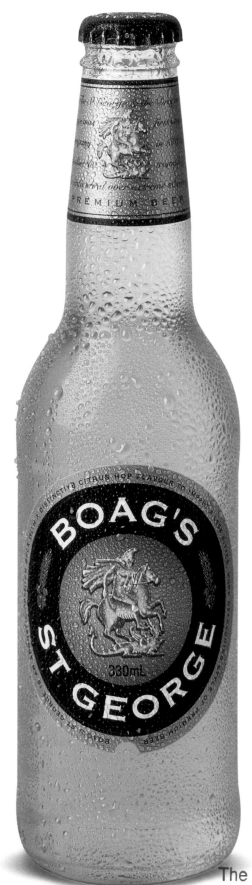

Perks Design Partners *J Boag & Son*

MERCIAN

GRAN
Fruits

One hard day is coming to an end at last. I'm lost in thought, looking back on what has happened today surrounded by favorite books and goods, I can return to "myself". This is a fruit wine that enhances happy mood of your important "my own time".

MUSCAT on CHARDONNAY
マスカット on シャルドネ

果実酒 500ml
メルシャン株式会社製造

MERCIAN

GRAN
Fruits

One hard day is coming to an end at last. I'm lost in thought, looking back on what has happened today surrounded by favorite books and goods, I can return to "myself". This is a fruit wine that enhances happy mood of your important "my own time".

GRAPEFRUIT on CHARDONNAY
グレープフルーツ on シャルドネ

果実酒 500ml
メルシャン株式会社製造

MERCIAN

GRAN
Fruits

The hard day is coming to an end at last. I'm lost in thought, looking back on what has happened today surrounded by favorite books and goods, I can return to your important "my own time".

ROSE HIPS on CHARDONNAY
ローズヒップ on シャルドネ

果実酒 500ml
メルシャン株式会社製造

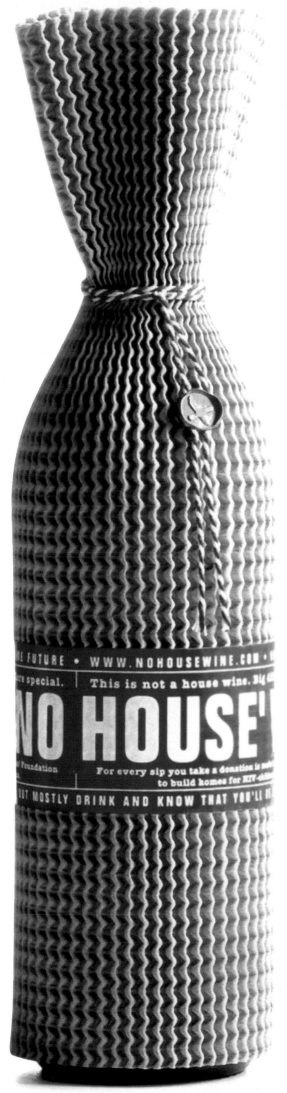
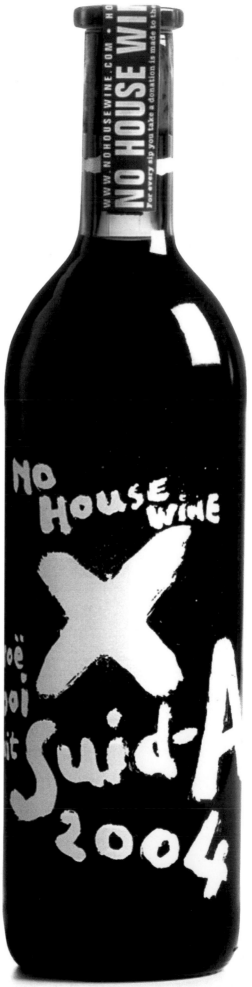

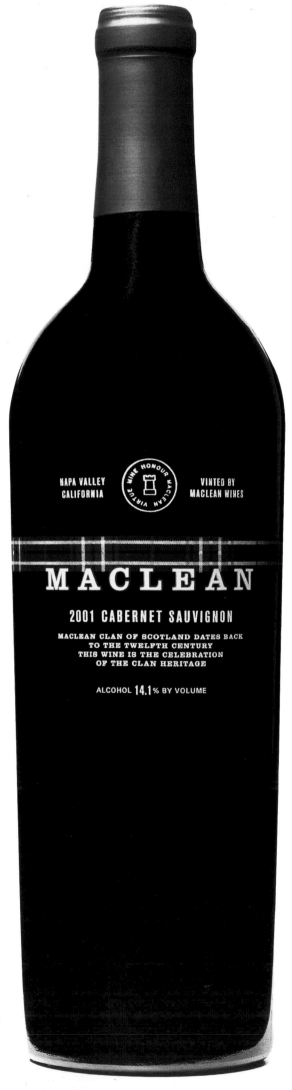

**NAPA VALLEY
CALIFORNIA**

WINE HONOUR MACLEAN VIRTUE

**VINTED BY
MACLEAN WINES**

MACLEAN

2001 CABERNET SAUVIGNON

MACLEAN CLAN OF SCOTLAND DATES BACK
TO THE TWELFTH CENTURY
THIS WINE IS THE CELEBRATION
OF THE CLAN HERITAGE

ALCOHOL **14.1**% BY VOLUME

(this spread) **Templin Brink Design** *MacLean Winery*

6x750 ML

NAPA VALLEY
CALIFORNIA

VINTED BY
MACLEAN WINES

MACLEAN

2001 CABERNET SAUVIGNON

MACLEAN CLAN OF SCOTLAND DATES BACK TO THE TWELFTH CENTURY
THIS WINE IS THE CELEBRATION OF THE CLAN HERITAGE

ALCOHOL 14.1% BY VOLUME

4.5 W.L.

NAPA VALLEY
CALIFORNIA

VINTED BY
MACLEAN WINES

MACLEAN

2001 CABERNET SAUVIGNON

LEAN CLAN OF SCOTLAND DATES BACK TO THE TWELFTH CENTURY
THIS WINE IS THE CELEBRATION OF THE CLAN HERITAGE

ALCOHOL 14.1% BY VOLUME

4.5 W.L.

/50 ML

Glu**Stitch**™

WOUND CLOSURE FORMULATION	2-Octyl-Cyanoacrylate

Preferred Storage	See instructions for use
Below 5°C	Glustitch Is Trade Mark of Glustitch Inc, Canada Glustitch Is Approved By Health Canada

Please tear along this line

Glu**Stitch**
WOUND CLOSURE FORMULATION
2-Octyl-Cyanoacrylate

Glustitch Is Trade Mark of Glustitch Inc. Canada
Glustitch Is Approved By Health Canada

GRAPHITE
DEODORANT BODY SPRAY
GAMMA / 100g

GRAPHITE
DEODORANT BODY SPRAY
SKULL / 100g

GRAPHITE
DEODORANT BODY SPRAY
FLAME / 100g

GRAPHITE
DEODORANT BODY SPRAY
CAUTION / 100g

GRAPHITE
DEODORANT BODY SPRAY
BOLT / 100g

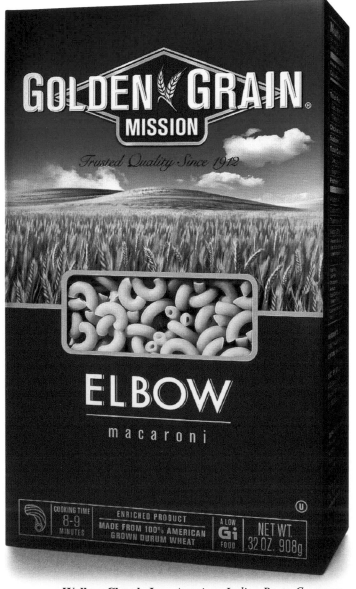

Wallace Church, Inc. *American Italian Pasta Company*

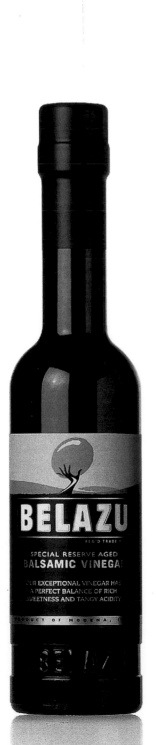
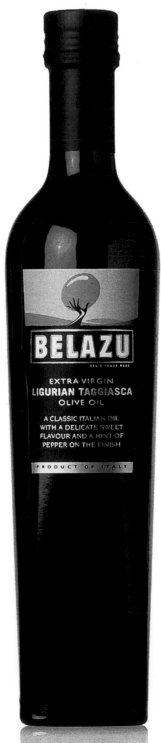
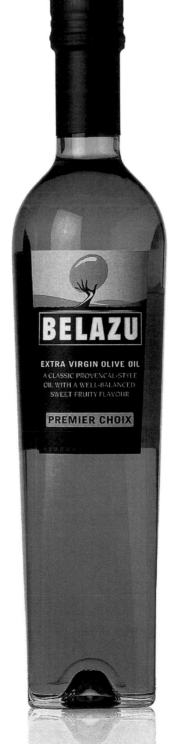
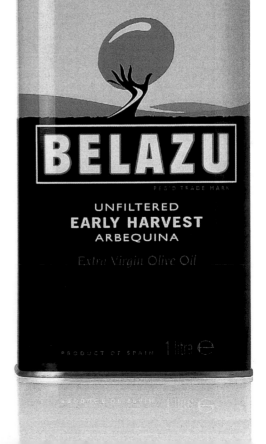

Turner Duckworth *Belazu*

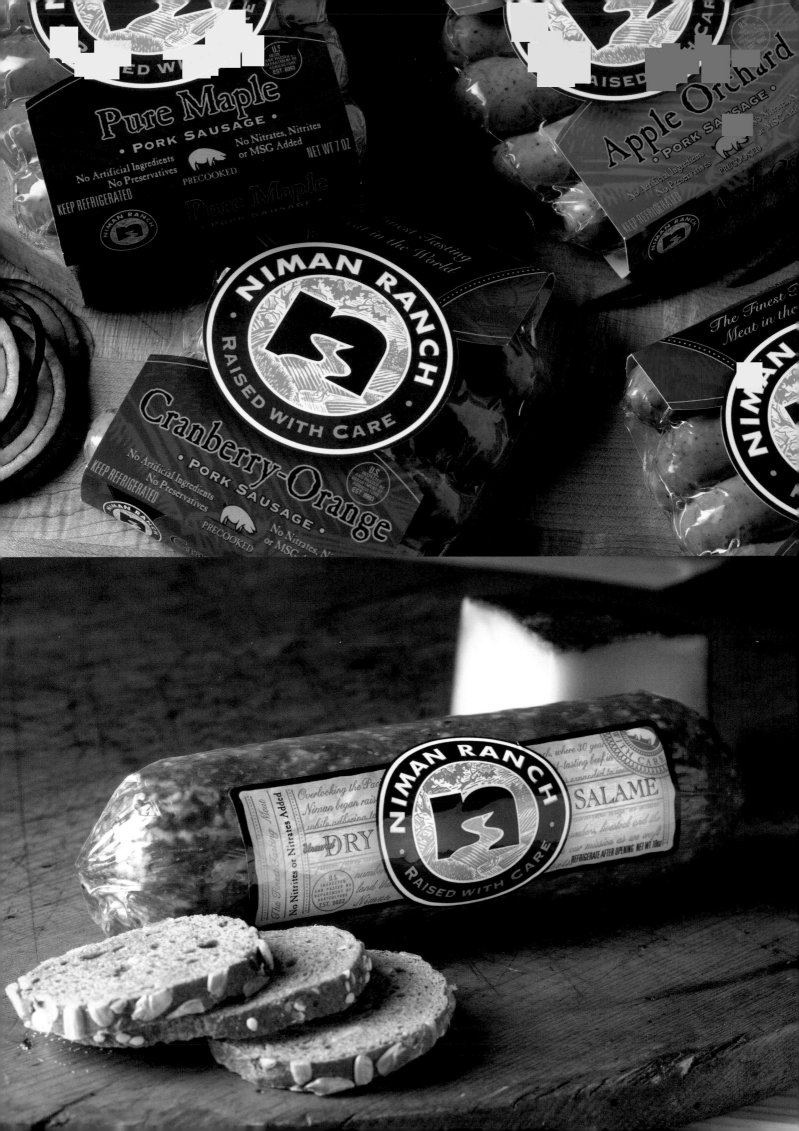

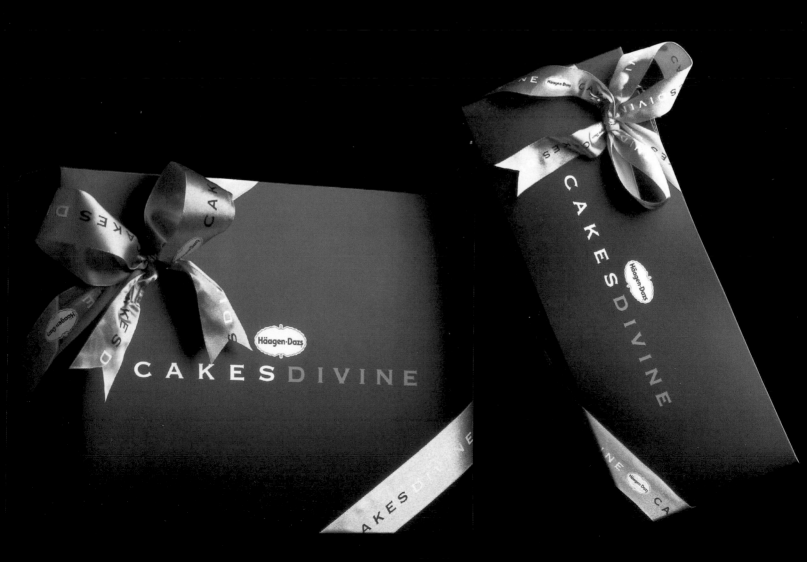

(opposite) **zeist design, llc** *Niman Ranch,* (this page) **Jae Soh** *Haagen Dazs*

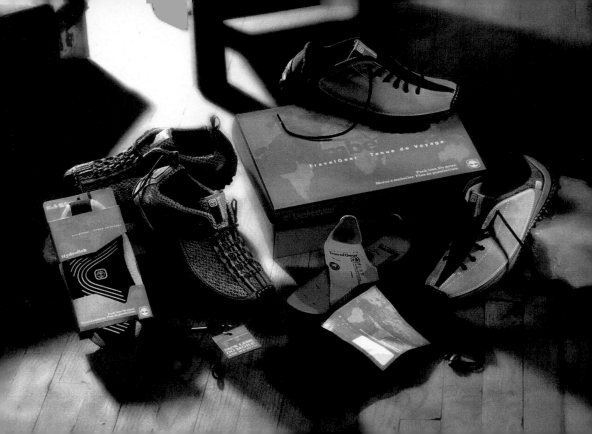

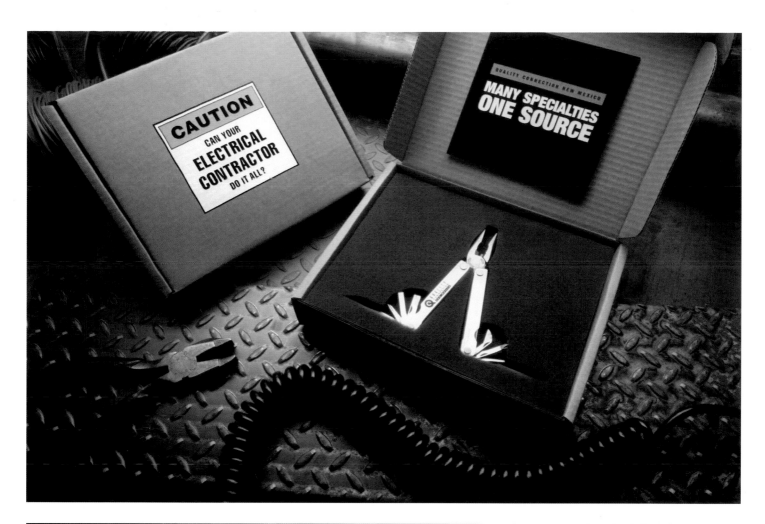

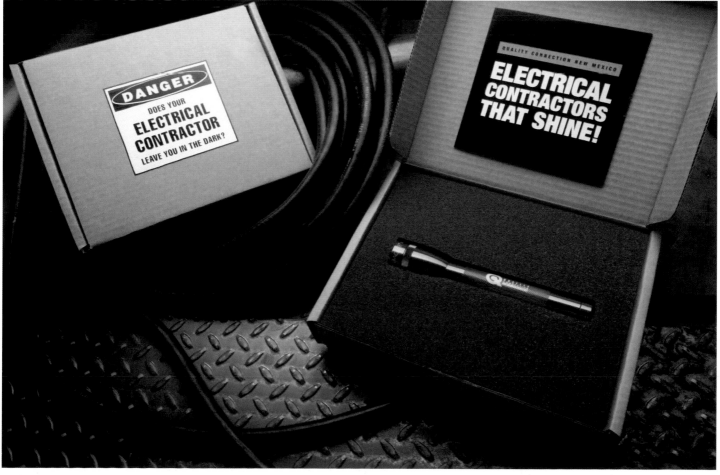

Kilmer & Kilmer Brand Consultants *Quality Connection of New Mexico*

Glacier by Arctic Paper
MUNKEN ONE • ARCTIC INE VOLUME, 300g/m²
CETTE FACE EST DU MUNKEN LYNX

Glacier by Arctic Paper
MUNKEN PURE • MUNKEN ONE, 300g/m²
CETTE FACE EST DU MUNKEN LYNX

Glacier™

Le papier qui fait recette !

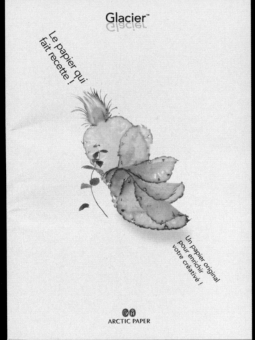

Un papier original pour enrichir votre créativé !

ARCTIC PAPER

Glacier by Arctic Paper
MUNKEN PURE • MUNKEN LYNX, 300g/m²
CETTE FACE EST DU MUNKEN PURE

Glacier by Arctic Paper
MUNKEN PURE • MUNKEN ONE, 300g/m²
CETTE FACE EST DU MUNKEN PURE

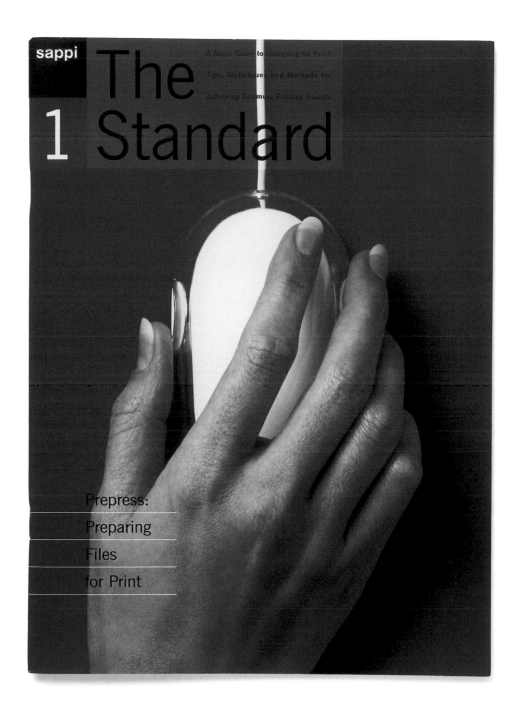

sappi

The
Standard

1

A Sappi Guide to Designing for Print:
Tips, Techniques and Methods for
Achieving Optimum Printing Results

Prepress:

Preparing

Files

for Print

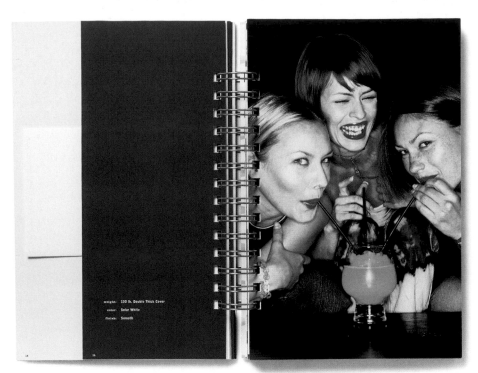

weight: 130 lb. Double Thick Cover
color: Solar White
finish: Smooth

N
NEENAH PAPER

Less time specifying paper
means more time for design.
Classic Crest® Paper:
all you need to communicate.

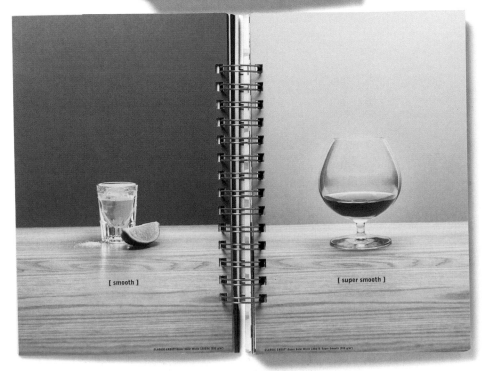

[smooth]

[super smooth]

NEENAH PAPER

NEENAH | bound.

1.

§ CHAPTER §

GETTING STARTED:
IMAGES ON PAPER

PICTURES, PAPER, AND YOUR PROJECT | Words and pictures on paper. In the business of communication, it doesn't get much simpler than that. But the relationship between message and medium should not be underestimated. For just as breathtaking images can incite an emotional response, the right paper can serve as the platform on which pictures can perform. So, which comes first, the picture or the paper? The answer is "both." And ultimately, it goes back to your main idea. What do you want to communicate? What image do you want to project? In this chapter, we'll demonstrate how an uncoated paper like Cougar Opaque can help you convey your ideas in ways that you might not have thought possible. Furthermore, you'll discover that Cougar Opaque performs as well as text & cover papers. You'll also learn how to choose the best available photography for uncoated. And for those of you who excel in chemistry (or who at least appreciate chemical references), you'll see how elements like paper color and surface texture combine to yield an impressive reaction.

*Photos
+Paper
Reaction*

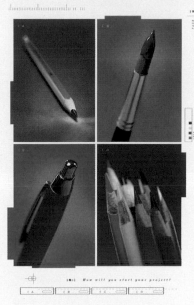

1D1 *How will you start your project?*

| 1 A | 1 B | 1 C | 1 D |

Spring Break

RULES!

2.

§ CHAPTER §

INK

WHAT YOU SEE IS NOT ALWAYS WHAT YOU GET | Any study of printing on uncoated paper begins with ink. After all, ink behaves differently on every paper, whether coated or uncoated. That's why Cougar Opaque has been designed with a consistent surface that can actually help inks perform at their peak.

The industry standard for producing "full color" images is 4-color process, or CMYK. Using combinations of cyan (C), magenta (M), yellow (Y), and black (K), it's possible to achieve a wide spectrum of colors. In recent years, the 4-color process has been modified by the addition of two more ink colors: orange and green. This Hexachrome® (or "six color") method can reproduce a broader color range, and works well in situations where images need some extra "punch." Hexachrome printing typically produces cleaner, less "muddy" photography. In Book Three, we'll discuss ultraviolet (UV) printing, which runs even cleaner. Finally, spot colors such as PMS and Japanese Toyo inks are single hues used for solid coverage and halftone photo reproduction.

Ultimately, there are as many ways to print on uncoated paper as there are ink combinations. So to see what's possible on Cougar Opaque, it just takes knowing how to apply the right ink — and a little common sense.

*4-COLOR PROCESS
HEXACHROME
SPOT
PANTONE
TOYO*

*DO THE COLORS
CHANGE ON
UNCOATED PAPER?*

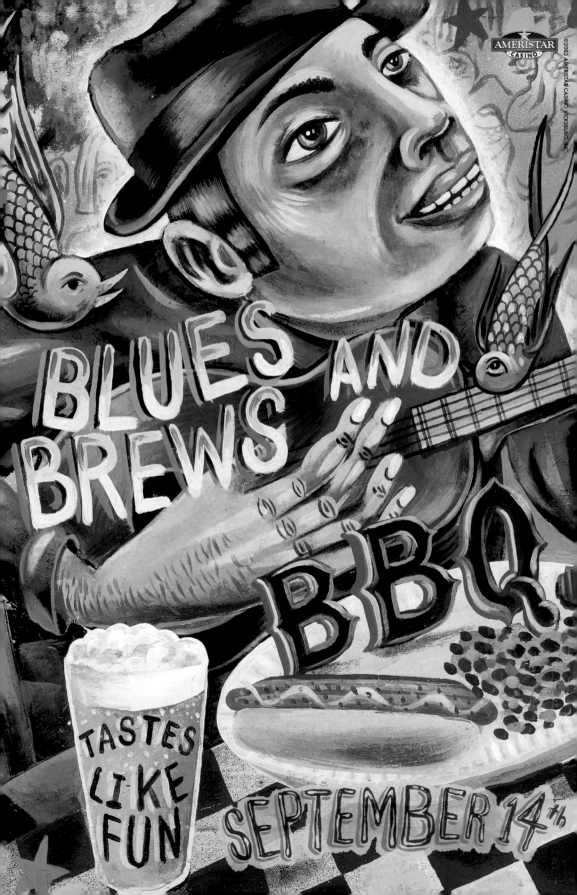

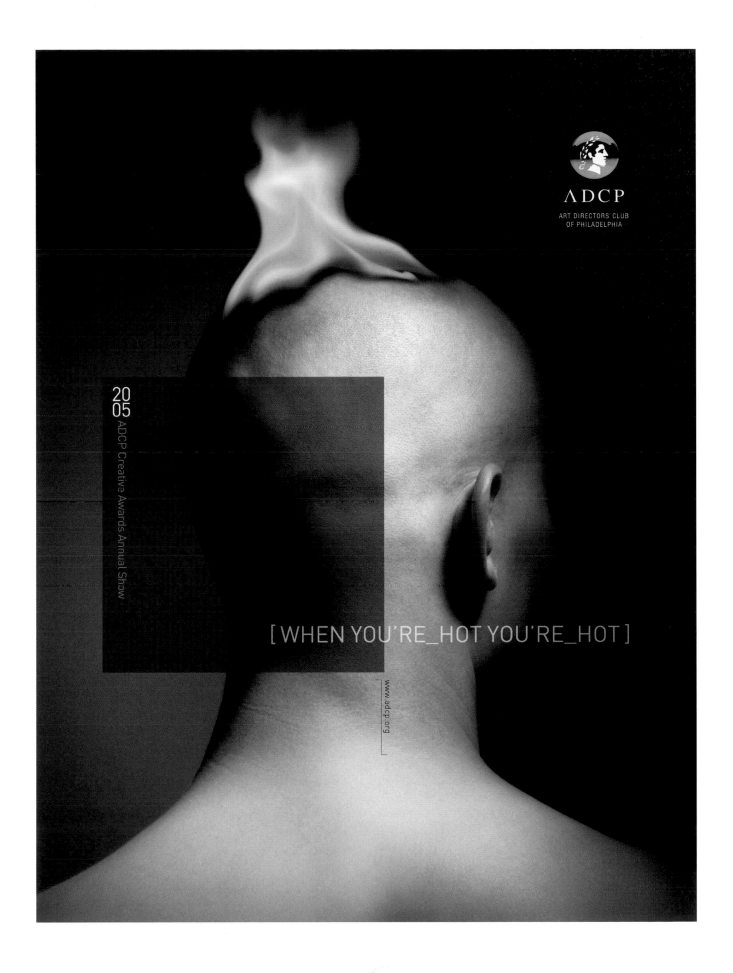

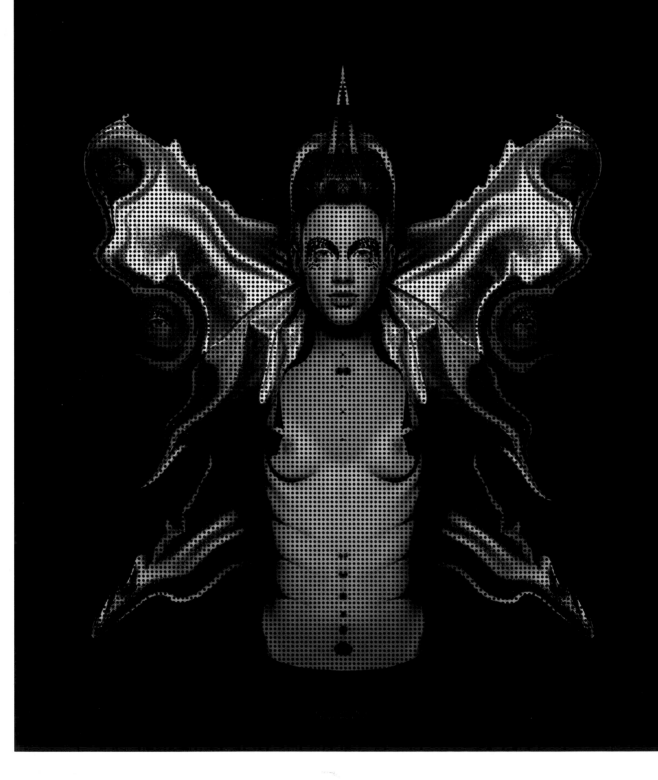

3 Deep Design *Poster Australasia Pty Ltd*

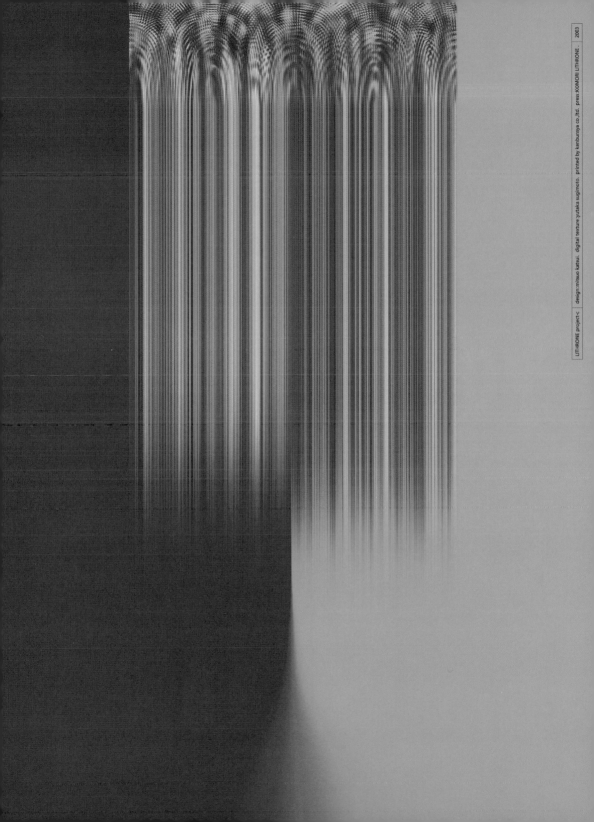

LITH-RONE project< | design:mitsuo katsui. digital texture:yutaka sugimoto. printed by kenburaya co.,ltd. press:KOMORI LITHRONE. 2003

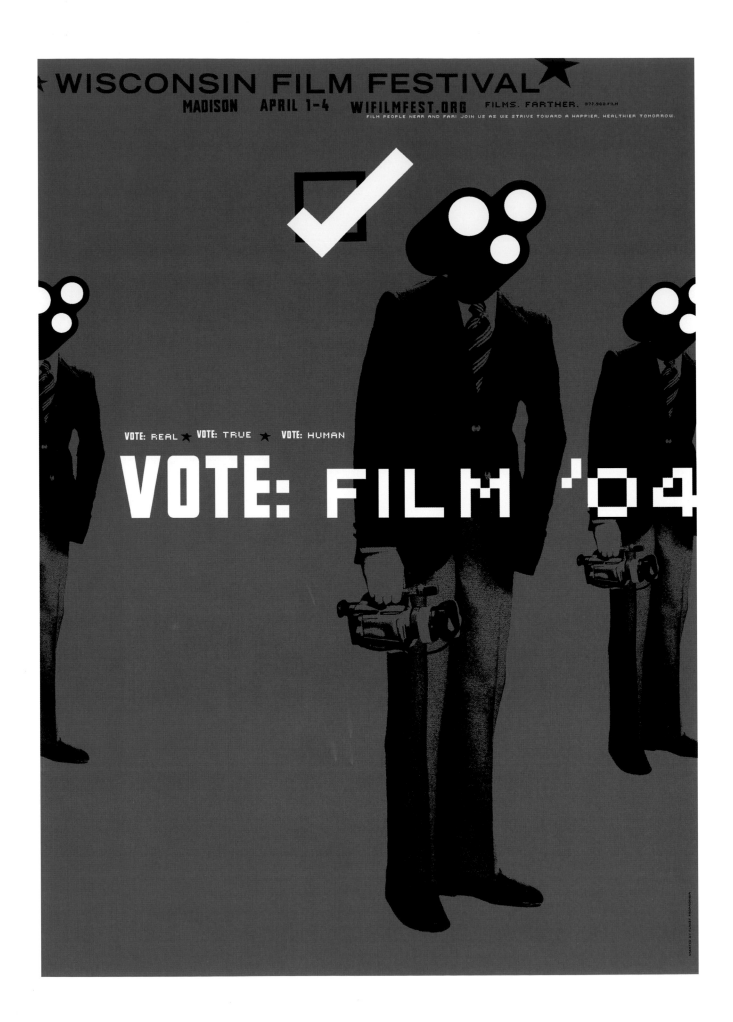

Travis Ott *Wisconsin Film Festival*

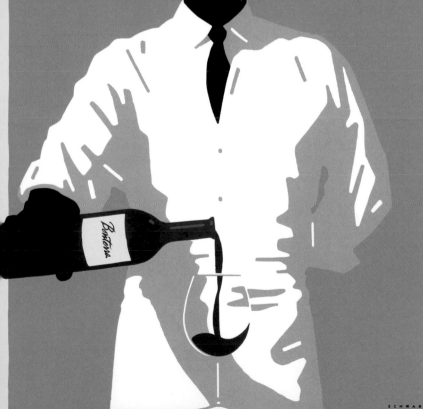

BONTERRA
V I N E Y A R D S

SCHWAB

100% ORGANICALLY GROWN GRAPES

**BRIDGEHAMPTON
CHAMBER
MUSIC FESTIVAL**
21ST SEASON
MARYA MARTIN
ARTISTIC DIRECTOR
2004
JULY 28 – AUGUST 21

FOR TICKET INFORMATION
212 741 9403 OR 631 537 6368
VISIT US AND ORDER TICKETS
ONLINE AT WWW.BCMF.ORG

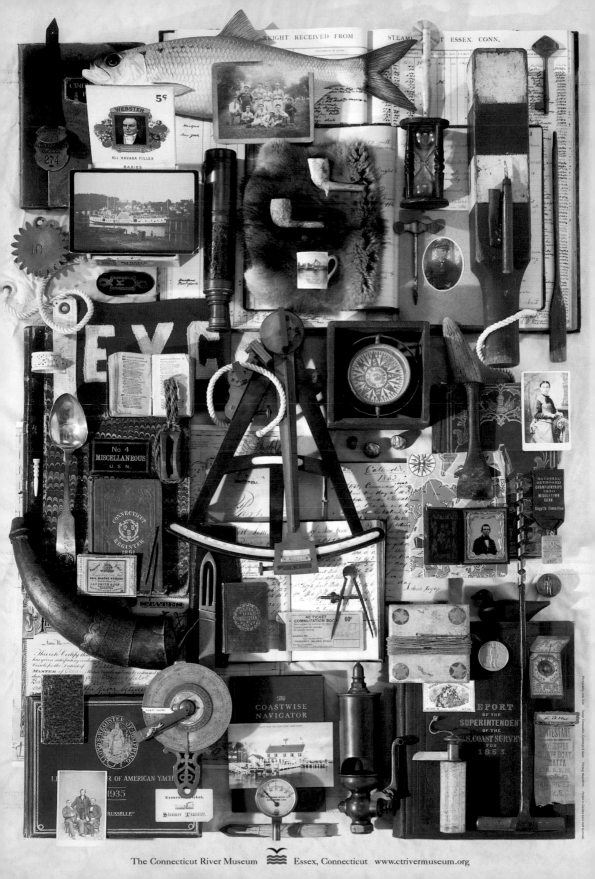

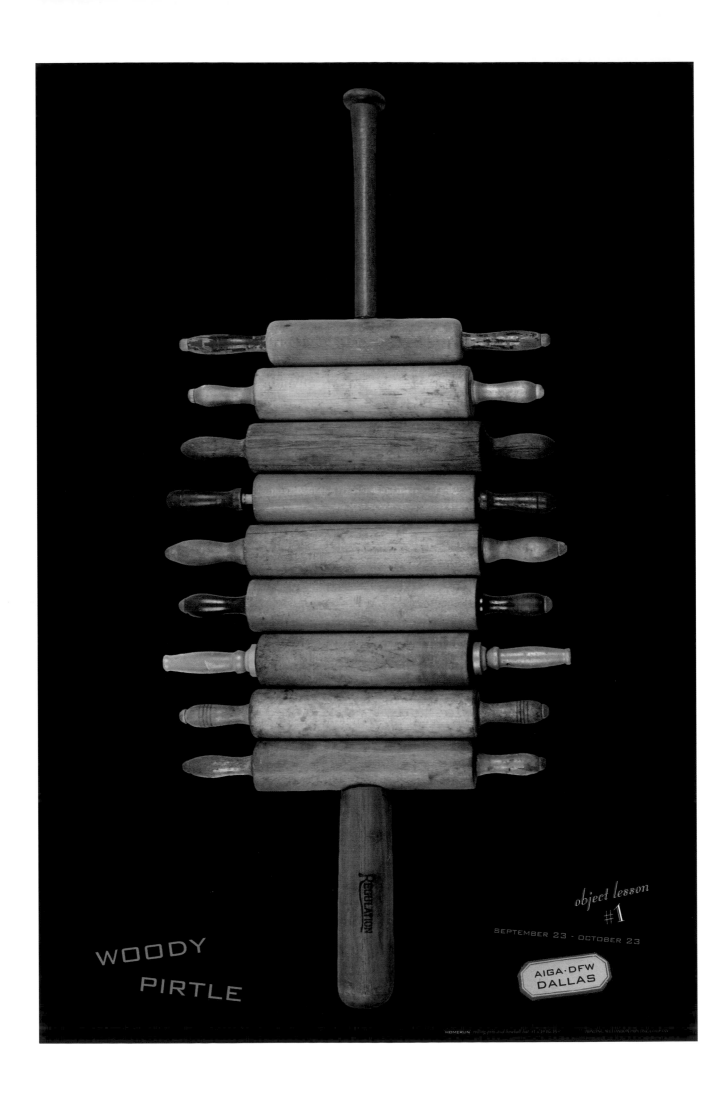

Pentagram Design *AIGA Dallas-Fort Worth Chapter*

Eric Chan Design Co. Ltd *China Exploration & Research Society*

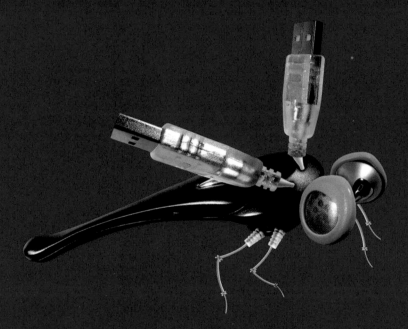

species diversity

nobby

accessories for mobiles

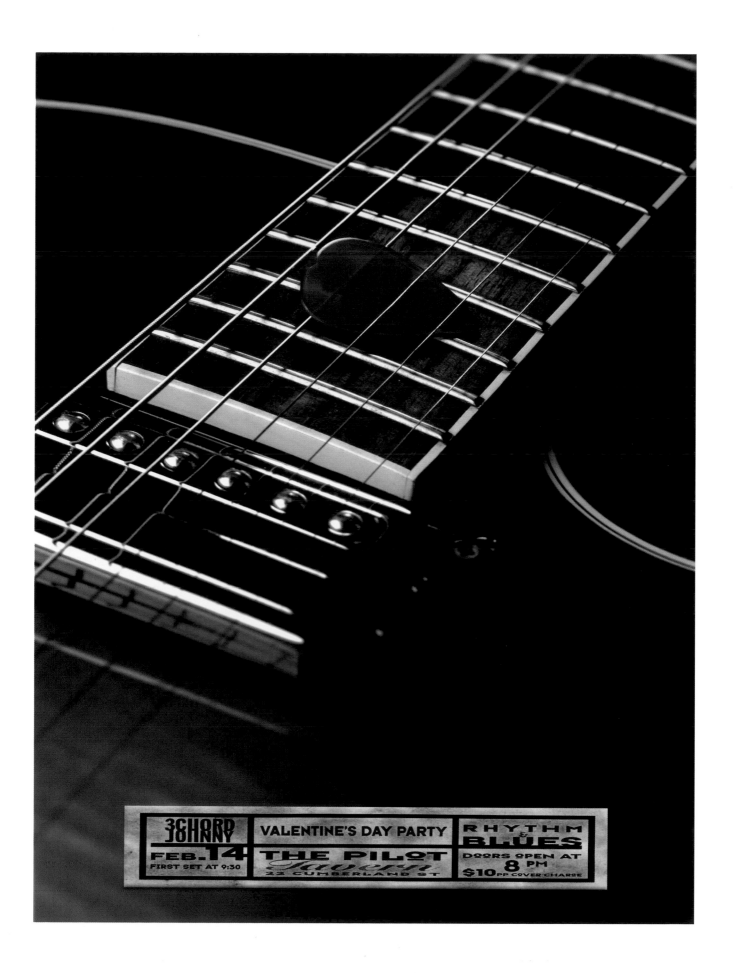

Nobaggage *3 Chord Johnny*

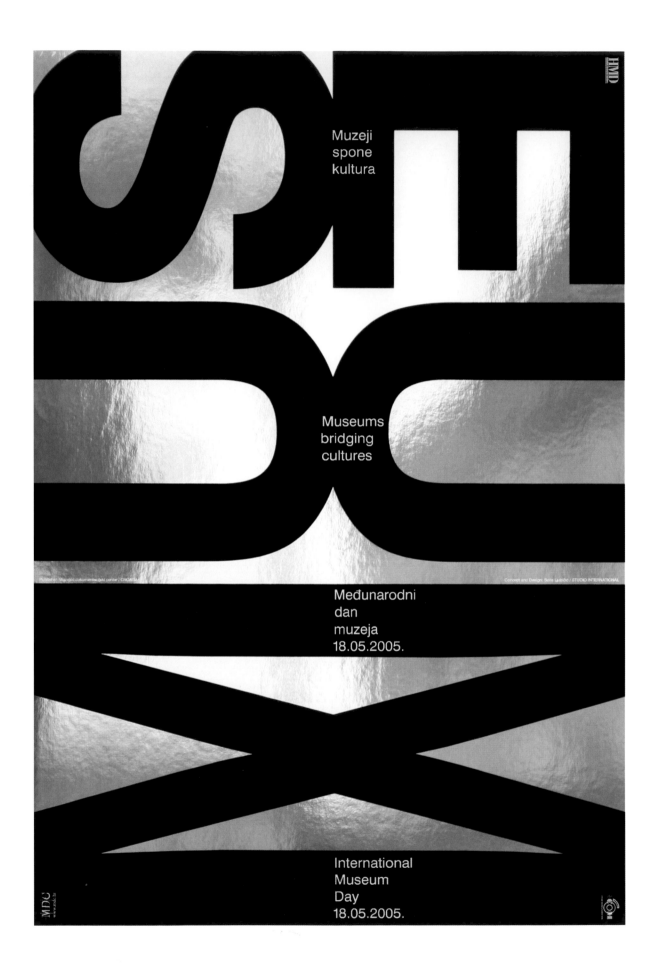

Muzeji
spone
kultura

Museums
bridging
cultures

Međunarodni
dan
muzeja
18.05.2005.

International
Museum
Day
18.05.2005.

STUDIO INTERNATIONAL *Museum Documentation Centre, Croatia*

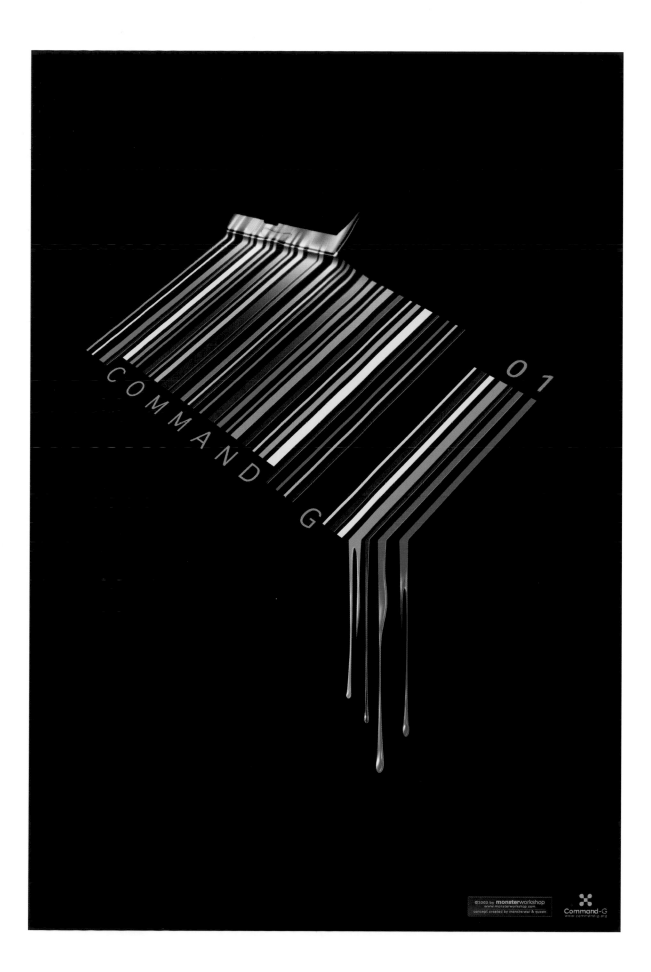

Eric Chan Design Co. Ltd *Hong Kong Heritage Museum*

LAX's Encounter Theme Building & Restaurant. The curved arches and whimsy space age motif of this 1961 building are typical of Los Angeles, a place where imagined visions of the future have set the standards for numerous emerging design trends and technologies.

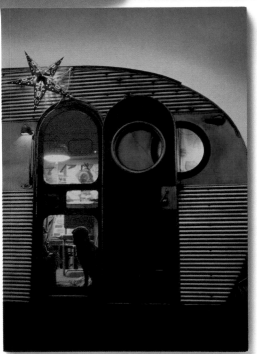

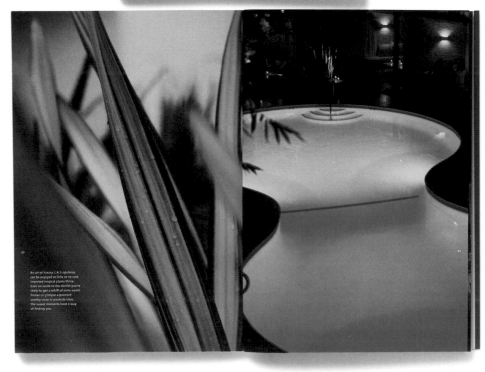

An air of luxury, L.A.'s opulence can be enjoyed at little or no cost. Imported tropical plants thrive. Even en route to the dentist you're likely to get a whiff of some exotic flower or glimpse a postcard-worthy vista or poolside view. The sweet moments have a way of finding you.

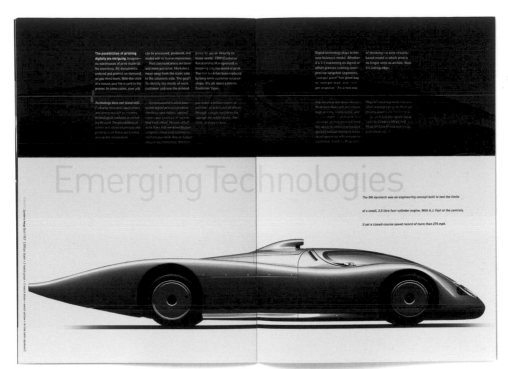

Emerging Technologies

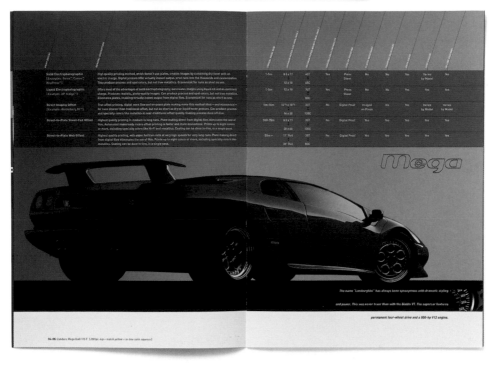

Perfection in printing has a new name. Stochastic. Stochastic is nothing short of the next generation in printing technology. It's revolutionary. It's breakthrough. It's exciting. Now you can achieve a truer reproduction of your original piece like never before. Imagine your last sheet looking like your first—and all sheets in-between. Relying on your proof to impeccably match your printed impression, eliminating the need for press checks. And consistently smoother tints and quarter tones. Images that are crisp and detailed. Stochastic printing solves the variance that frustrates many print buyers and production teams by delivering more consistent reproduction and control, while costing less in time and money. The speed, predictability, reliability, and accuracy of stochastic are unparalleled. See the difference for yourself. And turn to one of the few companies that has mastered stochastic technology: Sioux Printing.

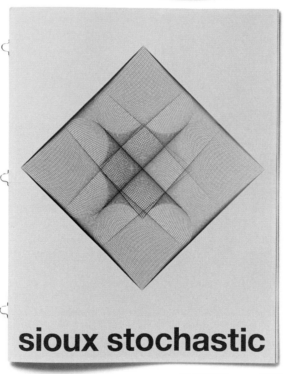

sioux stochastic

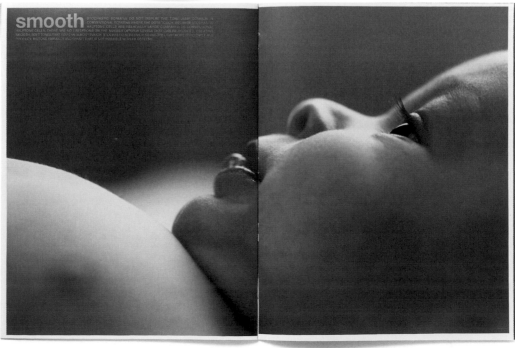

smooth STOCHASTIC SCREENS DO NOT DISPLAY THE TONE JUMP COMMON IN CONVENTIONAL SCREENS WHERE THE DOTS SUDDENLY BECOME STOCHASTIC HALFTONE CELLS ARE RELATIVELY LARGE COMPARED TO CONVENTIONAL HALFTONE CELLS, THERE ARE NO LIMITATIONS ON THE NUMBER OF TONAL LEVELS THAT CAN BE PRODUCED, CREATING SMOOTH, SOFT TONES THAT YOU CAN ALMOST TOUCH. STOCHASTIC SCREENS ALSO ABSORB LIGHT MORE EFFICIENTLY AND PRODUCE MUTING VIBRANCY AND GAMUT THAT IS NOT POSSIBLE WITH HALFTONING.

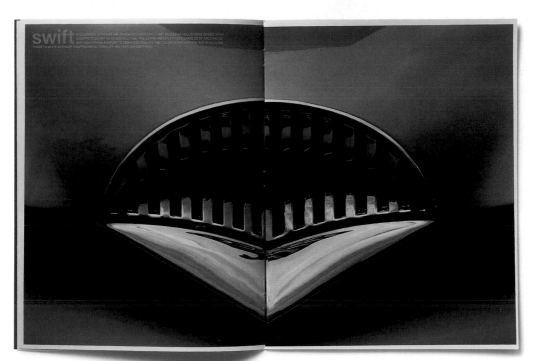

swift STOCHASTIC SCREENS ARE RENDERED, SCREENED, AND IMAGED AT FULL ENGINE SPEED, WITH NO EFFECT ON RIP OR RENDERING TIME. THE EXTRA FINELESS LATITUDE ENABLED BY STOCHASTIC NOT ONLY OPENS AVENUES TO ENHANCED QUALITY AND COLOR IN PRE-SEPARK, BUT ALSO GIVES ROOM TO MOVE WITHOUT COMPROMISING TONALITY, INK TRAP, OR CONTRAST.

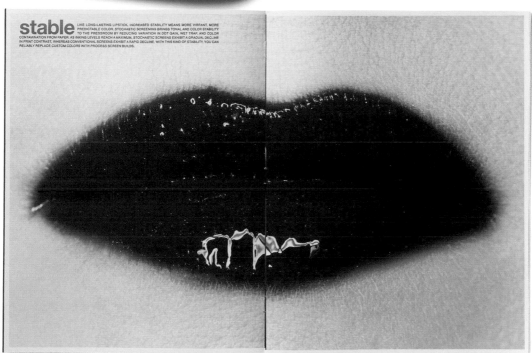

stable LIKE LONG-LASTING LIPSTICK, INCREASED STABILITY MEANS MORE VIBRANT, MORE PREDICTABLE COLOR. STOCHASTIC SCREENING BRINGS TONAL AND COLOR STABILITY TO THE PRESSROOM BY REDUCING VARIATION IN DOT GAIN, WET TRAP, AND COLOR CONTAMINATION FROM PAPER. AS INKING LEVELS REACH A MAXIMUM, STOCHASTIC SCREENS EXHIBIT A GRADUAL DECLINE IN PRINT CONTRAST, WHEREAS CONVENTIONAL SCREENS EXHIBIT A RAPID DECLINE. WITH THIS KIND OF STABILITY, YOU CAN RELIABLY REPLACE CUSTOM COLORS WITH PROCESS SCREEN BUILDS.

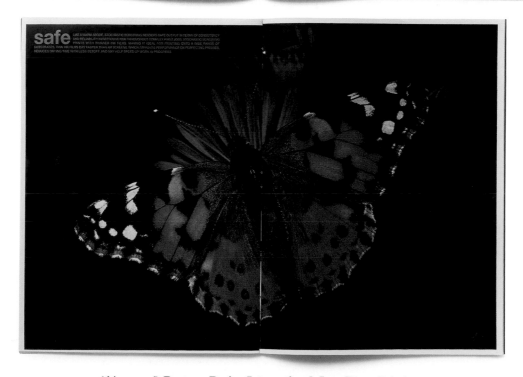

safe LIKE A WARM ABODE, STOCHASTIC SCREENING RENDERS SAFE OUTPUT IN TERMS OF CONSISTENCY AND RELIABILITY IN REPRODUCTION THROUGHOUT COMPLEX PIXEL JOBS. STOCHASTIC SCREENING PRINTS WITH THINNER INK FILMS, MAKING IT IDEAL FOR PRINTING ONTO A WIDE RANGE OF SUBSTRATES. THIN INK FILMS DRY FASTER THAN AM SCREENS, WHICH IMPROVES PERFORMANCE ON PERFECTING PRESSES, REDUCES DRYING TIME WITH LESS SETOFF, AND MAY HELP SPEED UP WORK IN FINISHERS.

(this spread) **Paragon Design International, Inc.** *Sioux Printing*

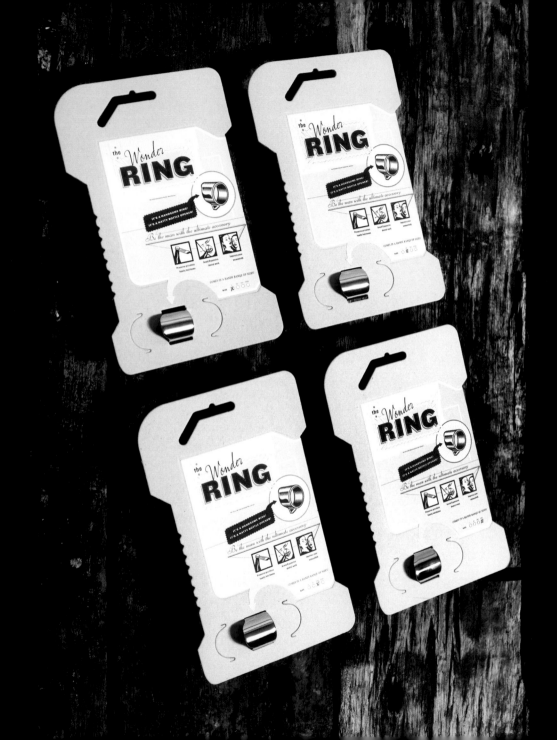

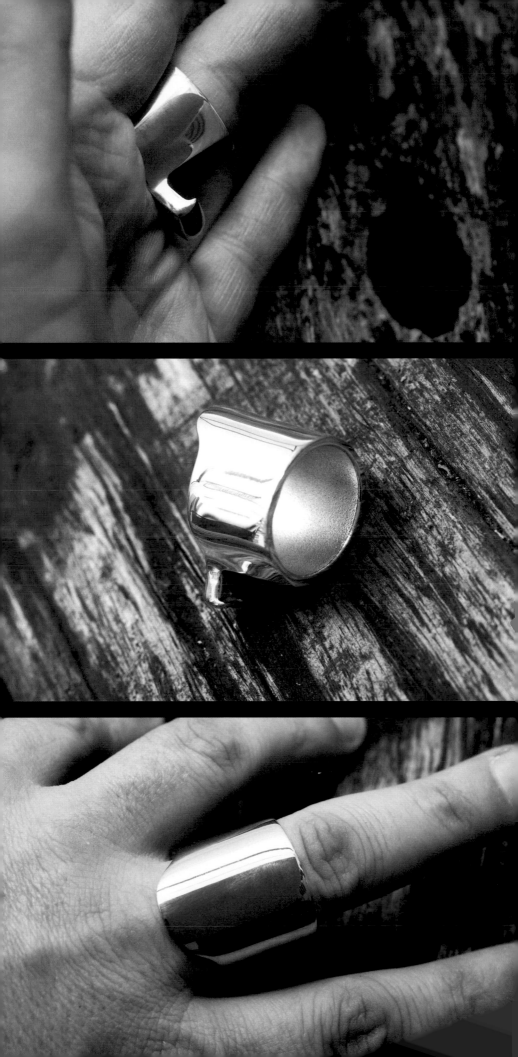

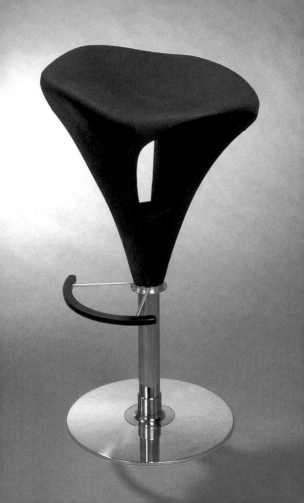

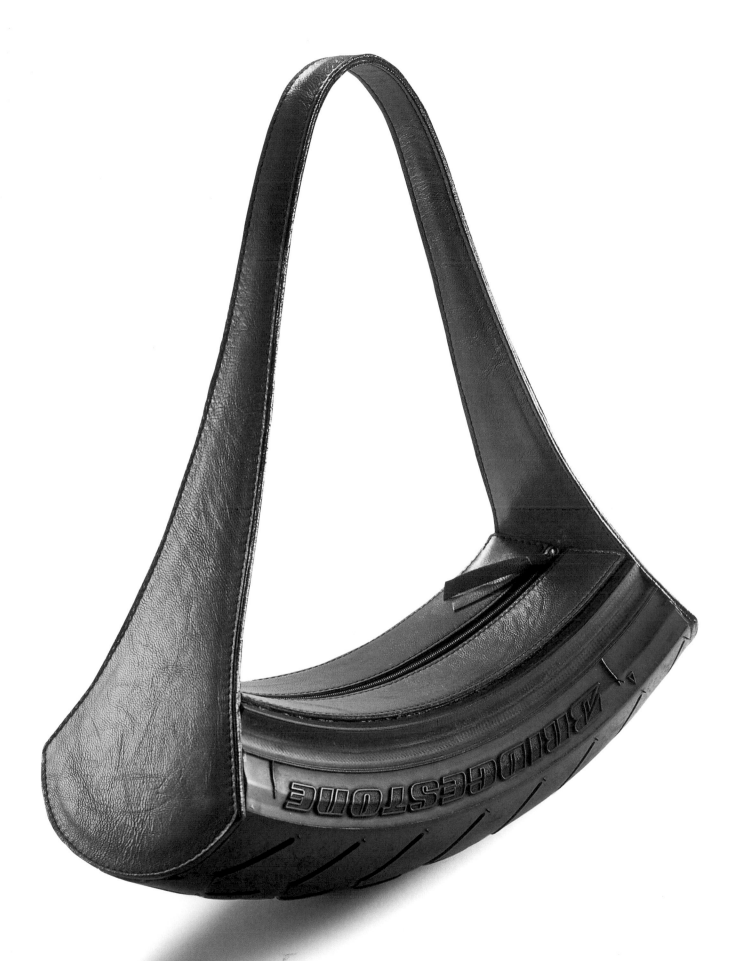

The Library
University College for the Creative Arts
at Epsom and Farnham

bernhard dusch *bernhard dusch*

You are cordially invited to become an
INAUGURAL MEMBER of LUX LUMINARIES and to join us at

LUX AFTER DARK

Saturday, December 4, 2004 at 6:30pm
at the home of
Richard and Kaye Woltman

15753 El Camino Real
Rancho Santa Fe, California 92067

Mires Design For Brands *LUX Art Institute*

WALTON
SIGNAGE

WALTON
SIGNAGE

WALTON
SIGNAGE

WALTON
SIGNAGE

NOËL font family

BASIC CHARACTER SET NOËL TEXT 24 POINT

Noël from focus2. A celebration of fonts and families for both text and display, specifically designed for the holiday season.

focus2 brand development™

BASIC CHARACTER SET NOËL TEXT 24 POINT

abcdefghijk mnopqrstuvwxyz
ABCDEFGHIJK MNOPQRSTUVWXYZ
1234567890%&(.,;:#!?) ❦

NOËL TEXT ITALIC 12 POINT

'Twas the night before Christmas, when a through the house, Not a creature was stirring, not even a mouse; The stockings were hung by the chimney with care, In hopes that St. Nicho as soon wou d be there; The chi dren were nest ed a snug in their beds, Whi e visions

NOËL TEXT 12 POINT

Dashing through the snow, In a one-horse open s eigh, Through the fields we go, aughing a the way. Be s on bob-tai ring, Making spirits bright, What fun it is to ride and sing, A s eighing song tonight. Jing e be s,

NOËL SMALL CAPS 12 POINT

SI ENT NIGHT, HO Y NIGHT! A IS CA M, A IS BRIGHT. ROUND YON VIRGIN, MOTHER AND CHI D. HO Y INFANT SO TENDER AND MI D, S EEP IN HEAVEN Y PEACE, S EEP IN HEAVEN Y PEACE. SI ENT

NOËL TEXT 8 POINT

Seasons greetings from focus2.

NOËL TEXT 10 POINT

Seasons greetings from focus2.

NOËL TEXT 12 POINT

Seasons greetings from focus2.

NOËL TEXT 14 POINT

Seasons greetings from focus2.

NOËL TEXT 18 POINT

Seasons greetings from focus2.

NOËL TEXT 24 POINT

Seasons greetings from

NOËL DISPLAY 60 PT

Christmas

NOËL DISPLAY 72 PT

Egg Nog

NOËL DISPLAY 96 PT

Snowy

NOËL DISPLAY 120 PT

Trees

NOËL DISPLAY 180 PT

Ma

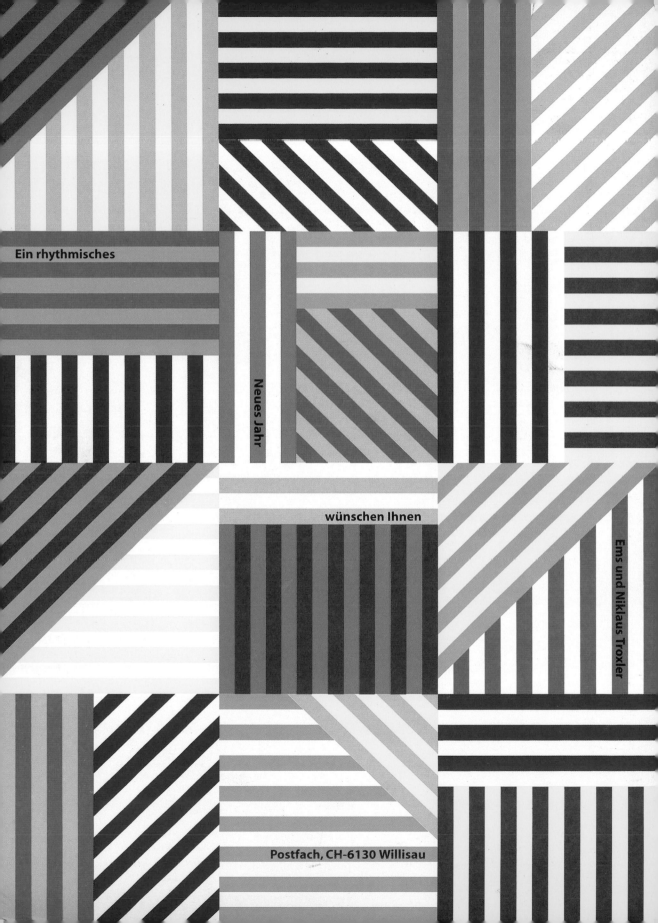

Ein rhythmisches

Neues Jahr

wünschen Ihnen

Ems und Niklaus Troxler

Postfach, CH-6130 Willisau

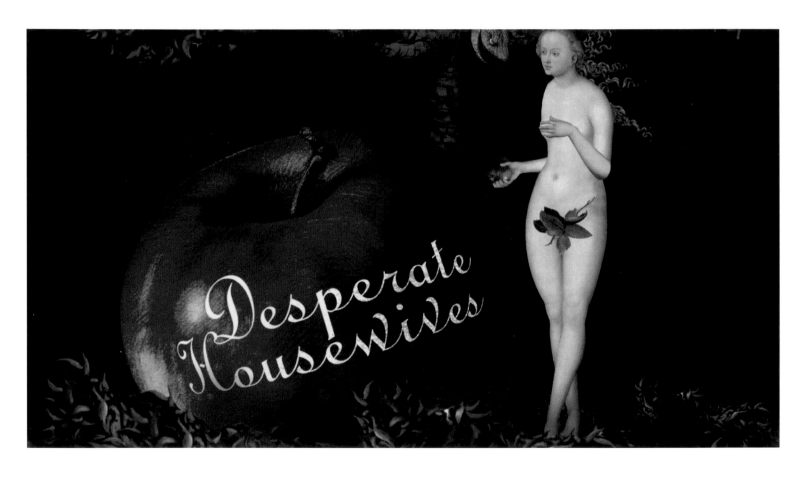

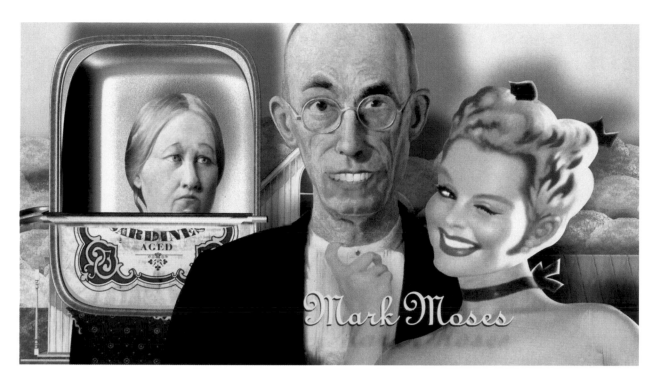

(this spread) **yU+co.** *ABC*

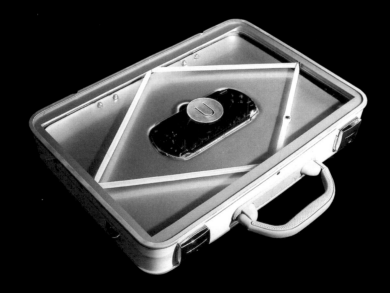

Sara Eames *Ubercool*

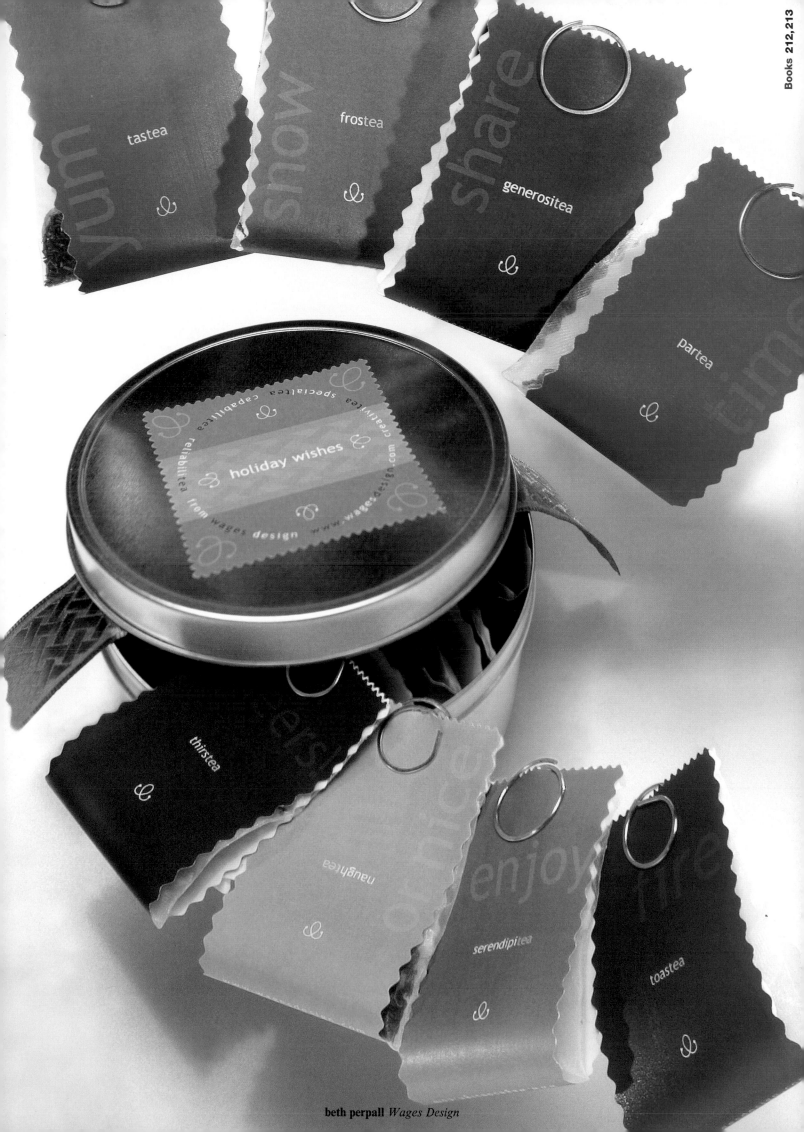

beth perpall *Wages Design*

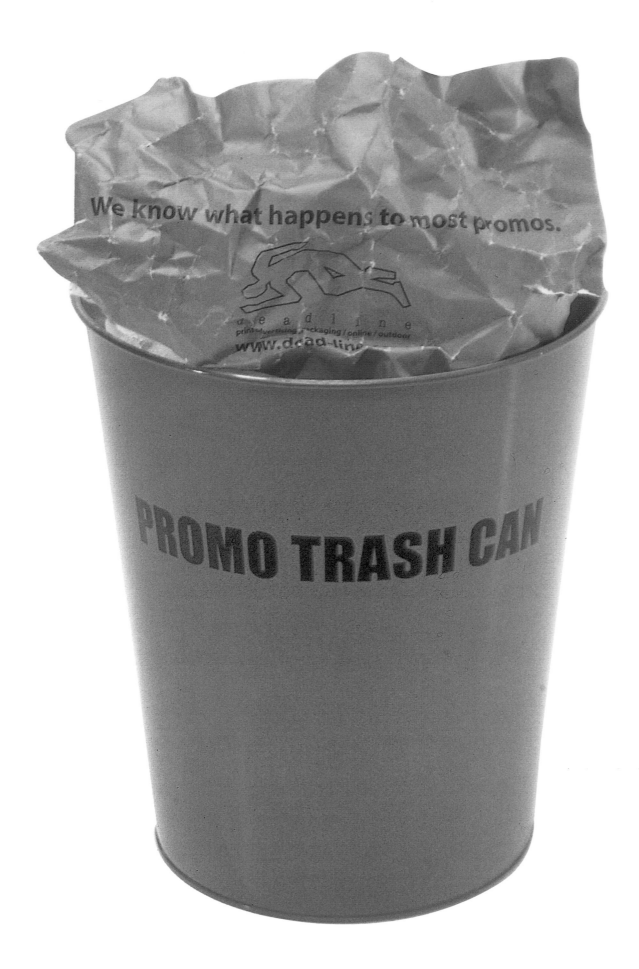

We know what happens to most promos.

PROMO TRASH CAN

Amir Parstabar *Deadline Advertising*

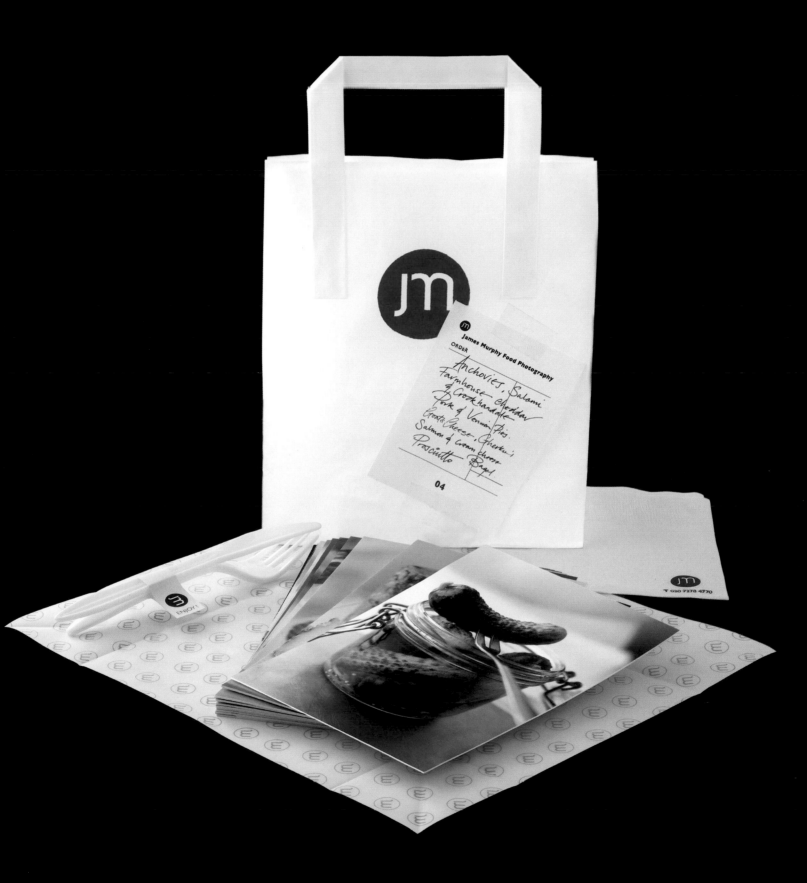

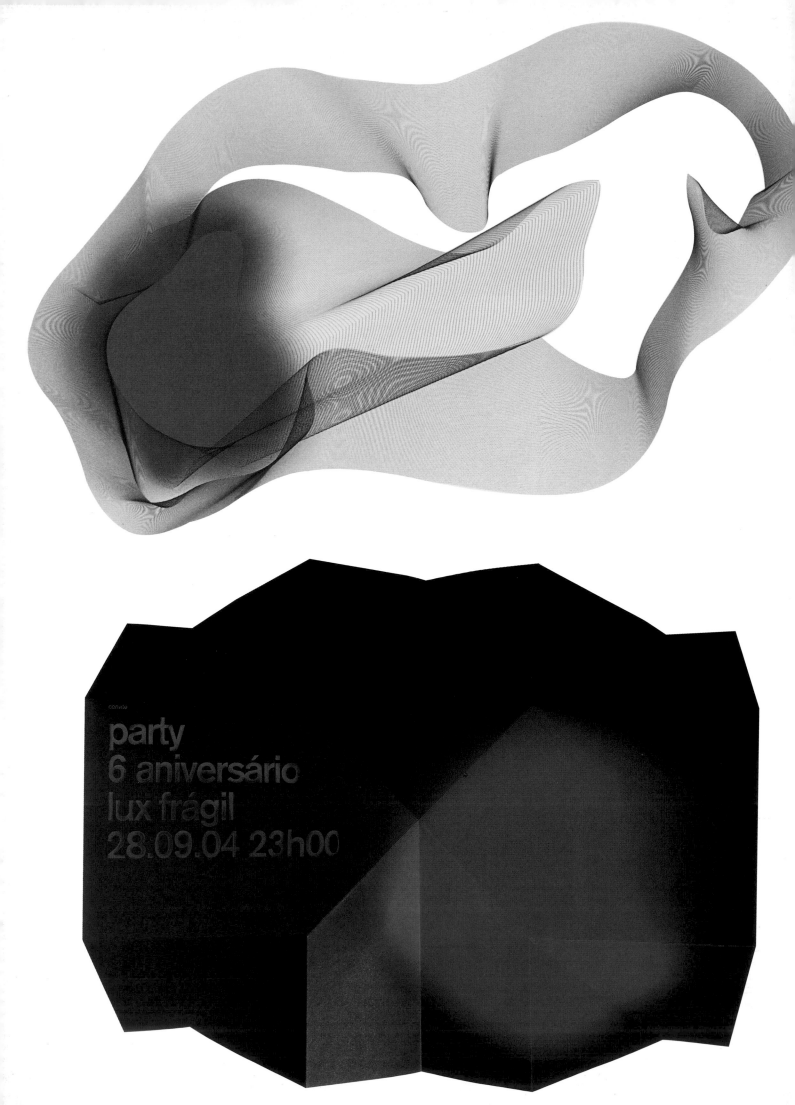

party
6 aniversário
lux frágil
28.09.04 23h00

RMAC Design *Lux Frágil*

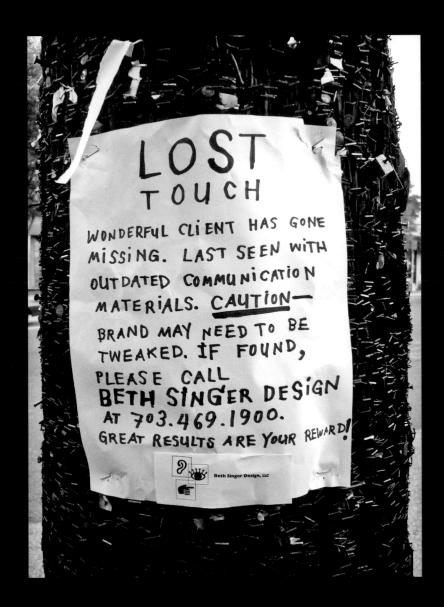

INTERNATIONAL BENJI BRIGADE
MAKING STRONG ASIAN FILM

A JOINT VENTURE BY
BALA ENTERTAINMENT INTERNATIONAL PVT. LTD.
& FILMS

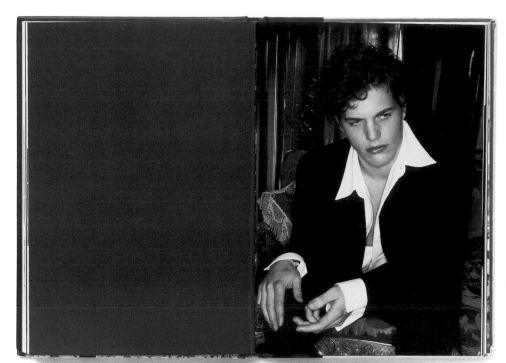

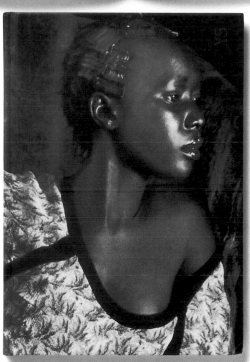

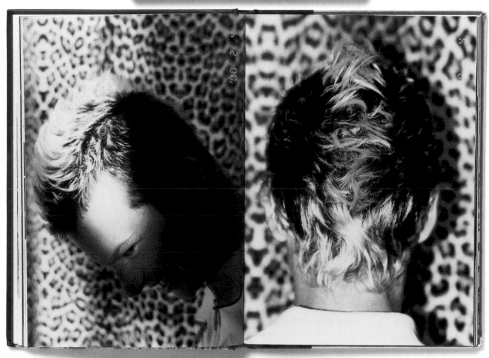

Sweet Design *Y Salon*

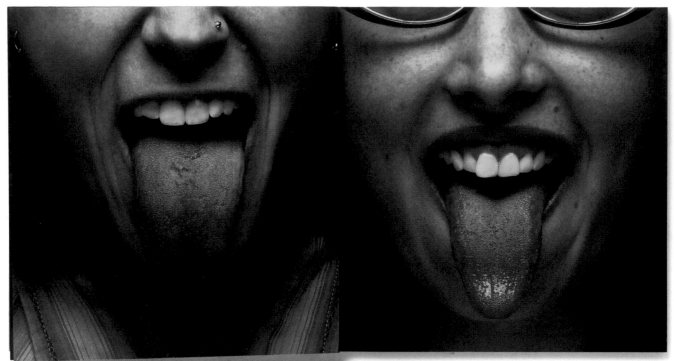

Lick

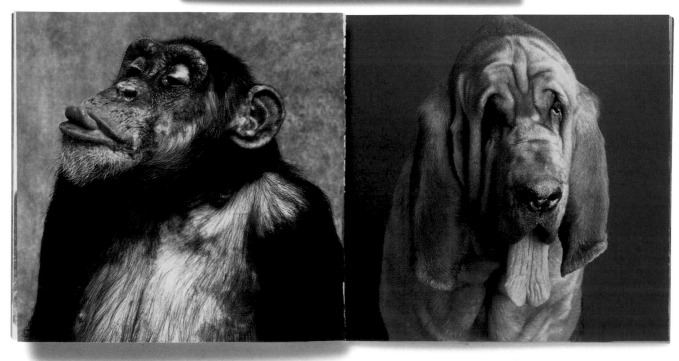

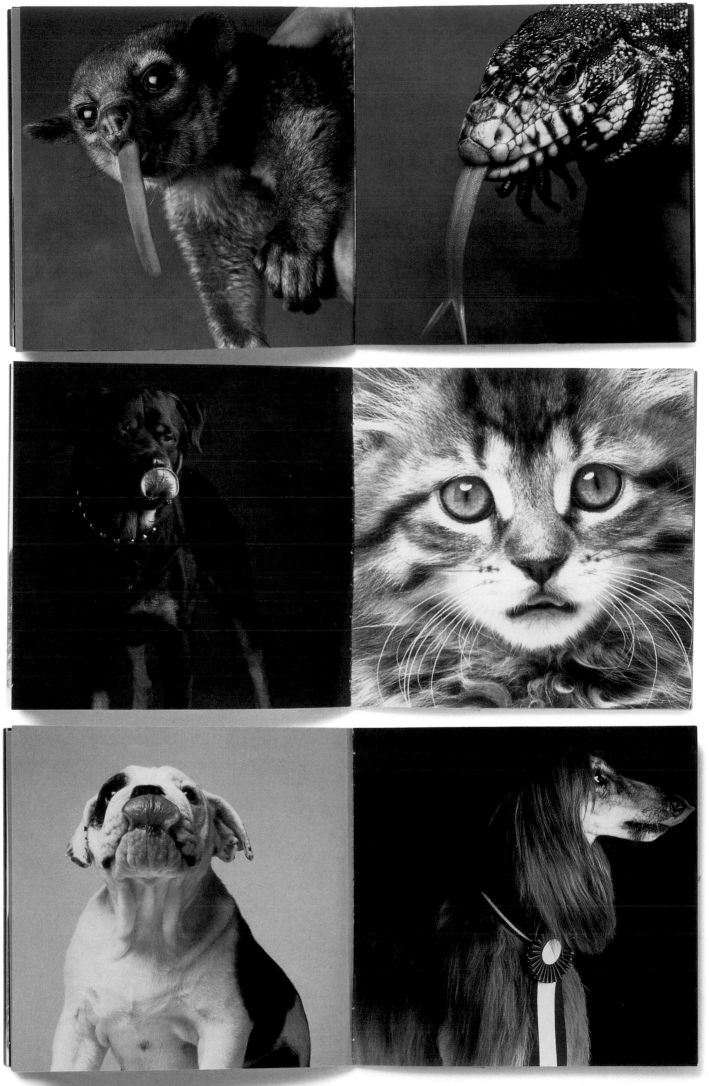

(this spread) Liska + Associates *Grubman*

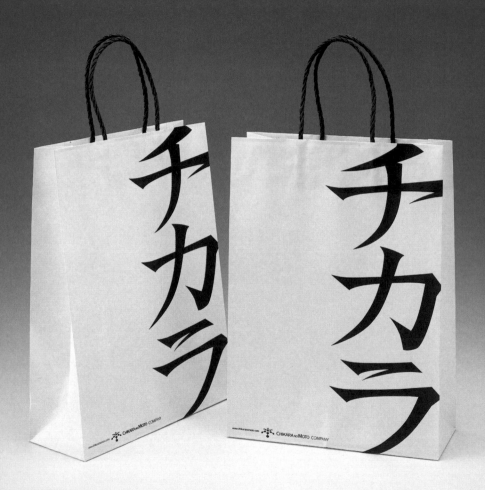

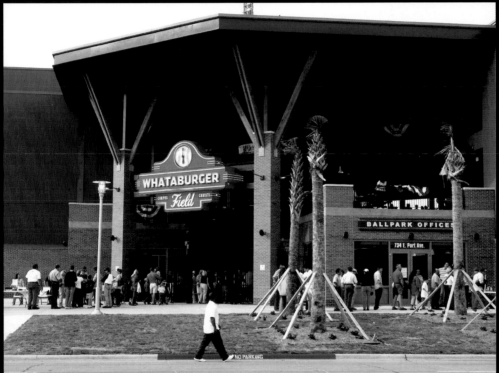

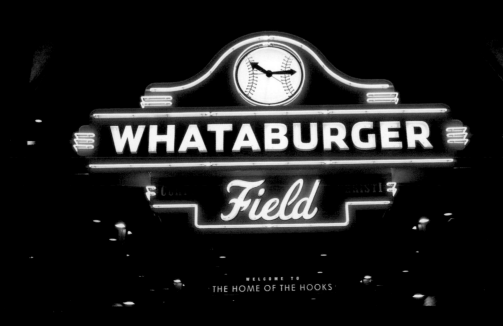

McGarrah/Jessee *Whataburger*

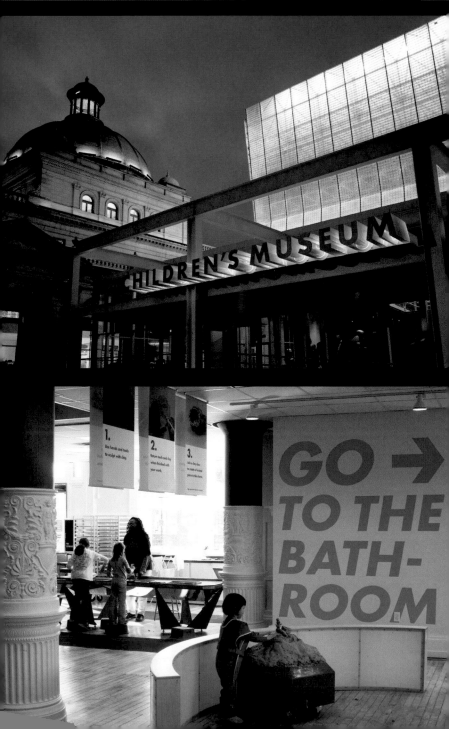

(this spread) **Pentagram Design** *Children's Museum of Pittsburgh*

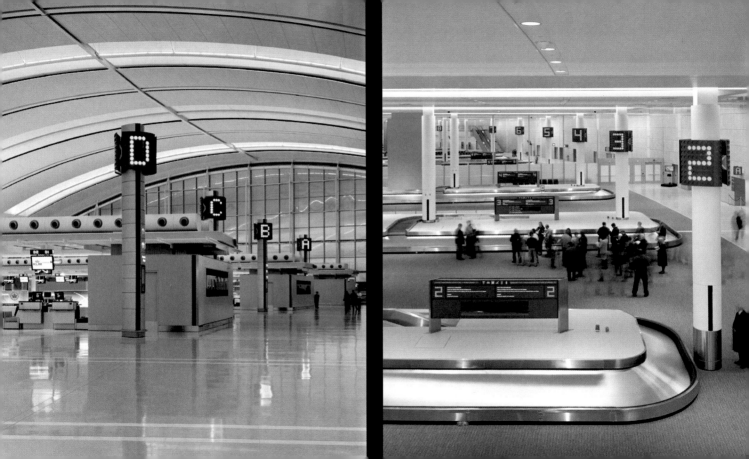

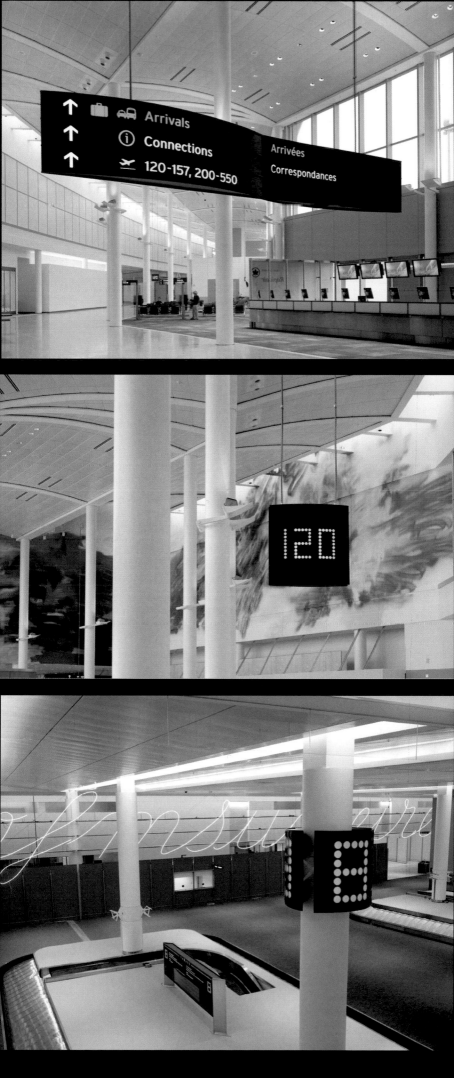

T'SIGN Werbeagentur *Die Schweizerische Post*
Interaction/design *Canada post*

55 DEUTSCHLAND 2004 1929 GEWINN DES »BLAUEN BANDES« DURCH DEN DAMPFER BREMEN

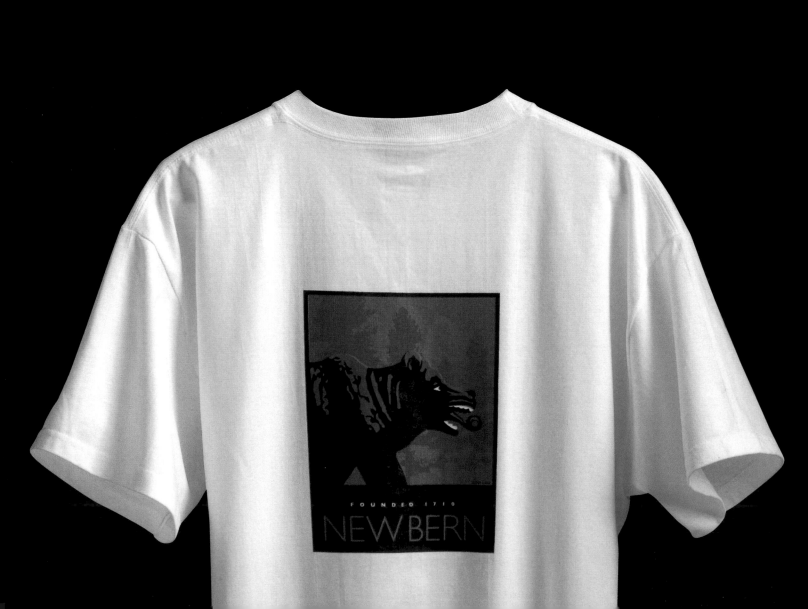

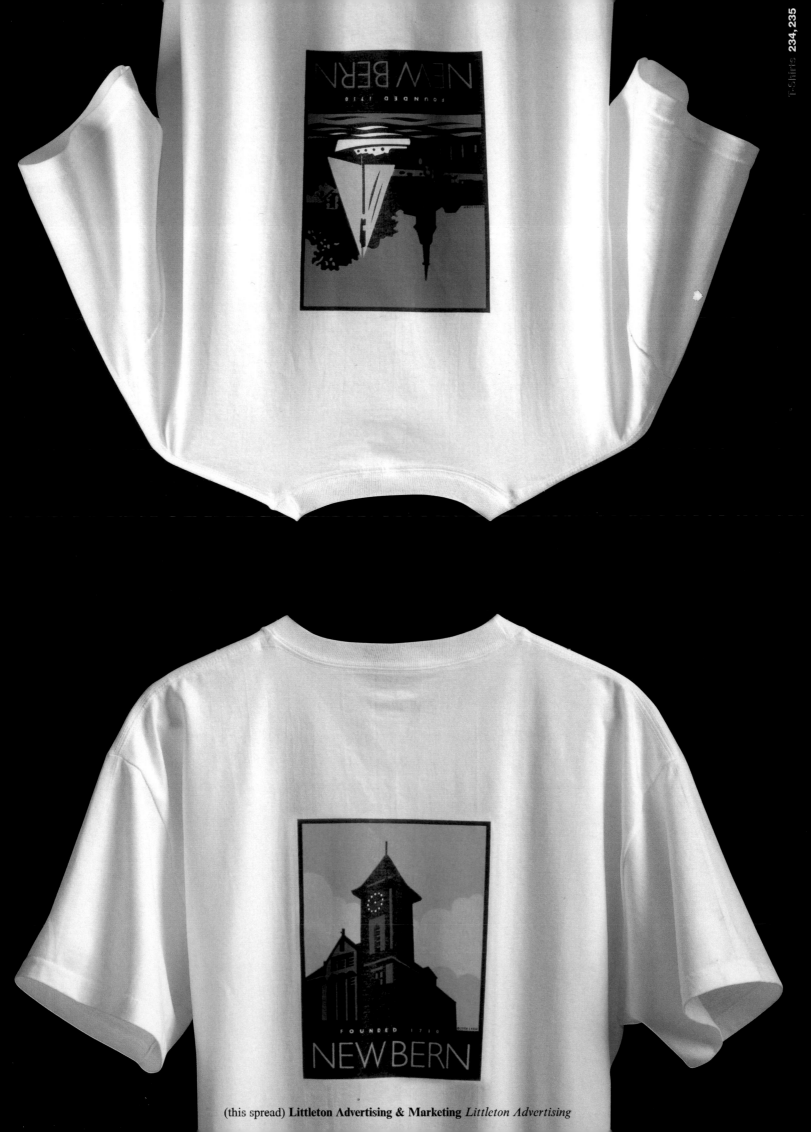

(this spread) **Littleton Advertising & Marketing** *Littleton Advertising*

Indices **Verzeichnisse** Index

Directory

160over90
One South Broad Street, 10th
Floor Philadelphia, PA USA
Tel 215 732 3200

3 Deep Design
148a Barkly Street
Melbourne, Victoria Australia
Tel +61 3 9593 8034
Fax +61 3 9534 2414

3D Ideation
1660 Bloor Street East, Suite 203
Mississauga, Ontario Canada
Tel 905 624 7591

50,000 Feet, Inc.
1700 W Irving Park, Suite 110
Chicago, IL USA
Tel 773 529 6760

601Bisang
481-11 Seogyo-dong, Mapo-gu
Seoul, Republic of Korea
Tel +82 2 332 2601
Fax +82 2 332 2602

Addison
20 Exchange Place, 18th Floor
New York, NY USA
Tel 212 229 5000
Fax 212 929 3010

American Airlines Publishing
4333 Amon Carter Boulevard
MD5374 Fort Worth, TX USA
Tel 817 963 5378

Anderson Thomas Design
116 29th Avenue North
Nashville, TN USA
Tel 615 327 9894
Fax 615 329 0665

Andrew Hoyne
Level 1, 77A Acland
St Kilda, Vic Australia
Tel +03 9537 1822
Fax +03 9537 1822

Angela Frenell
119 North 4th Street, Suite 400
Minneapolis, MN USA
Tel 612 338 4462

Anita Kunz
218 Ontario Street
Toronto, Canada
Tel 416 364 3846

Anthony Auston
101 South Coombs Street
Studio P Napa, California USA
Tel 707 226 9010
Fax 707 226 9010

Apple Computer
1 Infinite Loop MS: 65-MM
Cupertino, CA USA
Tel 408 974 1361
Fax 408 974 1361

Arnold Worldwide
701 Market, Suite 200
St. Louis, MO USA
Tel 314 421 6610
Fax 314 421 5627

AZURE Magazine
Tel 416 203 9674

Bailey Lauerman
1248 O Street, Suite 900
Lincoln, NE USA
Tel 402 475 2800
Fax 402 475 5115

Bandujo Donker & Brothers
22 West 19th Street, 9th Floor
New York, NY USA
Tel 212 332 4100
Fax 212 366 6068

BBDO West
637 Commercial Street, 3rd Floor
San Francisco, CA USA
Tel 415 274 6239
Fax 415 274 6221

Beduinenzelt.com
Hadayek Mohandessin,
6 of October City Building
517/3 Kairo, Egypt
Tel +002 010 145 6663

Benchmark
35 East 7th Street, Suite 800
Cincinnati, OH USA
Tel 513 621 3038
Fax 513 621 4932

Bernhard Dusch
Neumannstr 19 Fuerth
Bavaria, Germany
Tel +0049 911 475 1242

Beth Perpall
887 West Marietta Street
Atlanta, GA USA
Tel 404 876 0874

Beth Singer Design, LLC
1408 North Filmore Street,
Suite 6 Arlington, VA USA
Tel 703 469 1900
Fax 703 525 7399

Brad Simon
214 Sullivan Street, Suite 6C
New York, NY USA
Tel 212 254 4470
Fax 212 254 5266

Britton Design
724 First Street West
Sonoma, CA USA
Tel 707 938 8378

Bruketa&Zinic
Zavrtnica 17 Zagreb, Croatia
Tel +385 1 6064 000
Fax +385 1 6064 001

Calori & Vanden-Eynden
130 West 25th Street
New York, NY USA
Tel 212 929-6302

Carmichael Lynch
800 Hennepin Avenue
Minneapolis, MN USA
Tel 612 334 6045
Fax 612 334 6032

Ceradini Design Inc.
222 East 31st Street
New York, NY USA
Tel 212 252 0282
Fax 212 252 0782

Cesar Pelli & Associates
1056 Chapel Street
New Haven, CT USA
Tel 203 777 2515
Fax 203 787 2856

**Concrete Design
Communications Inc.**
2 Silver Avenue
Toronto, ON Canada
Tel 416 534 9960
Fax 416 534 2184

Cummings & Good
P.O. Box 570/3
North Main Street
Chester, CT USA
Tel 860 526 9595
Fax 860 526 4454

DarbyDarby Creative
2376 Seventh Avenue
New York, NY USA
Tel 646 489 1256
Fax 212 283 3850

Datagold Westersingel
101 Rotterdam, Netherlands
Tel +31 10 241 85 55
Fax +31 10 241 85 50

David Schimmel
156 5th Avenue, Suite 1234
New York, NY USA
Tel 212 414 4700
Fax 212 414 2915

Davidson Design
Level 1, Building 5, 658 Church
Street Richmond Melbourne,
Victoria Australia
Tel +61 3 9429 1288
Fax +61 3 9429 6855

DDB Melbourne
7 Electric Street Richmond,
Victoria Australia
Tel +61 3 9254 3600

Deadline Advertising
12424 Wilshire Blvd, Suite 850
Los Angeles, CA USA
Tel 310 442 8100

DesignworksEnterpriseIG
1 Barrack Street, Level 1
Sydney, NSW Australia
Tel +02 9299 8966
Fax +02 9262 6806

Desgrippes Gobé
411 Lafayette Street
New York, NY USA
Tel 212 979 8900
Fax 212 979 1404

**Design Hoch Drei
GmbH&Co.**
Hallstrasse 25a, Germany
Tel +49 711 55037730
Fax +49 711 55037755

Design Temple Pvt. Ltd.
12, Flowers Nest, Shirley Rajan
Rd, Off Carter Rd, Bandra (west)
Mumbai, Maharashtra India
Tel +91 22 26001728
Fax +91 22 26485649

Di Donato Associates
212 W. Superior Street, Suite 201
Suite 201 Chicago, IL USA
Tel 312 440 3225
Fax 312 440 3226

Direct Design Studio
41, 46\48, Zemlyanoy Val Street
Moscow, Russian Federation
Tel +095 916 0123

DNA Design
262-264 Thorndon Quay
PO Box 3056
Wellington, New Zealand
Tel +64 4 4990828
Fax +64 4 499 0888

Duffy & Partners
710 2nd Street South, Suite 602
Minneapolis, MN USA
Tel 612 548 2333
Fax 612 548 2334

Dugald Stermer Illustration
600 The Embarcadero
San Francisco, CA USA

Eleven Inc.
445 Bush Street
San Francisco, CA USA
Tel 415 707 1111
Fax 415 707 1100

Elixir Design
2134 Van Ness Avenue
San Francisco, CA USA
Tel 415 834 0300
Fax 415 834 0101

Enterprise IG Johannesburg
The Design Centre 19 Tambach
Road Sunninghill 2157 Private
Bag x16 Johannesburg,
Sunninghill South Africa
Tel +27 11 319 8000
Fax +27 11 319 8093

Equus Design Consultants
8B Murray Terrace
Singapore, Singapore
Tel 63232996
Fax 63232991

Eric Chan Design Co.
Unit 803, 8/F Park Commercial
Centre, 180 Tung Lo Wan Road,
Causeway Bay, Hong Kong
Tel 852 2527 7773
Fax 852 2865 3929

Factor Design Inc.
580 Howard Street, Suite 303
San Francisco, CA USA
Tel 415 896 6051
Fax 415 896 6053

Focus2 Brand Development
824 Exposition Avenue, Suite 2
Dallas, TX USA
Tel 214 741 4007
Fax 214 741 9231

Ford Weithman Design
431 NW Flanders Street,
Suite 304 Portland, OR USA
Tel 503 222 0296
Fax 503 222 0289

G2 Worldwide
747 3rd Avenue
New York, NY USA
Tel 212 616 9023
Fax 212 616 9095

Garfinkel Design
115 Cedar Springs Drive
Athens, GA USA
Tel 706 369 6831
Fax 706 369 1761

Gary Willmann
7007 Twin Hills, Suite 200
Dallas, TX USA
Tel 214 987 6500
Fax 214 987 3662

Geyrhalter Design
2525 Main Street, Suite 205
Santa Monica, CA USA
Tel 310 392 7615
Fax 310 396 0096

Giorgio Baravalle
123 Nine Partners Lane
Millbrook, NY USA
Tel 845 677 2075
Fax 845 677 2075

GQ Magazine
4 Times Square 9th Floor
New York, NY USA
Tel 212 286 7523
Fax 212 286 8515

Grafik
1199 North Fairfax Street,
Suite 700 Alexandria, VA USA
Tel 703 299 4500
Fax 703 299 5999

Graphics & Designing Inc.
3-3-1 Shirokanedai,
Minato-ku Tokyo, Japan
Tel +81 3 3449 0651
Fax +81 3 3449 0653

Greteman Group
1425 E. Douglas Avenue,
2nd Floor Wichita, KS USA
Tel 316 263 1004
Fax 316 263 1060

GRi.D Communications
301 Canberra Avenue Fyshwick
Canberra, ACT Australia
Tel +61 2 6280 0960
Fax +61 2 6280 0970

GSD&M
828 West 6th Street
Austin, TX USA
Tel 512 242 4736
Fax 512 242 8800

Haase & Knels
Atelier für Gestaltung
Am Landherrnamt
8 Bremen, Germany
Tel +0049421334980
Fax +00494213349833

Hambly & Woolley Inc.
49 Bathurst Street #400
Toronto, Ontario Canada
Tel 416 504 2742
Fax 416 504 2745

Herman Miller Inc
855 East Main Ave
Zeeland, MI USA
Tel 616 654 3000

Howry Design Associates
354 Pine Street 6th Floor
San Francisco, CA USA
Tel 415 433 2035
Fax 415 433 0816

Identica
Newcombe House
45 Notting Hill Gate
London, United Kingdom
Tel +44 0 20 7569 5600
Fax +44 0 20 7569 5656

Interaction/Design
55, Ave. Mont-Royal Ouest,
bureau 1005 Montréal,
Québec Canada
Tel 514 844 1995
Fax 514 849 4544

Jack Unruh
8138 Santa Clara Drive
Dallas, TX USA
Tel 214 327 6211

Jae Soh
14 Upper Bukit Timah View
Singapore 588144
Singapore, Singapore
Tel +65 98321515

Jan Sabach
16 Tompkins Place
Brooklyn, NY USA
Tel 646 220 3226

Jeff Pollard Design
8841 SW 52nd Avenue
Portland, OR USA
Tel 503 246 7251
Fax 503 246 5257

John Mattos Illustration
1546 Grant Avenue
San Francisco, CA USA
Tel 415 397 2138

Josh Owen LLC
700 South 10th Street
Philadelphia, PA USA
Tel 2159234856
Fax 2159234856

Directory

Katsui Design
3-48-9 Nishihara
Tokyo, Japan
Tel +81 3 5478 7681
Fax +81 3 5478 8722

KBDA
2558 Overland Avenue
Los Angeles, CA USA
Tel 310 287 2400
Fax 310 287 0909

Kilmer & Kilmer Brand
Consultants 125 Truman
Albuquerque, NM USA
Tel 505 260 1175
Fax 505 260 1155

Kinuko Y. Craft
83 Litchfield Road
Norfolk, CT USA
Tel 860 542 5018

KittyKombat Design Studio
11658 Springside Road
San Diego, CA USA
Tel 858 382 9612

Kuhlmann Leavitt, Inc.
7810 Forsyth Boulevard, 2W
St. Louis, MO USA
Tel 314 725 6616
Fax 314 725 6618

Landor Associates
1001 Front Street
San Francisco, CA USA
Tel 415 365 1700
Fax 415 365 3188

Larsen Design + Interactive
7101 York Avenue South
Minneapolis, MN USA
Tel 952 835 2271
Fax 952 921 3368

Lesniewicz Associates
222 North Erie Street
Toledo, OH USA
Tel 419 243 7131
Fax 419 243 3200

LGD Communications
3819 North Miami Avenue
Miami, FL USA
Tel 305 576 9400
Fax 305 576 9200

Liska + Associates
515 N. State Street, 23rd Floor
Chicago, IL USA
Tel 312 644 4400
Fax 312 644 9650

**Littleton Advertising
&Marketing**
202 Craven Street, Suite C
New Bern, NC USA
Tel 252 514 2211
Fax 252 514 2390

Love the Life
1-14-2 Denenchofu
Ohta-ku, Tokyo Japan
Tel +81 3 5483 6086
Fax +81 3 5483 6087

M Space Design
333A Harvard Street
Cambridge, MA USA
Tel 617 547-5503

**Marc Burckhardt/Burckhardt
Studio, Inc.**
Tel 512 458 1690

Matsumoto Incorporated
220 West 19th Street, 9th Floor
New York, NY USA
Tel 212 807 0248
Fax 212 807 1527

McGarrah/Jessee
205 Brazos Austin, TX USA
Tel 512 225 2000
Fax 512 225 2020

Melinda Lawson
387 Tehama Street
San Francisco, CA USA
Tel 415 896 0499
Fax 415 541 9106

Michael Schwab
108 Tamalpais Avenue
San Anselmo, CA USA
Tel 415 257 5792
Fax 415 257 5793

Michael Thede Design
105 North Main Street No. 105
St. Charles, MO USA
Tel 636 925 0312

Mires Design For Brands
2345 Kettner Boulevard
San Diego, CA USA
Tel 619 234 6631
Fax 619 234 1807

Mirko Ilic Corp.
207 East 32nd Street
New York, NY USA
Tel 212 481 9737

Miserez
60 ter Rue Haxo
Paris, France
Tel +01 40 30 94 61

Morla Design
1008a Pennsylvania
San Francisco, CA USA
Tel 415 543 6548
Fax 415 543 7214

Mucca Design
568 Broadway, 604A
New York, NY USA
Tel 212 965 9821
Fax 212 625 9153

NDW Group
100 Tournament Drive
Suite 230 Horsham, PA USA
Tel 215 957 9871
Fax 215 957 9872

Niket Parekh
306, Evening Star, Raheja Vihar,
Sakinaka, Opp. Chandivali
Studio, Andheri (E) Mumbai
400072 Mumbai, Maharastra India
Tel +91 22 28572544

Niklaus Troxler Design
Postfach Willisau
Ch-6130, Switzerland
Tel +41 41 970 27 31
Fax +41 41 970 32 31

Nobaggage
15 Melgund Road Toronto,
Ontario M5R 1Z9 Canada
Tel 416 937 9056
Fax 416 240 8021

Ocozzio
3506 Professional Circle
Augusta, GA USA
Tel 706 650 1968 x101
Fax 706 650 1968 x101

Origin Design
4203 Montrose Boulevard
Houston, TX USA
Tel 713 520 9544

P&W
21 Ivor Place Marylebone
London, London
United Kingdom
Tel +0207 723 8899

**Paragon Design
International, Inc.**
541 North Fairbanks,
Suite 1000 Chicago, IL USA
Tel 312 832 1030
Fax 312 832 1032

Pentagram Design
204 5th Avenue
New York, NY USA
Tel 212 683 7000
Fax 212 532 0181

**Perkins+Will | Eva Maddox
Branded Environments**
330 N. Wabash Suite 3600
Chicago, IL USA
Tel 312 755 4776
Fax 312 755 0775

Perks Design Partners
2nd Floor 333 Flinders Lane
Melbourne, Victoria Australia
Tel +61 3 9620 5911
Fax +61 3 9620 5922

Peter Krämer
Lindemannstr. 31
Düsseldorf, NRW Germany
Tel +0211 2108087
Fax +0211 228541

Peterson & Company
2200 North Lamar Street,
Suite 310 Dallas, TX USA
Tel 214 954 0522
Fax 214 954 1161

Philographica
1318 Beacon Street, Suite 12
Brookline, MA USA
Tel 617 738 5800
Fax 617 738 5889

Pleks
Kronprinsessegade 22100
Copenhagen K, Denmark
Tel +0045 33120797

Poulin + Morris Inc.
286 Spring Street Sixth Floor
New York, NY USA
Tel 212 675 1332
Fax 212 675 3027

RMAC Design
Avenida da Liberdade 220, 3°
Lisboa, Portugal
Tel +351213514180
Fax +351213514199

Roberts & Co
31 Oval Road
London, United Kingdom
Tel +44 20 7267 5544
Fax +44 20 7267 5544

Roy White
The Mercantile Building,
Suite 301-318 Homer Street
Vancouver, BC Canada
Tel 604 685 2990
Fax 604 685 2990

Rubin Postaer & Associates
2525 Colorado Avenue
Santa Monica, CA USA
Tel 310 633 6224
Fax 310 633 6917

Rule29
821 Kindberg Court
Elburn, IL USA
Tel 630 365 5420
Fax 630 365 5430

Sam Smidt
666 High Street
Palo Alto, CA USA
Tel 650 327 0707
Fax 650 327 0699

SamataMason
101 South First Street
Dundee, IL USA
Tel 847 428 8600
Fax 847 428 6564

Sandstrom Design
808 SW 3rd Avenue, Suite 610
Portland, OR USA
Tel 503 248 9466
Fax 503 227 5035

Sara Eames
1700 El Camino Real
Menlo Park, CA USA
Tel 650 838 7139
Fax 650 323 6930

**Selbert Perkins Design
Collaborative**
Playa del Rey, CA USA
Tel 310 822 5223

Seripop
PO Box 1911, Station B
Montréal, QC Canada
Tel 514 768 1320

ShapiroWalker design
101 N Chestnut Street, Suite 101
Winston Salem, NC USA
Tel 336 725 0110
Fax 336 725 0120

Skidmore, Owings&Merrill
One Front Street
San Francisco, CA USA
Tel 415 981 1555
Fax 415 398 3214

Squires & Company
2913 Canton Street
Dallas, TX USA
Tel 214 939 9194

Studio International
Buconjiceva 43 Zagreb, Croatia
(local Name: Hrvatska)
Tel +385 1 3760171
Fax +385 1 3760172

SullivanPerkins
2811 McKinney Avenue,
Suite 320 Dallas, TX USA
Tel 214 922 9080
Fax 214 922 0044

Suncica
1031 Menlo Oaks Drive
Menlo Park, CA USA
Tel 650 323 8253
Fax 650 323 8253

Sweet Design
212 St Kilda Road
St Kilda, Vic Australia
Tel +03 95254400
Fax +03 95254400

SynthesisDesign, LLC.
35 Grove Street
Haddonfield, NJ USA
Tel 856 616 8224
Fax 856 616 8226

Templin Brink Design
720 Tehama Street
San Francisco, CA USA
Tel 415 255 9295
Fax 415 255 9296

Teresa Fasolino
233 East 21st Apt 6
New York, NY USA
Tel 212 533 5543

**The Bradford Lawton
Design Group**
1020 Townsend
San Antonio, TX USA
Tel 210 832 0555

**The Design Studio
of Steven Lee**
135 South Park Street
San Francisco, CA USA
Tel 415 546 1701

The Designory
211 E. Ocean Boulevard,
Suite 100 Long Beach, CA USA
Tel 562 624 0200

The New York Times
Tel 212 556 7434
Fax 212 556 4150

The Engine Room, Inc.
610 22nd Street, Suite 307
San Francisco, CA USA

Thompsondesign
466 Lexington Avenue
2nd Floor New York, NY USA
Tel 212 210 6081
Fax 212 210 7388

Travis Ott
605 Williamson Street
Madison, WI USA
Tel 608 256 0000
Fax 608 256 1975

T'Sign
Werbeagentur Theaterstrasse
20 Basel, Switzerland
Tel +0612735040
Fax + 0612735041

Turner Duckworth
831 Montgomery Street
San Francisco, CA USA
Tel 415 675 7777
Fax 415 675 7778

Type.hu
Serleg u.7, Budapest, Hungary
Tel +36 1 3851 686

Vitrorobertson
625 Broadway Fourth Floor
San Diego, CA USA
Tel 619 234 0408
Fax 619 234 4015

Wallace Church, Inc.
330 East 48 Street
New York, NY USA
Tel 212 755 2903
Fax 212 355 6872

Wink
126 North Third Street,
Suite 100 Mpls, MN USA
Tel 612 455 2642
Fax 612 455 2645

YU+co.
941 N. Mansfield Avenue
Hollywood, CA USA
Tel 323 606 5050
Fax 323 606 5040

Zeist Design, llc
39 Mira Loma Drive
San Francisco, CA USA
Tel 415 305 6229

DesignersIllustratorsPhotographersWriters

DesignersIllustratorsPhotographersWriters

DesignFirms

Clients

Credits

Page 10
Living the Brand
Design Firm/Art Director/Creative Director
David Schimmel
Designers Lisa Paruch, Chris Korbey
Photographers Daniela Stallinger, Vincent Ricardel
Writers Cindy Knoebel, Walter Thomas
Client VF Corporation
2004 marked the first year of an ambitious new growth plan, resulting in many months of hard work by scores of people at VF Corporation. This year's annual report highlights the employees that played a vital part in realizing the growth plan while illustrating how each one of them truly lives the brand.

Page 11
2004 Annual Report
Designer Firm SamataMason
Art Director Pamela Lee
Creative Director Dave Mason
Designers Pamela Lee, Keith Leinweber
Photographer Joaquin Pedrero
Writers Dave Mason, TIR System
Client TIR Systems Ltd.

Pages 12, 13
Stretching The Boundaries
Designer Firm Equus Design Consultants Pte Ltd
Art Director/Creative Director Andrew Thomas
Designers Gan Mong Teng, Nicholas Paul
Client Colourscan Co. Pte. Ltd.

Page 14
2004 Report to Shareholders
Designer Firm Herman Miller Inc
Creative Director Steve Frykholm
Designer Andy Dull
Photographer Jim Powell
Writer Clark Malcolm
Client Herman Miller Inc
The Annual Report is intended to provide shareholders with financial information and to present Herman Miller as a "people centered" organization.

Page 15
Evolve
Designer Firm Addison
Creative Director Richard Colbourne
Designer Christina Antonopoulos
Client iStar Financial

Page 16
Station Casinos 2004 Annual
Designer Firm Kuhlmann Leavitt, Inc
Art Director/Creative Director
Deanna Kuhlmann-Leavitt
Designers Deanna Kuhlmann-Leavitt, Kerry Layton
Photographer Gregg Goldman
Client Station Casinos, Inc.

Page 17
Save Water Trophy
Designer Firm Sweet Design
Art Director/Creative Director Fiona Sweet
Designer Glass Artist Susan Palmieri
Client Yarra Valley Water
Yarra Valley Water commissioned a Save Water Trophy for it's Annual Water Saver Awards. Glass was the medium chosen to reflect water, with two shades of blue glass blown into the form.

Pages 18, 19
Inspiration
Designer Firm Beduinenzelt.com
Art Director/Creative Director
Photographer/Writer Andrea Taha
Client Creativ Club Austria
The book is also a museum of advertising. We imagine that we are living now in the year 4000 and the observer are re-discovering advertising from the 21th century. Sample: Average Daily Newspaper Advertisement (2004 AD) Remains of a mediocre campaign, published in a big daily newspaper. It is not possible anymore to detect who exactly drafted it, from whom or for what it was made, because it is completely rotten. Trails of blood and burns indicate that the creative worker was possibly so depressed due to his (or her) average performance so that the worst case scenerio happend. This view can not be proven. American experts hold the belief that, due to the pointlessly invested money, a fight between the customer and creative worker took place.

Page 20
Sappi Printer of the Year 2004
Design Firm Melinda Lawson
Art Director Belle How
Creative Director Kit Hinrichs
Designer Jessica Siegel
Photographer Jock McDonald
Writer Delphine Hirasuna
Client Sappi Fine Paper
Awards catalog.

Page 21
Poster Triennial Book
Design Firm Eric Chan Design Co. Ltd
Art Directors/Designers Eric Chan, Iris Yu
Creative Director Eric Chan
Photographer Lester Lee
Client Hong Kong Heritage Museum
The task was to create a cover and inside pages to bring out the main topic 'Dynamic Visual' for this publication in commemoration of the Hong Kong International Poster Triennial 2004 organized by the Hong Kong Heritage Museum. Different photos of a very pregnant woman exposing her belly are used as the main visual to explore the idea that dynamic visuals have to be nurtured. Each creator is like a mother about to give birth and the mood of the photo and the deliberately upside-down position express the intensity of this very important mission. A die-cut in the middle of the publication shows the place where the new baby or creation will appear.

Pages 22, 23, 24, 25
Robert Mapplethorpe and the Classical Tradition
Design Firm Matsumoto Incorporated
Art Director Takaaki Matsumoto
Client Solomon R. Guggenheim Museum
The cover had to reflect the conncection between this contemporary photographer and classical european art. This image, which displays symmetry and celebrates the nude human form, is evidence of classical principles in mapplethorpe's art.

Page 26
Gifts of the Street book
Design Firm/Art Director/Designer
Photographer/Client Sam Smidt

Page 27
WILD Fashion Untamed
Design Firm Matsumoto Incorporated
Art Director Takaaki Matsumoto
Client The Metropolitan Museum of Art
This catalog focuses on the use of animal products—fur, leathers, exotic skins and feather—in costume history. The cover of the book had to reflect the edginess and luxury of the subject matter.

Page 28
The Balthazar Cookbook
Design Firm Mucca Design
Art Director/Creative Director Matteo Bologna
Designer Victor Mingovits
Photographers Christopher Hirsheimer, Ron Haviv
Writer Keith McNally, Riad Nasr, Lee Hanson
Client Balthazar Restaurant
We designed a cookbook for Balthazar Restaurant that captures the look and feel of the restaurant itself. The design of the cookbook is a natural extension of the design we created for the restaurant.

Page 29
Sections Through a Practice
Design Firm Cesar Pelli & Associates
Creative Director Bruce Mau Design Inc.
Photographers Victoria Sambunaris, Jeff Goldberg
Writers Joseph Giovannini, Hiroyuki Suzuki,
Raul Barreneche
Client Cesar Pelli & Associates, Inc.
Introduction to Sections Through a Practice by Raul A. Barreneche Many volumes have been published on the work of Cesar Pelli. This, however, is the first about the work of Cesar Pelli & Associates (CP&A). The distinction is more than semantic. It acknowledges the contributions of the larger firm headed by Pelli and partners Fred Clarke and Rafael Pelli, as well as the firm's expanding scope as a global practice with offices and projects far beyond New Haven. The structure of this book was first conceptualized with Bruce Mau Design in the summer of 2002. Mau's approach—taking thematic slices through the breadth of the firm's work—is a fresh way to view CP&A's work, and indeed architecture

in general. Mau and his team wove together what they saw as common connections and trajectories among projects into "section cuts" through the practice that, like well-chosen architectural drawings, lend a new vantage point from which to view the work. Photographic juxtapositions of the ceilings, skins, and skeletal frames of buildings as different in form and function as airports, concert halls, and office buildings reveal shared conceptual and architectonic underpinnings that speak for themselves. New photographs by Victoria Sambunaris offer views into the firm's New Haven and New York studios, grounding the design process in a physical context. The texts animate the work with voices from inside and outside the practice: narratives by CP&A principals and essays by Joseph Giovannini and Hiroyuki Suzuki. An abridged catalog charts the firm's most significant projects according to the start of design rather than completion, to more accurately capture the zeitgeist of the office at any given moment. CP&A's spirit and character reflect the convivial characters of Pelli and his partners. Theirs is an office that discusses architecture with an unconventional vocabulary - youthful, dynamic, magical - and sets out to create buildings with a spirit of discovery, comfort, and optimism. It is hoped that this book captures those same qualities and offers a glimpse into the firm's own optimistic future.

Pages 30, 31, 32, 33
The Rarest of the Rarest
Design Firm Mucca Design
Art Director/Creative Director Matteo Bologna
Designer Andrea Brown
Client HarperCollins
We design this hard cover for Harper Collins. The book tells the stories behind the Treasures at the Harvard Museum of Natural History. The communication objective was to intrigue readers/viewer with a preview of the unusual artifacts potrayed in the book.

Page 34
Twentieth Century Fox: Inside the Photo Archive
Design Firm Pentagram Design
Art Director Abbott Miller
Designers Abbott Miller, John Kudos
Client Harry N. Abrams
"Twentieth Century Fox: Inside the Photo Archive" is designed to showcase intriguing, offbeat and unusual images from the movie studio's archives, pictures that have rarely been seen before: behind the scenes moments, publicity shots, idiosyncratic stills. The designers have paced the sections of the book within the countdown of a film leader, i.e. the characteristic 9, 8, 7... and the book finishes with "Start." The inside cover of the book employs the spotlight beams of the 20th Century Fox logo as an iconic graphic, while the typographic treatment of the back cover scatters the film names like stardust against the Fox sky.

Page 35
Scuola Holden Series
Design Firm Mucca Design
Art Director/Creative Director
Designer Matteo Bologna
Client Rizzoli
Mucca Design created this series of covers for the School of Literature "Scuola Holden" founded by one of the major Italian contemporary writers Alessandro Baricco.

Pages 36, 37, 38, 39
Design Impact
Design Firm Pentagram
Art Director/Creative Director Kit Hinrichs
Designers Amy Chan, Maria Wenzel
Illustrator Art Center Alumni
Photographers Steve Heller, Art Center Alumni
Writer Delphine Hirasuna
Client Art Center College of Pasadena
Full title is Design Impact: A history of the Art Center College of Design and the myriad ways its alumni shape and inform the vision of our global culture.

Page 40
Vanishing
Design Firm/Art Director/Creative Director
Designer Giorgio Baravalle
Photographer Antonin Kratochvil
Writer Michael Persson
Client de.MO
Vanishing is a riveting collection of 16 photo essays taken over 16 years. It is a tour through endangered life forms and ruined environments, human catastrophes and destruction – resulting in vanishing cultures. From the book's introduction:

Credits

Vanishing speaks on behalf of life, despite man's ever-threatening presence. This body of work offers nothing in the way of answers, neither is it a sermon in hopes of brighter days ... VANISHING gives those who go about their business, living their lives, a chance to look beyond their worlds and into others. Included are Guyana, Bohemia, Beirut, Bolivia, Congo, Louisiana, Zimbabwe, Ecuador, Prague, Chernobyl, Angola, The Caspian Sea, Azerbaijan, Cambodia, Iraq, New York City.

Page 41
Design of Dissent
Design Firm Mirko Ilic Corp.
Art Directors Milton Glaser, Mirko Ilic
Writers Steven Heller, Tony Kushner
Client Rockport publishing
Design of Dissent is the book about socially and politically driven graphics.

Pages 42, 43, 44
Foothills Brewing Identity
Design Firm ShapiroWalker Design
Art Director/Creative Director
David Shapiro, John Walker
Designer/Illustrator Kyle Webster
Client Foothills Brewing
Branding for Winston-Salem, North Carolina's first micro brewery.

Page 45
AtEdge
Design Firm Howry Design Associates
Art Director/Designer Ty Whittington
Creative Director Jill Howry
Writers Jill Howry, Ty Whittington
Client Serbin Communications
The client presented the problem to develop a Brand Identity for a new high-end Marketing concept called AtEdge which features only top photographers. It required an elevated design that would appeal both to the best photographers and art directors hence their tagline "where visionaries unite."

Pages 46, 47
Columbia Sportswear Packaging
Design Firm Ford Weithman Design
Creative Directors Mark Ford, Jeff Weithman
Designers Mark Ford, Clint Gorthy, Abraham Burns
Client Columbia Sportswear
A comprehensive packaging program was developed for Columbia Sportswear for all of their licensed products. Columbia's corporate branding was leveraged through prominent use of their brand ID, and the creation and use of corporate brown and tan colors.

Pages 48, 49
Fifth Avenue
Design Firm Direct Design Studio
Art Directors/Creative Directors
Dmitry Peryshkov, Leonid Feigin
Designer Serg Urkevich
Client Shopping centre Fifth Avenue
During this large-scale project the studio closely cooperated with architects and master-builders, experts of the Management Company, investors, contractors and representatives of some other organizations. Only responsibility and professionalism of participants of the project could provide harmonious and mutually advantageous cooperation in such a situation. Corporate identity of the "Fifth Avenue" shopping precinct creates a substantial and remarkable image. The name causes associations with the same street in New York, than the choice of a design direction is dictated. The "architectural" concept is based on visual components of a real Fifth Avenue landscape, - Flatiron Building, 500 Fifth Avenue, Rockefeller-center, Guggenheim Museum skyscrapers. Elements of visual identification, logotype and interior design comply with stringent laws of architecture. A basis of the logo is the monumental image of figure 5, and additional elements of identity are the stylized images of skyscrapers. The elongated type of letters in the logo corresponds to the concept too. Besides graphic palette with dominating red, dark blue and yellow colors provokes strong and bright emotions.

Pages 50, 51
Hive Mordern Home Furnishings
Design Firm Ford Weithman Design
Creative Director/Designer/Photographer Mark Ford
Client Hive Modern design for the home. Hive is an upscale urban furnishing retailer for the design enthusiast.

Pages 52, 53
SEE the potential of place spring 2005
Design Firm Herman Miller Inc
Designer Todd Richards
Illustrators Brian Cairns, Joseph Hart, Blair Thornley
Photographers Tim Simmons, Ingvar Kenne, Henning Bock, Robert Schlatter, Michael S. Yamashita, Todd Hido
Writer Clark Malcolm
Client Herman Miller Inc
This publication presents Herman Miller customers with perspectives, people and thoughts that might stimulate them in their conceptions of built environments.

Page 54
Foundation Mission Brochure
Design Firm Michael Thede Design
Art Director/Creative Director
Designer Michael Thede
Photographer Robert Pettus
Writer The Pulitzer Foundation for the Arts
Client The Pulitzer Foundation for the Arts
The Pulitzer Foundation for the Arts presents exhibitions and programs where creative forms of interaction with artists, scholars and the general public are encouraged. Michael Thede Design was selected by The Pulitzer Foundation for the Arts to create their Foundation Mission brochure. The resulting 10 page, accordion fold piece is available to patrons of the museum as a memento of their visit. It also serves as an effective medium for The Pulitzer to communicate its message to artists and other institutions for the arts. Crafted on uncoated paper, the brochure text communicates the history and mission of The Pulitzer while full-color photography showcases the Foundation's world-class architectural spaces, designed by Pritzker Prize winning architect Tadao Ando. The brochure met with critical acclaim by The Pulitzer and patrons alike for its beauty, simplicity and fiscal responsibility with respect to the Pulitzer's status as a not-for-profit foundation.

Page 55
04 Element Brochure
Design Firm Rubin Postaer & Associates
Art Director Paula Neff
Creative Director David Tanimoto
Illustrator Ames Bros.
Photographers Vincent Dente, Joe Carlson
Writers Steve Stein, Ryan Moore
Client Honda
Collateral Brochure for Dealerships

Page 56
05 Nissan Brochure Campaign
Design Firm The Designory
Art Directors Terry Medwig, Jennifer Yang, Joe Yule, Lisa Gee
Creative Directors Carol Fukunaga, Mike Monley
Designers Terry Medwig, Jeana Balestino, Jennifer Yang, Joe Yule, Lisa Gee
Illustrators Att Reps: Amanda Hench, Cori Amato, Amber Meza
Photographers Brian Garland, Kevin Necessary, Joe Carlson, Bob Grigg, Michael Moore, Tim Baur, Toshi Oku, Jeff Ludes, Tim Damon
Writers Amy Booth, Andrew Baker, Meg Crabtree, Terry Burns, Jerry Matthews
Client Nissan North America, Inc.
Vehicle brochure

Page 57
Mercedes Benz Campaign
Design Firm The Designory
Art Director Scott Izuhara
Creative Directors Ulrich Lange, Chris Hoffman
Designer Scott Izuhara
Photographers Kevin Ncessary, Charles Hopkins
Writer Scott Goldenberg
Client Mercedes Benz, USA
SLK Brochure

Page 58
Spring 2005 brochure
Design Firm Elixir Design
Art Director Jennifer Jerde
Designers Jennifer Jerde, Aine Coughlan, Nathan Durrant
Photographer Eric Tucker
Writer Alyson Kuhn
Client Taryn Rose
The goal was to convey the Taryn Rose brand and reflect the attributes of the Spring line, thru engaging photography.

Page 59
New Rules
Design Firm Bandujo Donker & Brothers
Art Director Laura Astuto
Creative Director Bob Brothers
Writer Shawn Kelly
Client Greenberg Traurig, LLP
Greenberg Traurig is the 8th largest law firm in America, but remains a relative unknown to the top law students it wants to attract. As this year's recruiting season approached, GT asked us to help them break through the clutter at major law schools with a recruiting brochure that would motivate top students to interview with them. The key message they asked us to communicate was "We're different." Our solution was a recruiting brochure that attracts entrepreneurial, business-minded law school grads by shouting "this ain't your father's stuffy old law firm" from every page. The anti-establishment personality begins immediately with the front cover. It's square, bright orange and features a headline that runs backwards. This attitude gains momentum inside thanks to surprisingly bold, conceptual photographs that would normally be viewed as sacrilegious in this gray-suited industry (when was the last time you saw a full-page, full-color shot in a law firm's brochure of a bullfrog wearing aviator glasses and a windblown scarf?) However, these visuals aren't different just to be different. Each is an integral part of a strategic sales message. Overall, this unexpected combination of elements shows the reader that GT is refreshingly different, adamant about empowering every attorney in their firm, and supremely professional, respected and successful.

Pages 60, 61
05 Infiniti Brochure Campaign
Design Firm The Designory
Art Directors Paula Neff, Dan Nguyen, Steve Chow
Creative Directors Chad Weiss, Steve Davis
Designers Gwen Pearson, Michelle Harrington, Lindsay Olsen
Photographers Toshi Oku, John Marian, Charles Hopkins, Eric Chmil
Writer John King
Client Infiniti Division, Nissan North America
Automotive vehicle brochure

Pages 62, 63
Unbound
Design Firm Concrete Design Communications Inc
Art Directors Diti Katona, John Pylypczak
Designer Andrew Cloutier
Photographer Various
Client Masterfile

Page 64
05 TL Brochure
Design Firm Rubin Postaer & Associates
Art Director Venita McClay
Creative Director Janine Rubinfier
Designer Pam Thomas
Illustrator Skidmore
Photographers Tim Damon, David Lebon, Michael Moore, Michael Ruppert
Writer Steve Stein
Client Acura
Collateral Brochre for Dealerships

Pages 64, 65
05 RL brochure
Design Firm Rubin Postaer & Associates
Art Director Venita McClay
Creative Director Janine Rubinfier
Designer Kelly Fitzpatrick
Illustrator Skidmore
Photographers Rick Rusing, David Lebon, Brian Trebelcock
Writer Steve Stein
Client Acura
Collateral brochure for Dealerships

Pages 66, 67
Meadowlands Xanadu
Design Firm Desgrippes Gobé
Art Director Stewart Devlin
Creative Director Phyllis Aragaki
Designers Stewart Devlin, Sahar El-Hage
Photographers Steve Vaccariello, James Worrell
Writer Lee Rafkin
Client Meadowlands Xanadu
Meadowlands Xanadu is a 4.7 million-square-foot, one-of-a-kind sports, leisure, shopping, and family entertainment complex. The client needed a promotional piece to be given

Credits

away at the launch party to wow and entice potential investors. This piece had to have a big impact and convey the magnitude of the project.

Pages 68, 69
365&36.5 communications
Design Firm 601Bisang
Art Director/Creative Director/Illustrator
Kum-jun Park
Designers Kum-jun Park, Jong-in Jung, Seung-youn Nam
Photographer Joong-gyu Kang
Writers Joon-young Bae, Eun-ju Ahn, Myoung Hwa Shin
Client 601Bisang
Target Audience: Clients, etc. Communications Objective: VIP calendar, Limited edition (601) Creative Strategy: Communicating with 12 keywords from the sentence 'communication design'. (for example: 'c mmu ication d sign' o n e ...the world we dream of) 12 keywords and illustration of faces from the imagination represent the message for ourselves and the title '365&36.5 communications' represents communication with sensibility (36.5 degree is same as human's body temperature) for 365 days.
Country/Language: Korea / Korean, English

Page 70
Life 05
Design Firm Rule29
Art Director/Creative Director/Designer Justin Ahrens
Illustrators Terry Marks, Bill Timmerman, Joel Nakamura, Cathie Bleck
Photographers Brian MacDonald, James Leland
Writers Rule 29 and Terry Marks
Client O'Neil Printing and Rule 29

Page 71
Spirit of Nashville 2005 Calendar
Design Firm Anderson Thomas Design
Art Director/Writer Joel Anderson
Illustrators Joel Anderson, Abe Goolsby, Emily Keafer, Matt Lehman, Kristi Smith, Darren Welch
Client Anderson Thomas Design
Vintage-style self-promotional calendar highlighting attractions of Nashville, Tennessee.

Pages 72, 73
Woody Pirtle: Object Lessons #1 catalogue
Design Firm Pentagram Design
Art Director Woody Pirtle
Client AIGA Dallas-Fort Worth Chapter
Catalogue to accompany the first exhibition of the designer Woody Pirtle's personal work, which consists of assemblages made from found objects. The book features 17 pieces produced from 2000 to 2002. The catalogue design suggests a period scrapbook. The show was on view at the Temerlin Advertising Institute at Southern Methodis University in Dallas-Fort Worth from 23 October 2004.

Pages 74, 75
Art Center 2004-2005 Catalog
Design Firm Art Center College of Design
Art Director/Creative Director/Designer
Takaaki Matsumoto
Photographer Steven A. Heller
Writer Dean Brierly
Client Art Center College of Design
Catalog of academic programs and course descriptions. Art Center wanted to present a sophisticated image of the school, one which really portrays the quality of students it attracts and the quality of work produced by its students and graduates. The goal of this publication is to communicate the value of an Art Center education. By showing work and including a personal statement from a successful alumnus of each department, potential students can get an idea of what kinds of careers are available with a degree from Art Center. Also, current student work for each department is shown, which highlight the quality of both the students and the instructors. The cover has an instant graphic impact, as it is embossed with fluorescent dots and has a die-cut circle in the center.

Page 76
Lida Baday Fall 2004 Brochure
Design Firm Concrete Design Communications Inc.
Art Directors Diti Katona, John Pylypczak
Designer Leo Jung
Photographer Chris Nicholls
Client Lida Baday

Page 77
Recchiuti Confections Catalog

Design Firm The Engine Room, Inc.
Art Director Mike Cotsifas
Creative Director Dave Braden
Photographer Maren Caruso
Writer Chantal Vasquez
Client Recchiuti Confections
Product Catalog for Recchiuti Confections centered around the idea of chocolate as a secret obsession. The idea took form with a series of diary entries that occur throughout the catalog, based on one's personal experiences with the confections.

Pages 78, 79
FISH
Design Firm Travis Ott
Creative Director Dana Lytle
Designer David Taylor
Writer John Besme
Client Gary Fisher Bicycles
The Gary Fisher 2005 Catalog is a magazine-like alternative to a brochure that captures the culture of the sport that Gary helped create and also showcasing the '05 bike lineup.

Page 80
kg
Design Firm Pleks
Art Director/Designer Mads Quistgaard
Photographer Ture Andersen
Writer/Client Kasia Gasparski
The intent was to present a very beautiful body of work in an easily accessible form. The shot was done as one long continuous shot reflected in the binding off the catalouge. A very complicated process made a very simple catalogue.

Page 81
Full Line Catalog
Design Firm Carmichael Lynch
Creative Director Michael Skjei
Designer David Schrimpf
Writer Dan Ruppert-Kan
Client Porcher

Pages 82, 83
Donald Ellis Gallery
Design Firm Hambly & Woolley Inc.
Art Director/Designer Barb Woolley
Photographers Frank Tancredi, John Bigelow Taylor
Client Donald Ellis Gallery

Pages 84,85
Fall 2004 Product Catalog
Design Firm Sandstrom Design
Art Director James Parker
Creative Director Steve Sandstrom
Designers James Parker, Kristin Anderson
Photographer Dave Bradley
Writers Joel Bloom, Jim Terry
Client Converse
Overview of Converse footwear products. Shoes are presented in every color (individually) larger than typical athletic footwear catalogs to feature details and materials better.

Page 86
MINI Motoring Gear: Always Open
Design Firm 50,000feet, Inc.
Art Director Ken Fox
Creative Directors Ken Fox, Jack Sichterman
Designers Ken Fox, Jonathan Sarmiento
Photographer Christa Renee
Writer Reid Armbruster
Client MINI

Page 87
Kozminsky Winter Catalogue
Design Firm Andrew Hoyne
Art Director/Creative Director Andrew Hoyne
Designer Dominic Minieri
Photographer Graham Bearing
Writer Jef Riner
Client Kozminsky

Pages 88, 89
Catalog
Design Firm Thompsondesign
Art Directors/Creative Directors
Kristina Backlund, Philip Kelly
Designers Philip Arias, Naoli Bray, Rei Fukui
Illustrator Philip Kelly
Photographers Keith Lathrop, Adam Savitch, Cleo Sullivan, Mark Squires, Lisa Charles Watson,

Writers Toby Barlow, Naoli Bray
Client Bailey Banks and Biddle
Bailey Banks & Biddle is an old American brand founded almost 175 years ago in Philadelphia. They came to us to be re-invented so we updated everything from their logotype to their catalogs, submitted in this entry. We wanted the brand to appear classic with it's own personality and wit. We have simplified the company's symbol: the Unicorn, and let it live in playfull illustrations on the cover. The catalog is printed in 350,000 copies and distributed in-store and to BBB's customers.

Page 90
Teri Hatcher/February 2005 cover
Art Directors Danko Steiner, Judith Schuster
Creative Director Stephen Gan
Designer Amaya Taveras
Photographer Alexi Lubomirski
Client Harper's Bazaar

Page 91
*MIT Plan, The Newsletter for the MIT
School of Architecture and Planning*
Design Firm Philographica
Art Director/Creative Director David Horton
Designers David Horton, Lahn Nguyen
Writer Scott Campbell
Client MIT School of Architecture and Planning
The first issue of a redesigned newsletter for the MIT School of Architecture and Planning.

Page 92
GQ Men of the Year Covers
Design Firm GQ Magazine
Art Director Fred Woodward
Photographers Inez Lamsweerde, Vinoodh Matadin
Client GQ Magazine

Page 93
The Conscience of Joe Darby
Design Firm GQ Magazine
Art Director Fred Woodward
Designer Sarah Viñas
Client GQ Magazine

The Ones That Got Away
Design Firm GQ Magazine
Art Director Fred Woodward
Designer Sarah Viñas
Client GQ Magazine

Page 94
Beyond the Sea
Design Firm GQ Magazine
Art Director Fred Woodward
Designer Ken DeLago
Photographer Brigitte LaCombe
Client GQ Magazine

The War Comes Home
Design Firm GQ Magazine
Art Director Fred Woodward
Designer Ken DeLago
Photographer Tom Schierlitz
Client GQ Magazine

Page 95
Cleared for Take Off
Design Firm GQ Magazine
Art Director Fred Woodward
Designer Anton Ioukhnovets
Photographer Steve Hiett
Client GQ Magazine

The Marquis de Sex
Design Firm GQ Magazine
Art Director Fred Woodward
Designer Anton Ioukhnovets
Photographer Terry Richardson
Client GQ Magazine

Page 96
Dot
Design Firm Art Center College of Design
Art Director/Creative Director
Designer Takaaki Matsumoto
Photographers Steven A. Heller, Vahe Alaverdian
Writer Dean Brierly
Client Art Center College of Design
Dot is Art Center's bi-annual magazine that is distributed to

the Art Center community, including students, faculty and alumni.

Page 97
AZURE Magazine
Design Firm/Creative Director Concrete Design Communications Inc.
Art Directors Diti Katona, John Pylypczak
Designer Concrete Design Communications Inc.
Photographer Steven Evans
Copywriter AZURE
Editors Nelda Rodger, Michael Totzke, Susan Nerberg
Client AZURE Magazine

Pages 98, 99
Jazz at Lincoln Center
Design Firm Pentagram Design
Art Director Paula Scher
Designers Paula Scher, Keith Daigle, Rion Byrd, Drew Freeman, Joseph Marianek
Photographer Peter Mauss/Esto
Client Jazz at Lincoln Center
Paula Scher and her team at Pentagram were commissioned with the design of a new identity and environmental graphics for Jazz at Lincoln Center's new home in the Time Warner Center. The Jazz facility is comprised of three performance spaces, and is an odd fit within the mixed-use development of the Time Warner Center. Project architect Rafael Viñoly successfully carved out a separate experience for Jazz that feels nothing like the corporate and retail spaces surrounding it. Similarly, Scher created an identity for Jazz that reflects the unique nature of the musical form, establishes the new Jazz at Lincoln Center as a major cultural institution, and does so in a way that is unlike that of any other institution in the city. The logo itself is a riff on the square-peg in a round hole; the disk-like letter "a" in jazz has a square at its center. Creating the exterior marquee, the designers programmed the colors of the logo to go through a cycle of "imperceptible" change that is quite graceful and almost musical in its shifts of color. (The imperceptible change also satisfied zoning laws for the location on Columbus Circle, a mixed residential and commercial area across from Central Park.) Interior murals are bright and colorful and use graphic forms of the printing process to visually link jazz to its popular roots.

Pages 100, 101
Simpatica
Design Firm Love the life
Art Directors Akemi Katsuno, Takashi Yagi
Designers Akemi Katsuno, Takashi Yagi, Yuji Oshimoto
Photographer Shinichi sato
Client Atsushi & Eri Ikeda
"Simpatica" is a casual spanish restaurant. The inside of "Simpatica" is characterized with innumerable dark purple balls. the balls are designed based on the olives. The olive is familiar for japanese and, the marinade of the olive is one of the most basic "tapas" (small dish of the spain style).

Pages 102, 103
Fourth Street Live!
Design Firm Selbert Perkins Design Collaborative
Designers Robin Perkins, John Lutz, Ian Jay, Jamal Kitmitto
Photographer Anton Grassl
Client The Cordish Company
Fourth Street Live! is an exciting new mixed-use development located in the heart of Downtown Louisville. The 8-acre site transforms a former shopping mall into a pedestrian-friendly outdoor entertainment district, which features national and regional retail shops, restaurants, a nightclub, bar and live entertainment. Design elements include identity, wayfinding and retail standards, which work to integrate the development with the adjacent hotel, convention center, residences, and other downtown attractions. The gateway monument, inspired by the development's industrial architecture, starts with a base of steel trusses and layers on bright neon lettering. Inside, tenant signage incorporates the neon element wherever possible to create a vibrant atmosphere evocative of the urban nightlife. Central to the development is the "TV tree," a tower that extends two stories overhead and sprouts plasma screens and light boxes from all sides. The light boxes provide ambience with colored lights, while the plasma screens, ranging in size from 30" to 50," play local and national sports events, concerts, music videos and in-house programming. Visitors can view the screens from tables and chairs below while enjoying food and drinks from the nearby bars and restaurants. The TV tree serves as a landmark and a dynamic central hub to the development.

Pages 104, 105
2004 Haworth Showroom
Design Firm Perkins+Will | Eva Maddox Branded Environments
Art Directors Eva Maddox, Eileen Jones
Creative Directors Rod Vickroy, Frank Pettinati
Designers Ron Stelmarski, Jason Hall, Anna Kania, Malgorzata Zawislak, Lindsey Steinacher, Patrick Grzybek, Bryce de Reynier, Maron Demissie, Becky Ruehl, Emily Neville, Daniel VonderBrink, Kevin Carlin, Lisa Estep, David Powell, Austin Zike, Nocolette Daly
Photographers Steve Hall, Craig Dugan, Hedrich Blessing
Client Susan Wray, Manager of Corporate Communications of Haworth, Inc. 2004 Haworth Showroom Project Description: The Haworth Center is a product showroom, sales office and conference facility featuring a variety of workplace concepts, product applications and integrated communications elements. The design of the facility demonstrates Haworth's evolution from a company offering workstations, to a solutions-driven resource for work spaces. It also functions as an industry-leading example of sustainability (from social, environmental and economic perspectives) demonstrating methods of integrating improved quality of life, restorative space, resource preservation, waste elimination and cost reduction. Design Solutions: The project team developed a solution driven by the new Haworth platform: Adaptable Workspace, Designed Performance and Global Perspective. This platform was embodied via: • The combination of good design and engineering to create environments that were both functional and beautiful, recognizing the need to address performance through demonstrating alternative ideas of "work" and "restore" (including a large reflecting pool). • Showcasing the concept of "work spaces", the full integration of interior architectural systems including furniture, modular walls, raised flooring, ceilings, HVAC, lighting, sound, power, voice and data. • Taking a holistic approach to product development that centers on people and ideas by incorporating the belief that user satisfaction and productivity are directly related to user control of their environment. • Incorporating restorative elements such as the indoor reflecting pool, green plantings throughout and a variety of casual interaction areas for both groups and individuals. • Development of "integrated communications" utilizing coordinated wall murals, traditional collateral and audio-visual graphics (in-floor, in-wall, rear projection & tabletop monitors). The solution merged a clean design aesthetic with high "green" performance including qualification for Gold level certification (pending) in the U.S. Green Building Council's LEED CI pilot program. (One of only 104 projects chosen by the USGBC to participate.) It was a showcase for Haworth's GREENGUARD certified products, Forest Stewardship Certified Wood finishes and products containing post-industrial/post-consumer content. This "green" design approach included the following features: • Separate low energy, higher air quality HVAC equipment, delivered through an efficient raised floor system capable of individual control at each work area. • Opening of the space to natural light and views throughout, as well as use of general ambient lighting systems and individually controlled task lighting at each work area, resulting in lower power consumption. • Re-use of materials salvaged and re-purposed from the prior showroom. • Rapidly renewable materials, such as wheat board substrate material and cork flooring. • "True fluid" product, allowing full adaptability and reconfiguration, incorporating "re-use, re-wire, re-task" philosophy.

Pages 106, 107
Sony Gallery
Design Firm Duffy & Partners
Art Director Joe Duffy
Creative Director Christopher Lee
Designer Cara Ang, Christopher Lee, Joe Duffy
Architects Perkins & Will, Jim Young, Eric Lagerquis
Client Sony
Duffy & Partners' goal was to create a branded environmental experience to build awareness of the brand, its heritage, and its full portfolio of products – including its pioneering technologies from the past and in the future. All aspects of the Sony brand needed to come to life as a story to be told to the Chinese consumer who had no previous appreciation of the Sony brand. Converted from an aging men's clothing store on one of the busiest boulevards in Shanghai, the gallery was designed from the ground up to fuse state-of-the-art image, sound and fun. It is a port for creativity, importing ideas, content and environment to and from China. Product installations were developed to allow consumers to experience first hand how Sony products can help to simplify and connect the various pieces of life, work, entertainment and personal heritage.

Page 108, 109
Iowa Hall of Pride
Design Firm SynthesisDesign,LLC.
Art Director Jason Ramos
Designer Francesca Ferrazzi
Photographer Bill Nellans Photography
Client Iowa High School Athletic Association
The Iowa Hall of Pride is a 26,000 square foot interactive exhibit experience to honor and inspire Iowa citizens by showcasing family, community, and schools. The first of its kind in the nation, the Iowa Hall of Pride opened February 2005 and is located in downtown Des Moines at the new Iowa Events Center. The museum showcases the achievements of all Iowans, from student athletes to sports legends, movie stars to scientists. Interactive, multi-media exhibits tell the stories of Iowa heroes while teaching about the state and its history. The guiding concept is the celebration of individual achievement through extracurricular events and athletics. The museum is sponsored by the Iowa High School Athletic Association (IHSAA) who chose SynthesisDesign,llc. to design 26 different interactive exhibits, theaters, and other components. Working in conjunction with various vendors, it was our goal to create a seamless environment using architecture, exhibitry, multi-media, graphics, and signage.

Pages 110, 111
2004 Antron Resource Center
Design Firm Perkins+Will | Eva Maddox Branded Environments
Art Director Eileen Jones
Creative Directors Brian Weatherford
Designer Anna Kania, Melissa Kleve, Patrick Grzybek
Client Georgina Sikorski
2004 Antron Resource Center Problem: • Develop a space to function as a combined conference center, sales office and product demonstration lab, while accommodating reconfiguration in an engaging manner for use targeted to the Architectural & Interior Design ("A&D") community. Project Description: • The Antron® Resource Center functions as a year-round conference center, educational facility and office for consultant staff and designers. For over 15 years it has been cost-effectively transformed for each NeoCon tradeshow at Chicago's Merchandise Mart. The primary 2004 project objective was to build awareness and understanding of why fiber matters and why Antron® is the industry leader, through use of "The Antron® Difference" positioning platform. Design Solutions: • For 2004, the Resource Center focused on communicating how specifying Antron® carpet fiber "makes all the difference in the world". The blurred imagery and graphic treatment built upon the visual aesthetic of new collateral elements, while the environment utilized bold, unconventional and unique fiber "objects" to express the four aspects of Antron® • Integrating strategic brand planning, marketing communications, interior architecture, exhibit display & environmental graphics, the design team utilized a holistic approach to maximizing Antron® brand impact within the environment, and building an emotional tie with the customer. • Visitors were posed four engaging questions upon entry. Answers were revealed throughout, by expressing the fundamental qualities of Antron® in an engaging manner. Secondary displays and communication elements also were used to build preference for the Antron® brand through presentation of its market position and illustration of product attributes, benefits and features. • To accommodate NeoCon traffic, the space was organized in a linear pathway, utilizing a "tunnel" element as the spatial organizer. This circulation procession was facilitated by the fiber displays and lead visitors from the corridor through the space and back out. • Utilizing a sustainable and adaptable system, a modular 3-dimensional framework was used throughout, maximizing the ability to reconfigure rooms, displays, messages and perimeter walls, while maintaining the power, data and A/V infrastructure. • Further enhancing the Antron® leadership position, product from over 15 carpet mills were featured in product displays and as floor covering applications within the Resource Center. Lighting was designed to create a visual contrast. Dark and bright spaces were juxtaposed to foster a sense of movement, anticipation and discovery, while drawing focus to the primary fiber display objects and communications.

Pages 112, 113
Faszination Mercedes-Benz Motorsport
Design Firm Design hoch drei GmbH & Co.KG
Art Directors Caroline Pöll, Marcus Wichmann
Creative Director Wolfram Schäffer
Designers Caroline Pöll, Marcus Wichmann
Architecture Ludwig Architekten
Client DaimlerChrysler AG
Motor racing means technology and emotion. Roaring

Credits

engines and the ecstasy of speed make races a great experience. This fascination had to be designed and converted into an expressive arrangement. Heart of the exhibition is a boomerang-shaped, rapid aloft-rising curve. The powerful sculpture is covered with motives, that are taken out of the courses' sphere: stand, curbs, flag, crash-barrier. Yet, the exhibition does not only exist of room-elements. The production also includes a sophisticated concept of sound and light.

Page 113
Trade Show for Interstuhl at the Orgatec 2004
Design Firm Design hoch drei GmbH & Co.KG
Art Director/Designer Jörg Dengler
Creative Director Susanne Wacker
Client Interstuhl Büromöbel GmbH
Our job was to develope a conclusive concept for the tradeshow motto "come together now" of Interstuhl, a high-quality chair producer. Each of the three brands of Interstuhl had to be presented clearly. The message: Interstuhl is both modern and self-confident, but still emotional and modest. The rainbow-coloured trade show developes its brightness from a long way off. Due to an ingenious arrangement of zones, the individual product-families were plainly recognizible. Within this system an open and attractive atmosphere could arise, which made the message "come together now" an experience.

Page 114
Hank Williams
Design Firm Marc Burckhardt/Burckhardt Studio, Inc.
Art Director Todd Detwiller
Creative Director Amid Capici
Client Rolling Stone
Portrait to accompany an article on the country legend for the "Immortals" issue

Page 115
Flying Boat Races
Design Firm John Mattos Illustration
Art Director John Mattos
Creative Director Victor Stabin
Client Stabin/ Morykin Gallery

Page 116
"Halt-before I make you listen to Matchbox Twenty again"
Design Firm Mirko Ilic Corp.
Art Director Chris Dougherty
Illustrator Mirko Ilic
Client Best Life Magazine
The usage of music as torture by the US military

Page 117
Travel Posters
Design Firm BBDO West
Art Director Heward Jue
Creative Director Jim Lesser
Illustrators Jeff Foster, David McMacken
Writers Mark Waggoner, Jim Lesser
Client Redwood Creek

Page 118
Anniversary Poster
Design Firm Dugald Stermer Illustration
Art Director Mimi Farina
Client Bread & Roses
Pro bono for an organization that brings live enterainment to shut ins, in places like hospitals, hospices, jails and prisons.

Page 119
Shakespeare's Leap
Art Director Arem Duplessis
Copywriter Stephen Greenblatt
Creative Director Janet Froelich
Designer Todd Albertson
Illustrator Marco Ventura
Client The New York Times Magazine

Page 120
Self Portrait
Design Firm Jack Unruh
Art Director Patrice Conyers
Creative Director Robert Maraziti
Client Aspen Sojourner magazine
An article about artists, who fly fish in the Aspen area.

Page 121
Bacchus & Still Life
Design Firm/Artist/Illustrator Teresa Fasolino
Art Director Barbara Vick
Client Florian's café

Page 122
Das Rheingold
Design Firm Kinuko Y. Craft
Art Director Kathleen Ryan
Client The Dallas Opera
Painting for an opera poster

Page 123
Like Mother Like Daughter
Design Firm/Illustrator Anita kunz
Art Director Francoise Mouly
Client The New Yorker
Cover painting for the mother's day issue about cloning

Page 124
Firefly Mobile Website
Design Firm Factor Design Inc.
Art Director Jeff Zwerner
Designers Gabe Campodonco, Alwin Mulyon
Client Firefly http://www.fireflymobile.com/
The Website is designed for kids (influencers) and parents (purchasers), of the Firefly mobile phone. It is intended to convince parents that a mobile phone for 8-12 year olds is not a luxury, but rather an important communication tool for keeping kids in touch with their parents.

Page 125
Design Firm Geyrhalter Design
Art Director/Creative Director/Designer Fabian Geyrhalter
Photographer Diverse Tool of North America Website
Created to showcase the directors of this award winning Santa Monica based production company.

Page 126
Sneaker Freak
Design Firm Vitrorobertson
Art Director Jera Mehrdad
Creative Directors John Vitro, John Robertson
Illustrator/Writer Elliott Allen
Client ASICS Amercia Corp.

Page 127
Areyoubold.com
Design Firm Vitrorobertson
Art Directors Mike Brower, Paul Lambert
Creative Directors John Vitro, John Robertson
Designer John Hopefl
Writer KT Thayer
Client Baskin-Robbins Teaser website (no longer alive)

Page 128
KraftHaus Website
Design Firm DNA Design
Art Director/Creative Director
Designer Charlie Ward
Client KraftHaus Films
A website which profiles the capabilities and staff for a film production and motion graphics company.

Page 129
Octavo
Design Firm Factor Design Inc.
Art Director Gabe Campodonico
Creative Director Jeff Zwerner
Client http://www.octavo.com/
The website communicates the archival benefits of digitizing rare books to institutions. To the consumer market, its about communicating the beauty and value of gaining access to these rare literary works that will otherwise always live in moisture controlled vaults.

Page 130
Chikara no Moto / Letterhead
Design Firm Graphics & Designing Inc.
Art Director Toshihiro Onimaru
Creative Director Atsushi Takeuchi
Designer Toshihiro Onimaru

Page 131
Tokyo Good Idea /Letterhead
Design Firm Graphics & Designing Inc.
Art Director Toshihiro Onimaru
Creative Director Takanori Aiba
Designer Toshihiro Onimaru
Client Tokyo Good Idea Development Institute co.,Ltd.

Page 132
Ohgiya Corporation /Letterhead
Design Firm Graphics & Designing Inc.

Art Director/Designer Toshihiro Onimaru
Client Ohgiya Corporation

Page 133
GRi.D
Design Firm GRi.D Communications Pty Ltd
Creative Directors Kathie Griffiths, Liam Camilleri, Tanya Grabow
Photographers Rob Little, Kathie Griffiths, Liam Camilleri

Page 134
LOUD
Design Firm/Art Director/Designer/Illustrator
Writer Niket Parekh
Client Ashutosh Parikh
Designed as a business card for a loudspeaker manufacturer who specialises in hi-end sound equipment for commercial purposes(concerts, disicothques etc).

Page 135
Timothy Hodapp Letterhead
Design Firm Larsen Design + Interactive
Creative Director Jo Davison
Designers Jo Davison, Timothy Hodapp
Because this client is a writer, the concept for this stationery system is built on words. Visually, these words appear to converge and transition from one thought to another, developing almost haphazardly, forming ideas, motivations, and responses. Each verb tells a story of what this writer's words and ideas can do and together create conversations that evoke myriad responses as they play through the reader's mind.

Page 136
Walton Signage Stationery System
Design Firm The Bradford Lawton Design Group
Art Director/Designer Roalndo G. Murillo
Creative Director Bradford Lawton
Photographer Kemp Davis

Page 137
Templin Brink Design Business Cards
Art Directors/Creative Directors
Joel Templin, Gaby Brink
Designers Eszter Clark, David Van Dommelen
The purpose of this project was to design a stationery system for a color consultant that minimized printing expenses while maintaining the level of design appeal. To do this, we cut down actual paint chips from our client's color library and applied two-color die-cut stickers to it. This process provided us with an endless rainbow of cards that perfectly captured his services.

Pages 138, 139
Stationery Set
Design Firm Roy White
Creative Directors/Designers
Roy White, Matthew Clark
Client Subplot design Inc
Rule #1 of Brand Identity Systems: "The design system must be unique and proprietary; completely ownable and recognizable by the organization." While this is normally true, the Subplot Design Inc. stationery system takes another approach entirely. Using a local printer's make-ready sheets from its own corporate brochure, the Subplot stationery appropriates another company's "garbage" and claims it as its own. Blind embossing the sheets and hand tipping-in glossy labels after the fact, the make-ready sheets are reclaimed and repossessed by Subplot. The resulting effect also combines two distinct sensibilities: one side is chaotic and maximalist with a multi-dimensional quality; the other side is clean and minimalist.

Page 140
Melody Nixon Logo
Design Firm The Bradford Lawton Design Group
Art Director/Creative Director Bradford Lawton
Designers Jason Limón, Melody Nixon
Identity for a local hair stylist.

Page 141
Hay Processing Unlimited Logo
Design Firm Jeff Pollard Design
Designer Jeff Pollard
Hay Processing Unlimited is a Northwest-based horse farm. The identity was intended to capture this particular client's fun and irreverant sense of humor while depicting a very different take on the "processing of hay". My additional design/brand goal was to create a mark that at first glance looked and felt like an old family business style logo.

Credits

National Beverage Properties Logo
Design Firm/Designer Brad Simon
Art Director John Klotnia

Office of Public Service and Outreach
Designer Wendy Garfinkel
Client Gold University of Georgia
Office of Public Service and Outreach
Logo

Copycats Logo
Design Firm Wink
Creative Director Richard Boynton, Scott Thares
Designer/Illustrator Richard Boynton
Trademark for Copycats, a CD and DVD manufacturer whose services include duplication, design, print, packaging, and fulfillment.

Food, Friends and Company Logo
Design Firm SullivanPerkins
Creative Director Mark Perkins
Designer/Illustrator Chuck Johnson
Logo for Food, Friends and Company, a holding company for new and developing restaurants.

Page 142
SmartTread product identity
Design Firm Jeff Pollard Design
Designer Jeff Pollard
National Safe Tire Coalition. SmartTread is a product developed by the National Safe Tire Coalition who is making strides with the United States government to make their so-called "smart tire" technology a requirement for all vehicles. As the tire's tread wears out color belts built in beneath the tread begin to show through which tell the driver when a tire is becoming unsafe.

Exposure
Design Firm Giorgio Baravalle
Art Director/Creative Director
Designer Giorgio Baravalle
TUFTS University. Exposure is dedicated to the advancement of human rights through the instruction, promotion, and encouragement of photojournalism and documentary studies. Exposure is a program of the Institute for Global Leadership at Tufts University

American Advertising Federation San Antonio Logo
Design Firm The Bradford Lawton Design Group
Art Director Rolando G. Murillo
Creative Director Bradford Lawton
Designer Rolando G. Murillo
American Advertising Federation San Antonio
Identity for the local Chapter of the AAF.

Jim's Cafe and Coffee Bar Logo
Design Firm The Bradford Lawton Design Group
Art Director/Designer Lisa Christie
Creative Director Bradford Lawton

Double Dutch Logo
Design Firm Travis Ott
Creative Director Kevin Wade
Designer Kelly English
The logo was created for a new film production company, Double Dutch, based in Chicago.

Page 143
White Owl Logo
Design Firm Sandstrom Design
Art Director Greg Parra
Creative Director Steve Sandstrom
Designer Greg Parra
Illustrator Larry Jost
Client Garcia y Vega.
The new White Owl logo, part of a complete redesign of the brand's packaging, honors their one hundred year heritage while creating a younger, more contemporary look.

Page 144
Tokyo Good Idea/Logo
Design Firm Graphics & Designing Inc.
Art Director/Designer Toshihiro Onimaru
Creative Director Takanori Aiba
Tokyo Good Idea Development Institute co.,Ltd

Page 145
Chikara no Moto/LOGO
Design Firm Graphics & Designing Inc.
Art Director/Designer Toshihiro Onimaru

Creative Director Atsushi Takeuchi
Client Chikara no Moto Company

GranFruits
Design Firm Graphics & Designing Inc.
Art Director Toshihiro Onimaru
Designers Toshihiro Onimaru, Toru Yukawa
Client Mercian Copration
Brand mark of wine

Nihon System/LOGO
Design Firm Graphics & Designing Inc.
Art Director/Designer Toshihiro Onimaru
Client Nihon System Inc.

Ohgiya Corporation/CI
Design Firm Graphics & Designing Inc.
Art Director/Designer Toshihiro Onimaru
Creative Director Atushi Takeuchi
Client Ohgiya Corporation

VIA/CI
Design Firm Graphics & Designing Inc.
Art Director/Designer Toshihiro Onimaru
Creative Director Atsushi Takeuchi
Client VIA Holdings Inc.

Page 146
HotSteel
Design Firm The Design Studio of Steven Lee
Art Director/Creative Director/Designer
Illustrator Steven Lee
Client HotSteel
A manufacturing company.

Presidio Social Club's identity
Design Firm Mucca Design
Art Director/Creative Director Matteo Bologna
Designers Christine Celic Strohl, Raymond, Shawn Tang
Mucca created the idendity for a San Francisco 1940's style restaurant.

Logo of Gerda "G-force" Hofstatter
Design Firm KittyKombat Design Studio
Designer Tina C. Hou
Client Gerda Hofstatter
Logo is for an Austrian Billiard player who also know as "G-force" in WPBA Tour (Woman's Professional Billiard Association) The logo represents the billiard player's nickname, nationality, smooth graceful playing style, and her profession.

David Beckham Athlete Identity
Design Firm Ford Weithman Design
Creative Director Jeff Weithman
Designer Mark Ford
Illustrator Clint Gorthy
Client Adidas
This logo was created for David Beckham to reflect his world-famous kick and his energetic personality and to position him globally as the adidas soccer front man.

Starvn Artist
Design Firm DarbyDarby Creative
Art Director/Creative Director/Designer
Keith L. Darby
Client Starvn Artist
Starvn Artist is an artist (singer, songwriter, and musician) management company. The logo represents the professionalism of the company and the ambitious nature of it's talent.

Page 147
Giving Groves Logo
Design Firm Vitrorobertson
Art Director Mike Brower
Creative Directors John Vitro, John Robertson
Illustrator Tracy Sabin
Writer John Robertson
Client Giving Groves

Page 148
Zipcar Logo
Design Firm M Space Design
Designer Melanie Lowe
Client Zipcar
An alternative to owning a car. It's a members car sharing service. Not quite a rental company but a new environmental transportation. Many of the car fleet are fun models such as, Minis, Bugs and more. The companies personality was described as quirky, fun, simple, smart, friendly and mobile.

Page 149
Duffy & Partners Identity
Design Firm Duffy & Partners
Exective Creative Director Joe Duffy
Creative Director Dan Olson
Designer Ken Sakurai
Client Duffy & Partners
The new brand identity for Duffy & Partners is to mark its formation as an independent branding and design firm. The new logo and identity were created for the new organization for use in all marketing and communication endeavors such as marketing materials, newsletters, computer presentations, merchandise, etc. The unusual interplay of the integrated "D" and "P" characters within the identity is simple yet highly creative and signals the core competency of the design firm. And suggests that the talent behind this brand could provide fresh and memorable brand identities for its clients as well.

St. Paul Travelers Identity
Design Firm Duffy & Partners
Exective Creative Director Joe Duffy
Creative Director Dan Olson
Designer Ken Sakurai
Client St. Paul Travelers
After merging to become one of the industry's largest insurance companies, The St. Paul Companies and Travelers needed a new brand identity rooted in their respective track records as well as their promise for the future. The identity combines icons from the rich heritage of both companies – The Wing of Mercy and the Shield of King Arthur – with the goal to signal strength and integrity of the new company moving forward. Creating a brand identity which has resonance with a newly merged company of two strong and proud corporate cultures is about creating excitement and uniqueness of the new company, but paying all the appropriate homage to the success of the past. The literal coming together of strong brand equities in each company's past demonstrates the power of the union to employees, customers, agents, and investors alike.

Toyota Trucks Logo
Design Firm Duffy & Partners
Exective Creative Director Joe Duffy
Creative Director Dan Olson
Designers Esther Mun, David Mashbur
Client Toyota
The Toyota brand had recently achieved the position of the second biggest selling car brand in the U.S. Toyota trucks on the other hand were facing a bit of an identity crisis. Their vehicles have historically been perceived as being less tough then their American competitors. But new features and styling have been developed to break that tradition. The goal was to communicate these improvements in a strong and memorable brand identity for Toyota trucks. The solution builds off of Toyota's equities while at the same time pointing to a bold future. The opportunity was to reinforce Toyota's attributes of quality, reliability and dependability. The new mark was designed to be strong yet humble, timely yet timeless. This mark is being featured throughout all truck communications and will eventually be integrated on the vehicles themselves.

North Island
Design Firm Enterprise IG Johannesburg South Africa
Creative Director/Designer Robert du Toit
Client Wilderness Safaris
The challenge of this design programme was twofold. Firstly, the generic name of the destination had to be overcome. By highlighting the geographic position of the island relative to its neighbouring islands in the Seychelle Archipelago, this has been achieved. Secondly, the identity had to reflect the exclusive retreat nature of the destination, this was achieved by representing the identity in a kinetic manner.

Page 150
Laughing Planet Logo
Design Firm Jeff Pollard Design
Designer Jeff Pollard
Client Laughing Planet
Laughing Planet is a five-store restaurant chain specializing in healthy alternatives for "fast-food". The mark is intended to reflect Laughing Planet as not just a good, inexpensive place to eat clean food but also a mind-set, a lifestyle, a way of being and interacting with people as well as the environment.

Purebred corporate identity
Design Firm Jeff Pollard Design
Designer Jeff Pollard

Credits

Client Purebred Productions
Purebred is a film production company specializing in off-beat documentaries and "indie" films. The logo is intended to be something of a visual pun or un-expected re-definition of what a purebred is. It also represents the two-person founding team who created the company; two minds, one common goal

PLUS logo
Design Firm Melinda Lawson
Creative Director Kit Hinrichs
Designer Erik Schmitt
Client Picture Licensing Universal System

Market Salamander Logo
Design Firm Grafik
Creative Director Judy Kirpich
Designers Michelle Mar, Heath Dwiggins
Illustrator Michelle Mar
Client Market Salamander

Lingenfelter Phoenix Logo
Design Firm Origin Design
Art Directors Jim Mousner, Jeff Culbertson, Martin Pepper
Creative Directors Jim Mousner, Jeff Culbertson
Designer/Illustrator Martin Pepper
Client Lingenfelter
After the tragic and untimely death of renowned engine builder and cult hero John Lingenfelter as the result of a crash at an NHRA drag racing event, the company he left as his legacy needed to reposition its brand to assure its customers that John's quality and innovation would carry on.

Page 151
Fiona Cairns Ltd logo
Design Firm Roberts & Co
Art Director/Designer Julian Roberts
Calligrapher Peter Horridge
Client Fiona Cairns Ltd
Fiona Cairns Ltd is a cake maker based in England. They hand make and supply cakes to prestigious food retailers such as Harrods, Fortnum & Mason. Roberts & Co. were commisioned to create a new logo to adorn their cake packaging and work through to other applications such as stationery and website. Roberts and Co. worked with Peter Horridge, the calligrapher, to create a logo that communicates the craft and attention to detail for which their cakes are admired. The flourishes of penmanship reflect the use of ribbons that are a signature for Fiona Cairns Ltd

Pages 152, 153
Houlihan's menu
Design Firm Arnold Worldwide
Art Directors Candy Freund, Sara Huerter
Creative Directors Ron Lawner, Mark Ray, Jen Gulvik
Designer Candy Freund
Illustrator David Broadbent
Photographer Neal Brown
Writers Lori Jones, Jen Gulvik
Client Houlihan's Restaurants, Inc

Page 154
ZEN
Design Firm Temple Pvt. Ltd.
Art Director/Creative Director Divya Thakur
Designers Divya Thakur, Niyam Mayekar
Client Hotel Leelaventure Ltd.

Page 155
EN Branding
Design Firm Mucca Design
Art Director/Creative Director Matteo Bologna
Designer Andrea Brown
Client EN Japanese Brasserie
Brand idendity for a NY based restaurant that incorporated the Kanji logo of its sister restaurant in Japan.

Page 156
Japather/ Viking club split cd
Design Firm Seripop
Art Directors/Designer/Illustrators Yannick Desranleau, Chloe Lum
Client Busy Bodies, tapes records

Program Cut
Design Firm Bruketa&Zinic
Art Director/Creative Director
Designer Tonka Lujanac
Photographer Sasa Pjanic
Client Vatra

Nardis Bohemia CD Packaging
Design Firm Travis Ott
Creative Director Kevin Wade
Designer Kelly English
Client Go Jazz
The CD packaging was created for adult contemporary artist Leo Sidran. It was important to show the environment the music was created in throughout the packaging design.

Blue Nightfall CD
Design Firm Peterson & Company
Art Director/Creative Director
Designer Bryan Peterson
Photographer Pete Lacker
Writer Jimmy LaFave
Client Red House Records

Page 157
MIN LEE CD
Design Firm/Art Director
Designer/Illustrator Jae Soh
Client Centrestage

Page 158
VERTIKAL Vodka
Design Firm Suncica
Art Director/Creative Directors Suncica Lukic, Branko Lukic
Photographer Nicolas Zurcher
Writer Branko Lukic
Client Arteska International Company
In well-saturated market of Vodka brands we tried to create new level of experience for consumers through design, to stir up new emotional responses, connections. We felt that the bottle design today, specifically in alcoholic drinks category, is not as progressive as we would like it to be so we went on to explore, redefine and push the limits further, keeping in mind the cost implications, engineering complexity and manufacturability. The question we asked ourselves in the beginning was: How could we make the bottle without the neck? That is where our journey started and this is the result, the VERTIKAL Vodka.

Page 159
SKYY 90
Design Firm Landor Associates
Excutive Creative Director Nicolas Aparicio
Senior Designers Anastasia Laksmi, Andy Keene
Client SKYY
SKYY wanted to enter into the ultra-premium segment and wanted to break the category ideas that exist within the ultra premium lines and bring a modern luxurious feel.

Page 160
Slate Bourbon
Design Firm DesignworksEnterpriseIG
Art Director/Designer/Illustrator Tony Ibbotson
Client Diageo

Page 161
1792 Ridgemont Reserve
Design Firm Di Donato Associates
Creative Director Peter Di Donato
Designer Doug Miller
Writer Bob Fugate
Client Barton Brands, Ltd.
Develop brand identity for a new premium small batch Kentucky bourbon. The brand name - 1792 -was selected to commemorate the year Kentucky became a state. The bold typography allows the brand name to stand out. A burlap wrap dresses the bottle neck adding a touch of down home flavor. The elegant decanter is topped with a wooden cork stopper.

Page 162
Tequila Matador
Design Firm Ceradini Design Inc.
Art Director David Ceradini
Creative Director David Ceradini, Lori Raymer
Designer Lori Raymer
Client Heublein Inc.
Imported Authentic Mexican Tequila

Page 163
Cool
Design Firm Identica
Designer Identica design team
Client Russian standard
New packaging design for a Vodka mix drink for Russian coolsters. Moscow's first alcopop.

Page 164
Steel Six Packaging
Design Firm Turner Duckworth
Creative Directors David Turner, Bruce Duckworth
Designer David Turner
Client McKenzie River
The Steel Brewing Company makes strong beer. Due to the success of their Steel Reserve brand, they chose to launch another, more premium and slightly lower alcohol version, that is still stronger than the average beer. This design focuses on the fact that the beer is 6% alcohol and is "Precision brewed". It is intended to have the look and feel of a component from a precision machine.

Page 165
Boag's St George
Design Firm Perks Design Partners
Creative Director Keith Smith
Designers Keith Smith, Reina Alessio
Illustrator Neil Moorhouse
Client J Boag & Son
Marketing Objectives. J Boag & Son approached Perks Design Partners to create and name a brand designed to broaden appeal to a more youthful audience, open to new ideas and tastes in boutique beer. Our challenge was to create something new using the essentially traditional heritage motifs within the masterbrand visual vocabulary. Strategy/overview. The central label feature of St George and the dragon is derived from the rich visual iconography and heritage of the brand first used by the company in 1881. In naming the product St George we were able to not only continue some of the unique history of the brand but also neatly tie in the idea of a 'hero' as a representation of individuality and personal choice for the discerning consumer.

Page 166
Gran Fruits
Design Firm Graphics & Designing Inc.
Art Director Toshihiro Onimaru
Designers Toshihiro Onimaru, Toru Yukawa
Client Mercian Copration

Page 167
No House' wine
Design Firm Datagold
Art Director Patrick van der Heijden
Creative Director Jeroen Tebbe
Designers Edwin Vollebergh, Petra Janssen, Studio Boot
Writer Jeroen Tebbe
Client Foundation Homeplan
No House Wine This is not an ordinary 'house' wine. Big difference. This is a 'No House' wine. For every sip you take a donation is made to the Dutch HomePlan Foundation, to build homes for Aids orphans and HIV-inffected children in South Africa. As you drink you contribute to building pride, creating hope, and restoring family dignity. The 'No House' wine is available at a selected group of restaurants in The Netherlands. Check www.nohousewine.com for more information.

Pages 168, 169
Templin Brink Design wine label and box
Art Directors/Creative Directors Joel Templin, Gaby Brink
Designer Megumi Kiyama
Illustrator Sean McGrath
Client MacLean Winery
When renowned wine maker Craig MacLean set off to start a winery to reflect his Scottish heritage, we incorporated elements from his family crest and patterns from the Clan MacLean kilt in the bottle and identity design.

Page 170
GluStitch Wound Closure Formulation
Design Firm/Art Director/Designer Jae Soh
Client Amsco Healthcare Marketing Pte Ltd

Page 171
Graphite Launch
Design Firm DDB Melbourne
Art Director/Designer Linda Fahrlin
Creative Director Christy Peacock
Client PZ Cussons
Graphite Deodorant- Caution, Skull, Gamma, Bolt & Flame.

Page 172
Golden Grain/Mission Pasta
Design Firm Wallace Church, Inc.
Art Director Lawrence Haggerty
Creative Director Stan Church

Credits

Designer Clare Reece-Raybould
Illustrator Simon Critchley
Client American Italian Pasta Company
Merging two regional brands into one cohesive national brand is a true challenge. The American Italian Pasta Company set out to do just that when it acquired the Golden Grain and Mission pasta brands. Wallace Church's design strategy sought to synthesize prior brand recognition equities within a new, compelling, all-American image. This new brand identity architecture had to be leveraged across more than a dozen different product forms and package configurations, visually unifying the new national brand on shelf. In its new design for Golden Grain Mission, Wallace Church sought to convey a wholesome, all-American image. A dynamic new logo is set against the "amber waves of grain" of an American wheat field. The design's rich colors convey the brand's quality and wholesome goodness, while greatly enhancing the brand's appetite appeal. This new brand identity architecture is then consistently leveraged across more than a dozen different product forms and package configurations, visually unifying the new national brand on shelf.

Page 173
Belazu Packaging
Design Firm Turner Duckworth
Creative Directors David Turner, Bruce Duckworth
Designer Christian Eager
Illustrator Mike Pratley
Client Belazu
With the success of the brand (originally designed by us in 1999) came an opportunity to update the brand identity and packaging for the Belazu range of oils, tapenades and balsamic vinegar. The brand retains its premium price point but success and changing environments (it is now found on the mainstream shelves within supermarkets--not just the specialty or delicatessen areas) means that it needs to communicate with new consumers as well as retaining existing ones.

Page 174
Niman Ranch Salame
Design Firm zeist design, llc
Creative Directors Oscar V. Mulder, Richard Scheve
Designer Oscar V. Mulder
Client Niman Ranch

Page 175
Cakes Divine Packaging
Design Firm/Art Director/Designer Jae Soh
Client Haagen Dazs

Page 176
Timberland Travel Gear
Design Firm Benchmark
Creative Director Beth Harlor
Designer Joe Napier, Maria Deacon
Client The Timberland Company
Packaging to support and sell the "Timberland Travel Gear-Pack Less. Do More" concept, while keeping in equity with the brand. Communicate the uniqueness by introducing the system, explaining its features and end results.

Page 177
Quality Connection 3D Direct Mail Campaign
Design Firm Kilmer & Kilmer Brand Consultants
Art Director Richard Kilmer, Randall Marshall
Client Quality Connection of New Mexico
Quality Connection is a customer-focused partnership between the National Electrical Contractors Association and the local chapter of International Brotherhood of Electrical Workers. Their primary audience consists of a handful of general contractors who are the ultimate decision-makers. Our objective was to grab their attention while communicating the advantages of working with a Quality Connection contractor. This series of dimensional direct-mail pieces rewarded the recipient with a quality tool and the reasons they would benefit from using a Quality Connection contractor.

Page 178
Glacier brochure
Design Firm Miserez
Art Director/Designer Serge Miserez
Photographer Daniel Mettoudi
Writer Daniel Wormeringer
Client Arctic Paper

Page 179
The Standard
Design Firm Pentagram
Creative Director Kit Hinrichs

Designer Takayo Muroga
Photographer Terry Heffernan, Tom Tracy, Barry Robinson
Client Sappi Fine Paper

Page 180
Neenah Paper Classic Crest Promotion
Design Firm Morla Design
Creative Director Jennifer Morla
Designers Jennifer Morla, Brian Singer
Illustrator Juliette Borda
Photographers Holly Stewart, David Martinez, Masterfile, CSA Images
Writer Penny Benda
Client Neenah Paper
Neenah Paper hired Morla Design to create a paper promotion that demonstrates the variety of applications and possible uses for Classic Crest Paper. We created a fictional character, the in-house Creative Director who has a nominal time frame to re-design every aspect of his company's identity. He is an archetype, a designer who wants to produce great work. We identified the core benefits and created a narrative that showcased the simplicity of specing Classic Crest.

Page 181
Neenah Bound
Design Firm Angela Frenell
Art Director/Creative Director Steve Sikora
Designers Anne Peterson, Jay Theige, Wendy Bonnstetter
Photographers Kevin White, Michal Daniel
Writer Jeff Mueller
Client Neenah Paper
The first set of "bound" desk reference paper promos on the topics of various forms of direct mail.

Pages 182, 183
Paper University
Design Firm Squires & Company
Creative Director Brandon Murphy
Designers Bret Sano, Adam Hallmark, Brandon Murphy, Laurie Williamson
Illustrator Ernesto Pachecho
Photographer Neill Whitlock
Writer Wayne Geyer
Client Weyerhaeuser Paper Company
Create informational/educational mailer (tin) that contained various books regarding pre-press, conventional printing and specialty printing techniques. Mailed to students and professionals.

Page 184
More Casino More Fun
Design Firm Eleven Inc
Art Director Josh Baker
Creative Director Paul Curtin
Designer Goldy VanDeWater
Illustrator The Clayton Brothers
Copywriter Goldy VanDeWater
Client AMERISTAR CASINOS, Inc
Posters displayed in Ameristar Casino Properties as an in-house promotion campaign.

Page 185
2005 Creative Awards Annual Show Poster
Design Firm NDW Group
Creative Director/Designer/Writer Bill Healey
Photographer Dave Robertson
Client Art Directors' Club of Philadelphia

Page 186
Design Firm 3 Deep Design
Photographer David Murrell
Client Airbrush Poster Australasia Pty Ltd

Page 187
Design Firm Katsui Design
Art Director/Designer Mitsuo Katsui
Client Komori Corporation

Page 188
2004 Marquee Posters
Design Firm Travis Ott
Creative Director Dana Lytle
Designer David Taylor
Writer James Breen
Client Wisconsin Film Festival
The Wisconsin Film Festival Marquee Posters were posted about downtown Madison before and during the 4-day independent film festival.

Page 189
Bonterra Vineyards
Design Firm/Designer/Illustrator Michael Schwab
Art Director Owsley Brown lll
Client Brown Forman Corporation

Page 190
Bridgehampton Chamber Music
Design Firm G2 Worldwide
Art Director Diane Depaolis
Client Bridgehampton Music Festival

Page 191
The Connecticut River Museum
Design Firm Cummings & Good
Creative Director/Art Directors Peter Good, Jody Dole
Designer/Photographer Jody Dole
Client The Connecticut River Museum
The brief was to create awareness of the museum and it's collection

Page 192
Woody Pirtle: Object Lessons #1 poster
Design Firm Pentagram Design
Art Director Woody Pirtle
Client AIGA Dallas-Fort Worth Chapter
Poster to promote the first exhibition of the designer Woody Pirtle's personal work, which consists of assemblages made from found objects. (The piece pictured is titled "Homerun" and constructed from a baseball bat and old rolling pins.) The show was on view at the Temerlin Advertising Institute at Southern Methodist University in Dallas-Fort Worth from 23 September to 23 October 2004.

Page 193
Save The Antelope
Design Firm Eric Chan Design Co. Ltd
Art Director/Designer Eric Chan, Iris Yu
Creative Director Eric Chan
Illustrator Iris Yu
Writer Iris Yu, Cat Tyrell
Client China Exploration & Research Society
The objective of this poster is to let the world know about the horrors of killing the endangered Tibetan antelope in order to satisfy human's "fashion" needs. A graphic illustration of the once alive animal and handwritten headline and message in blood with splatters convey the shocking truth. The logo of the concerned society is also handwritten to project the rawness and cruelty of these events. The stark contrast of a black background against the red graphic stresses the brutality of these murders. Stop the gruesome killings or there won't be any more of these animals left!

Page 194
NOBBY
Design Firm DIRECT Design Visual Branding
Creative Directors/Art Directors Leonid Feigin, Damitry Pioryshkov
Designer/Photographers Taisiya Ganga
Client Alt Telecom (celluar communications)

Page 195
Nobaggage Pick
Creative Directors/Designers Howard Beauchamp, David Walllen
Art Director Howard Beauchamp
Client 3 Chord Johnny
Poster promotes 3 Chord Johnny playing on Valentine's Day

Page 196
International Museum Day 2005
Design Firm Studio Inernational
Art Director/Creative Director
Designer Boris Ljubicic
Client Museum Documentation Centre, Croatia
Motive: Museums bridging cultures The word Museum on its reflective metallic ground receives an image of the surroundings, the appearance of it thus changing. The poster is printed on Metalic paper with two matt inks.

Page 197
Human Bomb
Design Firm Eric Chan Design Co. Ltd
Creative Directors/Art Directors
Designers Eric Chan, Micheal Miller Yu
Photographer Lester Lee
Client Hong Kong Heritage Museum
Creations concerning universal themes; the Conditions and existence of man, civilization problems, social and political sction is what the museum is about.

Page 198
Every Day is Saturday
Design Firm KBDA
Art Director/Creative Director Kimberly Baer
Designer Keith Knueven
Photographer Dave Lauridsen
Writer Jill Vacarra
Client ColorNet Press
KBDA has created a limited edition book to celebrate the quixotic culture called Los Angeles. The client, ColorNet Press, wanted to produce an unusual self-promotional piece that designers would respond to and keep. The book's colorful photography features ColorNet's state of the art printing. The book focuses on some of the most colorful and unusual places the city has to offer, and includes a collection of little-known local sources for an eclectic mix of goods and materials, plus a set of running sidebars that showcase some quintessential eyewitness moments that capture the surreal essence of L.A.

Page 199
Megamorphosis Issue 8
Design Firm NDW Group
Creative Director/Designer Bill Healey
Photographer Michael Furman
Writer Heidi Tolliver-Nigro
Client M-real

Pages 200, 201
Sioux Stochastic
Design Firm Paragon Design International, Inc.
Creative Director/Designer Bob Gailen
Photographer Corbus
Writer Lydia Marchuk
Client Sioux Printing
Showcase the advantages of stochastic print technology.

Pages 202, 203
Wonder Ring Packaging
Design Firm DNA Design
Creative Director/Designer Phil Dunstan-Brown
Illustrator Graham Parslow
Client Weave
Packaging for a gift item that doubles as a piece of jewellery and bottle opener.

Page 204
MIKA
Design Firm 3D Ideation
Designer Dennis L. Kappen
Photographer Rodney Daw
Writer Steve Dipple-Prototyping
Client 3D Ideation
MIKA is a simple and elegant stool that is sculptural in appearance and redefines movement in standing space. The design is characteristic of up-liftment, exhilaration and the excitement associated with the concept of sitting on a barstool. A simplistic bar stool that emphasizes softness via texture. The negative space under the seat creates an emotional appeal, and could house a soft under the seat lighting that turns itself on when a person sits on the stool. The essence of the design is the simplistic lines that conform to high style in a fashion conscious environment. It is a new furniture icon that is a statement of style, elegance and fashion.

Page 205
burn bag
Design Firm/Designer/Client Bernhard Dusch
It is a example for recycling design. Without much effort, the fragment of a motorcycle tire is easily transformed into a ladies handbag.

Page 206
LUX After Dark Invite
Design Firm Mires Design For Brands
Creative Director John Ball
Designer Gale Spitzley
Client LUX Art Institute

Page 207
Walton Signage Brochure
Design Firm The Bradford Lawton Design Group
Art Director Rolando G. Murillo
Creative Director Bradford Lawton
Designer Rolando G. Murillo
Photographers Kemp Davis, John Dyer
Client Walton Signage

Page 208
Nöel Greeting Card
Designers focus2 Brand Development
Art Directors Duane King, Shane Bzdok
Creative Directors Todd Hart, Duane King
Designer Duane King
Client focus2 Brand Development
Our latest holiday announcement took the form of a typographic specimen sheet for a font named Nöel. The authentic look of the typographic specimen sheet combined with the clever conceptual twist of removing all the letter L's from the design, reinforces the creative strengths focus2 has to offer and captures the playfulness within the firm.

Page 209
Christmas Card 2005
Design Firm/Client Niklaus Troxler Design
Designer Niklaus Troxler

Pages 210, 211
Desperate Housewives Show Open
Design Firm yU+co.
Art Director Garson Yu
Creative Director Yolanda Santosa
Designers Edwin Baker, Harkim Chan, Martin Surya (Designers); David Yan (Animator); Nate Homan, Chris Vincola (3D Artists); Joel Chang, Otto Tang (2D Artists)
Photographer Ryan Miller
Writer Marc Cherry
Client ABC
We offered a wickedly funny take on the history of female angst in this opening title for ABC's new hit series. Iconic imagery is used to convey the anguish of the feminine mind, displaying how women from Eve to the present have chafed under their marital status. The designers' aim goes beyond typical television show opens which merely introduce the characters and setting. Here familiar historical artwork and icons are employed - and humorously violated - to evoke the show's quirky spirit and playful flaunting of women's traditional role in society.

Page 212
Ubercool Sponsorship Kit
Design Firm Sara Eames
Creative Directors Gareth Walters, Elaine Tajima
Designers Gareth Walters, Komal Dedhia, Peter Merridew, Fil Rodriguez
Client Ubercool
Create awareness and sponsorship interest for Ubercool via state-of-the-art, unique kit.

Page 213
self-promotion
Design Firm beth perpall
Creative Director Bob Wages
Designer/Writer Rina Motokawa Menosky
Client Wages Design
Packaged gourmet tea with holiday wishes

Page 214
Promo Trash Can
Design Firm/Client Deadline Advertising
Creative Director Amir Parstabar
Deadline's promotional trash can sends the distinct message of understanding the client's needs. Each of these high-impact trash cans, painted in Deadline's trademark orange, was equipped inside with a velcroed piece of "wastepaper" advertising Deadline with the line, "We know what happens to most promos." With all the vendor promos they receive, clients could use a place to dump them, making Deadline's promo a keeper.

Page 215
James Murphy Photography- Deli Mailer
Design Firm P&W
Creative Director Simon Pemberton, Adrian Whitefoord
Designer Wesley Anson
Photographer/Client James Murphy Photography
Audience-Potential customers/ creative directors Objective-To stand out from the crowd and emphasise that James Murphy is a quality food photographer Creative- Deli bag containing various branded elements and photographs of deli products- simple and cost effective with maximum impact Market- UK

Page 216
Lux Frágil's 6th anniversary invitation
Design Firm RMAC Design
Art Directors/Creative Directors/Designers Ricardo Mealha, Ana Cunha

Client Lux Frágil
Situated in the port zone of Lisbon, overlooking the Tagus River Tejo, the Lux/Fragil is the hippest nightclub of Portugal, commemorate the 6th anniversary of this nightclub we designed an invitation whose concept is both the color and shape: it reminds us of Japanese Origamis and a pop-up map.

Page 217
Lost Touch Client Card
Design Firm Beth Singer Design, LLC
Art Director/Creative Director Beth Singer
Designer/Illustrator/Photographer Sucha Snidvongs
Writer Beth Singer & Gerette Braunsdorf
Client Beth Singer Design, LLC

Page 218
International Bhenji Brigade
Design Firm Design Temple Pvt. Ltd.
Art Director/Creative Director/Illustrator
Client Divya Thakur
Designer Divya Thakur, Niyam Mayekar
Target Audience : Potential and upcoming film makers. Comm. Objectives: To confer a sense of the cool but kitschy Indian Bollywood sensibility. Creative Strategy: Irreverance; blowing the trumpet; sounding the horn- the trademark was inspired from the identities of the older traditional bollywood production houses combining it with the energy and vibrance of present day bollywood.

Page 219
Y5
Design Firm/Art Director
Creative Director Fiona Sweet
Designer/Illustrator Faye Triantos
Photographers Duke Dinh, Guy Offerman, Ray Barry, Paul Allen, Georgie O'Shea, Damien Plemine
Client Y Salon
Y5 book was designed in celebration for the five year anniversary of the Y Salon. The book features a range of hair designs from the salon stylists. Print features include foils & Spot UV.

Pages 220, 221
Grubman Lick Book
Design Firm Liska + Associates
Art Director/Designer Kim Fry
Creative Director Steve Liska
Photographer Steve Grubman
Client Grubman
Grubman specializes in photographing all types of animals, from everyday companions like dogs and cats to the exotic. The Lick Book is a collection of Steve Grubman's photographs of animals in various states of licking. The images capture and project the personalities of creatures including sheep, leopards, lizards, binturongs and huskies. Liska designed this book as a fun promotional piece that Grubman could send to clients and business prospects.

Page 222
CHIKARA
Design Firm Graphics & Designing Inc.
Art Director/Designer Toshihiro Onimaru
Client Chikara no Moto Company

Page 223
Whataburger Field Sign
Design Firm McGarrah/Jessee
Creative Director Bryan Jessee
Designer Derrit DeRouen
Client Whataburger
Whataburger helped fund the new AAA baseball field in Corpus Christi. We were asked to create a logo, Signage and store branding for the stadium. The signage and logo was created to reflect not only the feel of baseball's history, but also the history of Whataburger and it's presence in Corpus Christi.

Page 224
NYU Robert F. Wagner School of Public Service
Design Firm Pentagram Design
Art Director Michael Bierut
Client NYU Wagner
The Robert F. Wagner School of Public Service is a school of New York University that is devoted to government and public service. Its attitude is one of hands-on, "street-smart" learning: NYC as lab. In 2004 it moved from a vintage Georgian building on Washington Square Park to a loft in the Puck Building in Soho. Collaborating with project architects Suben/Dougherty Partnership, the designers have cre-

ated environmental graphics that integrate the school's mission with its unique building. The interior circulation is grid-like and reminiscent of city streets. The designers had created an identity and visual language for the school's printed promotions, and extended this to the environmental graphics for the school. Wayfinding signage resembles street signs, but here they are affixed to the original columns of the loft. Signage typography leads around corners. The graphics help create a sense of activity that is commensurate with the school's mission to reframe public service.

Pages 225, 226
CityArts Environmental Signage
Design Firm Greteman Group
Art Directors Sonia Greteman, Craig Tomson, Garrett Fresh
Creative Director Sonia Greteman
Designer Garrett Fresh
Client CityArts

Page 227
Children's Museum of Pittsburgh
Design Firm Pentagram Design
Art Director Paula Scher
Designers Paula Scher, Rion Byrd, Andrew Freeman
Photographer Peter Mauss/Esto
Client Children's Museum of Pittsburgh
Paula Scher and her team at Pentagram created environmental graphics for the new expansion of the Pittsburgh Children's Museum, designed by architects Koning Eizenberg. The signage form is inspired by the architecture of the new building, which has a crown of layered plastic panels that move in the wind. Lobby signage and the donor wall consist of colorful fluorescent panels, while other identifying signage appear as playful treatments of words ("Garage" is set in rubber tread; "Theater" appears in reverse, as though projected.) Overall, the signage is inspired by the activity of the museum. The letters of the marquee signage on the museum entrance extrude from the building and are lit by neon from within a wire mesh, resulting in dimensional letterforms that look like something out of superhero comics. Throughout the museum, the signage employs inexpensive materials that are easily repaired or replaced.

Pages 228, 229
Terminal 1 at Toronto International Airport
Design Firm Pentagram Design
Art Director Michael Gericke
Client Toronto International Airport
Pentagram developed a comprehensive wayfinding program for the new Terminal 1 at Lester B. Pearson International Airport in Toronto. The building, designed by Skidmore, Owings & Merrill in collaboration with Moshe Safdie & Associates, is the largest public building project in the history of Canada. Toronto is a major hub for international travel and the airport is a major staging area for customs and immigration between the US and Canadian borders. The new terminal is intended to be a key portal to North America and abroad, and presents visitors with an experience that is friendly, efficient and memorable. The design team was challenged with creating a seamless signage program that was intuitive to use and truly integrated with the building's dramatic architecture. The program also needed to comply with the Canadian National Language Act, which mandates all public signage appear in English and French.

Two key elements of the program were components marking destinations within the airport (such as ticket counters, gates, and baggage carousels), and hanging directional signs. The departures hall includes tall pylons that present check-in counter identification, directions, gate numbers and other information (including arrivals and departures in LCD screens mounted in the base), in a shape reminiscent of air-control towers and Toronto's own CN Tower. The overhead hanging signage is a sculptural structure that is comprised of two sections, one for English and one for French, in curving forms that echo the arc of the terminal roof and the shape of an airfoil. Extensive studies, including testing with visually impaired users, were conducted to ensure the graphics would provide maximum visibility across the terminal's vast interior spaces. Travelers can easily make their way through the terminal following color-coded messages and pictograms that are identified according to user path (i.e., gates, ground transportation, customs, and amenities). All fixtures are made of aluminum and internally illuminated with long-life lighting elements for minimal maintenance.

Pages 230, 231
GAIN Conference
Design Firm Calori & Vanden-Eynden
Art Director/Creative Director Chris Calori
Designers Liz Talley, Chris Calori, David Vanden-Eynden
Photographer Liz Talley, Chris Calori, Tom Leighton
Client American Institute of Graphic Arts
How do you adapt a conference identity established by another firm to three-diemsional signage elements? How do you capture the attention of the conference attendees in a vast lobby space? How do you indelibly brand the conference spaces for a 3-day event when you're prohibited from affixing any signage to any surface? How do you do all this on a small budget? These were some of the design challenges facing the conference signage design team. Drawing on the conference logo and promotional materials, the signage became the identity of the conference. Everything associated with the conference was a vibrant fluorescent yellow-green, from the logo, to the volunteers' jackets. Yellow fluorescent acrylic was chosen as the main sign material, which created maximum impact for minimal cost and extended the energy of the conference through to the signage. Freestanding floor and table signs, along with low tack vinyl graphics applied to glass surfaces, claimed the site as the conference's own. The conference logo became a large-scale graphic element that intriguingly created translucent and opaque shapes, while playfully engaging the conferees. The masked opaque shapes enhanced the glowing effect of the fluorescent acrylic, thereby electrifying the signs.

Page 232
Year of the Rooster
Design Firm Interaction/design
Designer/Illustrator Hélène LHeureux
Client Canada post
Each year, Canada Post celebrate the Lunar New Year with the release of a serie of two stamps and products, First-day envelops, press sheet, postcards, etc. The design is inspired by the ancient eastern art of brush painting, with a western technological twist. The brush-strokes were generated on the computer, in a modern gesture of respect and admiration for an ancient art form. The design links an artistic tradition with the latest technology, honouring cross-cultural connections.

Page 232
Werbeagentur 150 years ETH Zurich
Design Firm T'SIGN
Art Director/Creative Director/ Designer
Illustrator Marco Trüeb
Client Die Schweizerische Post
Swiss Post is commemorating the lengthy history of the Swiss Federal Institute of Technology with a special stamp, "150th anniversary of the ETH Zurich". The 85-centime stamp shows the facade of the main ETH Zurich building, which was designed by the famous 19th-century architect Gottfried Semper (1803-1879). The special stamp will go on sale at all post offices and philatelic outlets on 8 March 2005.

Page 233
Steamship Bremen
Design Firm Haase & Knels Atelier für Gestaltung
Art Director/Illustrator Fritz Haase
Creative Directors Sibylle Haase, Fritz Haase
Designer Katja Hirschfelder
Client Federal German Ministry of Finance

Pages 234, 235
New Bern T-Shirt
Design Firm Littleton Advertising & Marketing
Art Director Chris Enter, Tom Lewis
Creative Director Chris Enter
Designers Tom Lewis, Chris Enter
Client Littleton Advertising
Littleton Advertising & Marketing is located in New Bern, a quaint river town in eastern North Carolina. To coincide with the City of New Bern's annual Mumfest, LA&M's art directors created three t-shirts with distinct New Bern features. These included images of City Hall, a bear (New Bern's "mascot"), and a boat on one of the rivers in downtown New Bern.

Page 236
Moving Typefaces
Design Firm Type.hu
Art Director/Creative Director
Designer Péter Vajda
Client Type.hu

Graphis www.graphis.com

GraphisBooks

PhotoAnnual2006

November 2005
Hardcover, 256 pages;
400 color illustrations;

Trim size: 8 1/2 x 113/4"
ISBN: 1-931241-46-5
US $70

GraphisPhotoAnnual2006 is a stylistic *tour de force* and presents the best in fine art and commercial photography. The top photography masters internationally have been consistently represented every year in this popular annual. This book is invaluable as an inspirational reference tool for ad agency art directors, graphic designers and of course the photography community. Full indexes of the photographers, representatives and thier clients makes this book an essential resource for your library.

AdvertisingAnnual2006

November 2005
Hardcover, 256 pages;
300 color photographs;

Trim size: 8 1/2 x 11 3/4"
ISBN:1-931241-48-1
US $70

GraphisAdvertisingAnnual2006 is the advertising art community's premiere showcase of print ads from around the world. Registering the pulse of advertising creativity, this high quality Annual is arranged into trade categories such as automotive, beauty & cosmetics, corporate, and sports. Over 300 examples of single ads and campaigns, plus detailed credits and indexes ensure that art directors, account managers, and graphic designers will find this edition an invaluable reference tool.

Letterhead6

October 2004
Hardcover, 256 pages;
300 full-color photographs;

Trim size: 8 1/2 x 11 3/4"
ISBN: 1-931241-20-1
US $70

A striking collection of stationery designs that seamlessly combines art and function to visually represent a client's identity. This powerful communication tool is explored through more than 300 original letterhead designs, convenie-ntly arranged by business category and indexed for reference. In addition to an unparalleled reproduction quality, *Letterhead6* features a story by collector Norman Brosterman that focuses on 19th C. art used for fine letterheads.

AnnualReports2005

July 2005
Hardcover, 224 pages;
400 color photographs;

Trim size: 8 1/2 x 11 3/4"
ISBN: 1-931241-42-2
US $70

GraphisAnnualReports2005 presents the best 33 reports, selected by a jury of some of the best designers of annual reports in the business. Each piece was reviewed for clear concepts in appropriately presenting the clients business as well as for design. The jury consisted of Dana Arnett, Jill Howry, Tom Laidlaw, Greg Samata and Michael Weymouth who has an essay on A/R's along with "Investor Relations Magazine" on what makes for a successful or unsuccessful CEO letter.

NewTalent2005

April 2005
Hardcover, 256 pages;
500 full-color illustrations;

Trim size: 7 x 11.75"
ISBN: 1-931241-44-9
US $70

GraphisNewTalentDesignAnnual2005 is the only international forum giving students the recognition and exposure they deserve. Showcased in full color, featured works include examples of effective advertising, corporate identity design, photography, packaging, and product design. Included is an interview with the progressive design school Ecole Cantonale d'art de Lausanne "ECAL" Director Pierre Keller with his exciting result directed education program in Switzerland.

PosterAnnual2005

July 2005
Hardcover, 256 pages; 300
plus full-color photographs;

Trim size: 8 1/2 x 11 3/4"
ISBN: 1-931241-43-0
US $70

GraphisPosterAnnual2005 presents outstanding poster design by the world's leading graphic designers. This edition shows a variety of graphic virtouosity and modes of expression that only this powerful medium makes possible. Featuring Commentary with Rene Wanner poster collector from Basel Switzerland and a Q+A with the Ginza Graphic Gallery Creative Team on what qualifies posters for their museum design collection, and what they predict may be the values in the future.

GraphisBooks

PackagingDesign9

October 2004
Hardcover, 256 pages; 300
plus full-color photographs;

Trim size: 8 1/2 x 11 3/4"
ISBN: 1-931241-38-4
US $70

Interactive3 is the premier international presentation of brilliantly produced websites and interactive media. The dynamic visuals of this still emerging industry were all created over the past two years. Included are more than 100 award winning results by some of the top art directors, designers, programmers, developers along with their clients all listed in the index for convient reference. Also included is an article on the design media firm of Bob Greenberg of R/GA.

InteractiveDesign3

July 2005
Hardcover, 256 pages;
300 full-color illustrations;

Trim size: 8 1/2 x 11 3/4"
ISBN: 1-931241-45-7
US $70

GraphisPackagingDesign9 is an international collection of the best 3-D designs. As packaging design becomes more integrated into a full circle branding campaign, our selection focuses on the highest standards of execution and innovation Divided into categories such as food & beverage, promotion, and cosmetics, this edition includes detailed indexes and credits. Q+A with package collector Tamar Cohen, a case study of VOSS Water, and a sampling of innovative materials from Material ConneXion library

Brochures5

September 2004
Hardcover, 256 pages;
300 full-color illustrtions;

Trim size: 8 1/2 x 11 3/4"
ISBN: 1-931241-37-6
US $70

In today's corporate communications clutter designers are challenged more than ever to conceive and produce high quality brochures. The fifth edition of *Brochures* presents more than 250 international designers and showcases complete design solutions and techniques with reproductions of covers, details and inside spreads. An index provides creative personnel, clients, and design firms. Includes Q+As with Taku Satoh, Anders Kornestedt, and the duo Terry Vine/Lana Rigsby.

PromotionDesign2

November 2003
Hardcover, 256 pages;
300 full-color photographs;

Trim size: 8 1/2 x 11 3/4"
ISBN: 1-931241-15-5
US $70

GraphisPromotionDesign2 is an international collection of the best designs created for various promotional purposes. The pieces shown range from holiday greetings and wedding announcements, to film premiere and retail openings. Detailed indexes, credits, and other information about each design firms is included, plus categories such as corporate, fashion, food & beverage, and awards. Commentary with Charles S. Anderson, Domenic Lippa, and Richelle J. Huff.

Logo6

October 2004
Hardcover, 256 pages;
300 full-color photographs;

Trim size: 8 1/2 x 11 3/4"
ISBN: 1-931241-19-8
US $70

This is the best book on logos available, with the examples of logos, corporate symbols, and trademarks by top designers from around the world, this collection is an invaluable resource for design firms, clients and students alike. All logos are indexed for easy reference, and presented with a description of the business they serve. Stories include the making of the logo for the city of Venice under the creative direction of Philippe Starck and interviews with designers working in an illustrated logo vein.

Nudes4

November 2005
Hardcover, 272 pages; 300
plus full-color images;

Trim size: 10 1/2 x 14"
ISBN 1-931241-49-X
US $70

Nudes4 presents the body's infinite possibilities through the work of internationally acclaimed photographers who have explored the diverse beauty of the nude figure. With it's international scope, *Nudes4* is an elegant presentation that will continue to inspire and intrigue an audience as diverse as its contents.

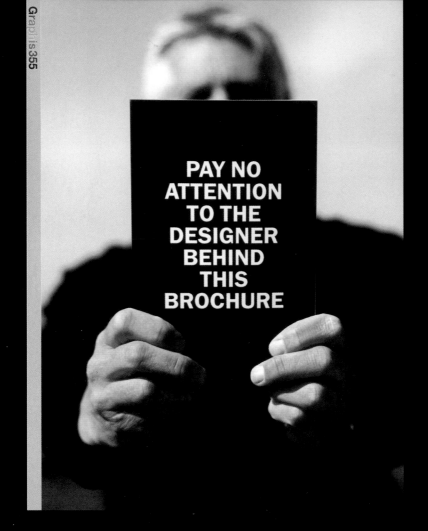